OIL PAINTING
A DIRECT APPROACH

JOYCE PIKE

OIL PAINTING
A DIRECT APPROACH

NORTH
LIGHT
BOOKS

Cincinnati, Ohio

A special thanks to my dear friend, Myrtle Smith, who worked with me throughout the rough construction as my consultant and typist.

Also Greg Albert for all his patience and knowledge and to David Lewis for his advice at the beginning and help on my photography.

ABOUT THE AUTHOR

Joyce Pike began formal art studies with Sergi Bongart at the age of twenty-three, and later continued with Viona Ann Kendall and Hal Reed. She taught art for seventeen years at the Los Angeles Valley College, and now teaches for Scottsdale Artist School, Artist Workshop Tour Agency and others.

For the past several years, Pike has demonstrated and lectured on the impressionistic approach to visual art throughout the United States and Europe and has appeared in more than fifty television programs on art. She is listed in *Who's Who in American Art, World's Who's Who of Women*, is a member of Women Artists of the American West, The Salmagundi Club of New York and The American Artist Professional League of New York and won the Notable American Award in 1980.

She is the author of both *Painting Floral Still Lifes* and *Painting Flowers with Joyce Pike* (North Light Books), as well as forty-eight one-hour instructional videotapes on painting floral still lifes, landscapes, seascapes, marine life and portraits. She resides in California with her husband, Bob.

Oil Painting: A Direct Approach. Published by North Light, an imprint of F&W Publications, 1507 Dana Avenue, Cincinnati, Ohio 45207. Copyright © 1988 by Joyce Pike, all rights reserved. No part of this publication may be reproduced or used in any form or by any means—graphic, electronic, or mechanical, including photocopying, recording, taping, or information storage and retrieval systems—without written permission of the publisher. Manufactured in Hong Kong. First paperback printing 1992.

96 95 94 93 92 5 4 3 2 1

Library of Congress Cataloging in Publication Data

Pike, Joyce, 1929-
 Oil Painting, a direct approach.

 Bibliography: p.
 Includes index.
 1. Painting—Technique, I. Title
ND1500.P48 1988 751.45 87-35003
ISBN 0-89134-425-X

Edited by Greg Albert
Designed by Carole Winters

To my family, especially my four grand-
sons, Phillip, Robert, Ricky, and Jason

CONTENTS

INTRODUCTION

Whether you are painting for fun or have a serious goal in mind, it's you and you alone who is doing it. No one can do what you do in just the same way you do it. You can reach your goals if you are willing to work for them. For some, the work will seem easier, for others a laborious task. That is life and can't be changed.

I would like to tell you about a recent conversation I had with my husband. We were discussing how many months I'd been working at getting this book compiled and written. His comment was, "I wouldn't work that hard for anybody or anything!" My reply was, "The difference between you and me is I would." I feel that anyone with knowledge should share it. How else can future generations learn from all our hard work!

This book is a composite of what I have learned throughout my life as an artist. I feel I have covered all the essentials of painting in it. I also hope as you read it you feel you have found a friend as well as learned from a teacher.

Truly good artists paint with emotion. Their creations are part of them, like giving birth to a child: that part of you that only you can produce. As you start on your walk through life as an artist, keep your eyes on your goal, but never quite reach it. Before you get there, set new goals, not so far out of reach that you become discouraged, but just far enough away to keep your interest stimulated. I have included many subjects in this book. However, the subject you paint shouldn't be that important. A nose or a rose, there really is very little difference. Everything you paint is made up of form and color. Each individual artist will have his or her own style, no matter what the subject.

As you go through life as an artist, you will have your lows as well as your highs. Learn to expect them. They are inevitable. There will be times when you may feel you are taking a giant step backwards, but don't get discouraged. Often when this feeling of depression hits, you are about to make a leap forward. As your teacher and your friend, I hope I have kindled a fire of enthusiasm in your desire to be a painter. The world of art is a beautiful place to live. Enjoy it to the fullest.

PREPARING TO PAINT

Planning your pictures before you paint is one of the most important steps to painting directly. The artist must make some very important decisions before putting any paint on the canvas. Often these decisions will determine the success or failure of the final picture. All too often, students and beginners forget the importance of making decisions about color schemes, overall tonality, or composition before they begin. No matter how well you wield the brushes or mix colors to match what you see, your painting isn't going to work if you haven't considered the picture's center of interest or what colors should go together.

In this part, Preparing to Paint, I will discuss the materials I have found to be the best for painting with a direct approach. I will show you how I handle tools. I will discuss composition and what you need to think about when you are designing your pictures. I will review the basics of color theory and show how I apply them for harmonious color schemes.

All this information will help you prepare to paint. As you will see, the more thinking you do beforehand, the greater the chances the final picture will be to your liking. Sometimes my students are amazed when they see me paint. They say it seems magical, as a few strokes become a bunch of grapes, desert flowers, or a necklace. I remind them that what they are seeing is the result of careful and deliberate thought, much of which took place before I picked up the brush. I also remind them that the preparation for the painting they see before them includes years of patient and persistent practice, a willingness to learn from mistakes and to try new things, and a love of the sheer joy of painting.

CHAPTER ONE

MATERIALS & TECHNIQUES

The materials you work with make a tremendous difference in your way of painting. Because I paint without a lot of fuss, I select my tools and materials with that in mind. I want to keep things simple. There's enough to think about when you are painting. You don't want to be distracted or handicapped by the wrong or inadequate equipment. Once you've gained some experience, I recommend you use the best. When you consider how much time and effort goes into your art, not to mention your own personality, it makes sense to work with high-quality materials. You shouldn't have any doubt that you and your work are worth the best.

Technique means how I manipulate materials—simply the way I put my paint down on my painting surface. Techniques may just be the hardest part of painting to teach. First, there are as many approaches to painting as there are stars in the heavens. Second, technique is very personal, like handwriting, so it is difficult to guide someone else in an area so completely individual. Third, you will develop your own best technique simply by painting and painting and painting.

Before I discuss the materials and techniques in detail, let me remind you that my recommendations are based on my own personal discoveries. As you paint you'll soon discover your own preferences and find what works best for you, just as I did. So don't take my suggestions as gospel. Find your own way on the road to success.

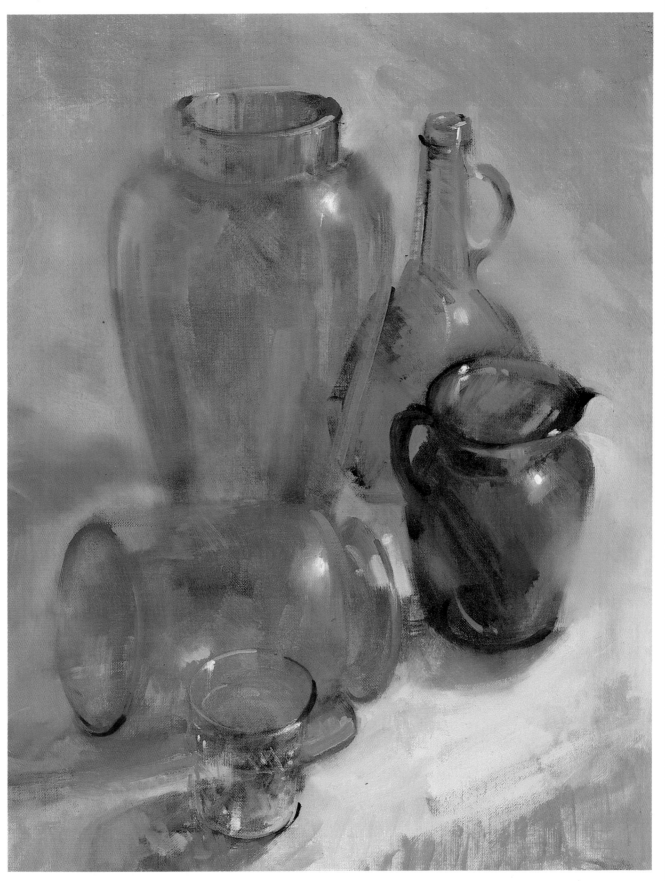

Clear Glass in Colors
24" × 18"

BRUSHES

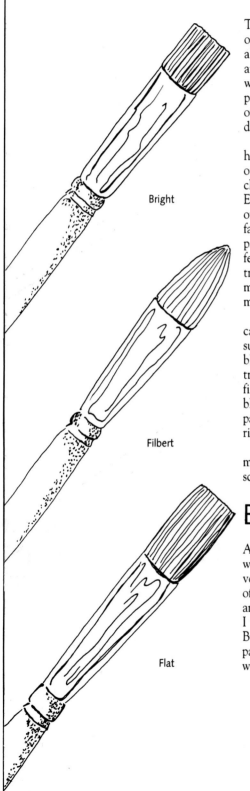

Bright

Filbert

Flat

The brush is the most important tool one can use for painting directly. It's also one of the most personal. There are many brushes on the market, all of which were designed for a specific purpose. But once they are in the hands of the artist, they'll be used in very different and individual ways.

Over the course of my career, I have added brushes to and taken them out of my collection, making each change a new approach to painting. Each discovery added the excitement of finding new and better ways to do familiar things. When I first began to paint, I used only bristle brights. In a few years I added filberts and rounds. I tried every brush that came on the market, selecting from among the many I tried.

Now I do not use rounds at all because I find filberts give the same results more easily. I also use Royal Sable brights almost exclusively for portraiture. I use a combination of filberts, bristle brights, and Royal Sable brights for almost everything else I paint. I keep a selection of pointed riggers for finish or line work.

Since all these different names might be confusing to you, let me describe each brush and how I use it.

Brights

A bright is a short, flat, bristle brush with a long handle. It is one of my favorite painting tools. I do a great deal of scrubbing when I begin to paint, and this brush gives me control when I want to cover a large surface quickly. By "scrubbing" I mean applying the paint in a circular or random pattern with a light rotating motion, rather than brushing on the paint in smooth parallel strokes. I also use brights when I make a straight line, for instance, in windows, doors, sides of a building, fence posts, trees, and so on. Because I can control the paint easily with a bright, I like to use it when I need to apply the paint carefully and delicately, such as when painting distant mountains or clouds. I use sizes no. 2, 6, 8, 10, and 12.

Filberts

A filbert is a long, flat brush with an oval-shaped point. I use this brush to do foliage, ground cover, flowers, or areas that need irregular shapes, such as tree trunks, branches, and rocks. In general, I use a filbert for anything that doesn't require a straight line. The brush holds more paint because of its extra bristle length and can be used when a direct, loaded brushstroke is needed. I use sizes no. 4, 6, 8, 10, and 12.

Flats

A flat is a brush with a long, square bristle tip. It is sometimes called an "egbert." Of the brushes I use now, flats are my last choice, or least favorite. I do use a few, mainly when I need a generous amount of paint and I need to make a squarish stroke. I use sizes no. 6, 8, and 10.

Rigger

A rigger is an unusually shaped brush with a very long, pointed tip, usually made of sable. The rigger is a favorite of mine. I use riggers for almost everything I paint, from a highlight in an eye in a portrait to the delicate branches of a tree in a landscape. I even use it to sign my paintings. I use sizes no. 1, 2, 4, and 5.

Royal Sable

Royal Sable brushes are made by Langnickel from sable bristles, but are firmer and more resilient, or springier, than red sable. In fact, when new, a Royal Sable has almost the same rigidity as a bristle brush. I cannot praise Royal Sable brushes enough. I truly feel that I discovered a new world in painting when this brush came into my life! I use Royal Sable brights for everything I do. I use sizes no. 6, 8, 10, 12, 18 and 24 for detail work and no. 28, 32, and 44 for large background work.

I almost always use a combination of Royal Sable brights and filberts. They are all short-handled brushes with short bristles. I prefer short handles because they feel more responsive, but I use long-handled brushes when I can't get the short ones.

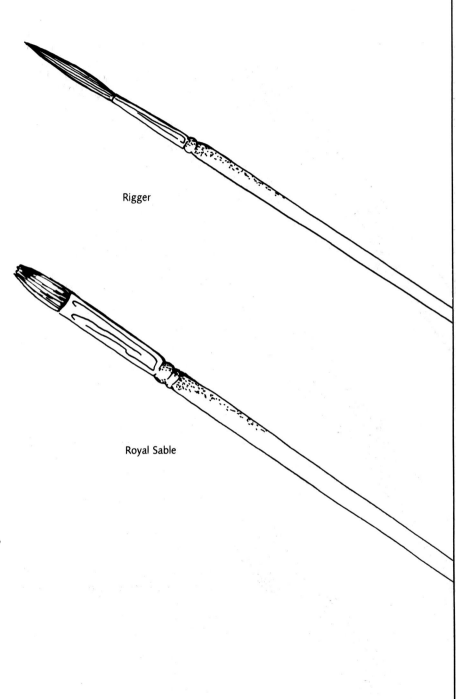

Rigger

Royal Sable

BRUSHWORK

Actual size detail of brushwork

Technique means how you manipulate the materials—simply the way you use a brush or knife to put paint down on a painting surface. Technique may just be the hardest part of painting to *teach*. First, there are as many approaches to painting as there are stars in the heavens. Second, technique is very personal, like handwriting, so it's difficult to guide someone else in an area that's so completely individual. Third, you will develop your own best technique simply by painting and painting and painting.

However, by studying other artists, you can glean a great deal of information that will help you develop more efficiently, with less frustration. I can only show you what works for me, after years of struggles and experiments. Even if you were to do everything exactly the same way, it would still be different, simply because your hand was on the brush. A brush in your hand will produce a different stroke than the same brush in mine.

Most artists use a rhythmic gesture when they paint that's like handwriting or even like a dance step with a definite rhythm. For instance, I tend to have a scrub-line-dot rhythm that comes naturally to me. I don't think I could stop doing it even if I tried. Follow your own rhythm, and you'll soon have your own confident technique.

Here's my way of using a brush and why. When I work over large negative areas such as background, I use broad, more relaxed scrubbing strokes with a no. 10 or 12 bristle bright or filbert brush. If the painting is 30″ × 40″ (75 × 100 cm) or larger, I usually use a large no. 20 bristle brush, covering the area as freely as possible. I often use more than one color in the background area, which sometimes calls for a bit of merging or blending. I do this with a controlled scrubbing stroke to keep it from looking labored.

When working in the backgrounds, I prefer to apply the paint thinly with large brushes and a scrubbing stroke that doesn't create hard edges. As I continue to work on a painting, moving forward to objects in the foreground, my strokes become shorter, more definite, and more descriptive. The paint is thicker and applied with greater control. When I work with a loaded brush and definite stroke, I usually plan to put it down in a strong statement. I want it right the first time, so I don't risk overworking the paint or creating mud. I try to do all my thinking before the brush touches the canvas.

Sometimes I cover a large area by using what I call a drip technique in which I guide the flow of paint down the canvas with my brush or finger, controlling the direction or speed of the drip as it trickles down. No matter what, I avoid overworking an area. I never labor over it. I try to stop just before I have made my statement, not after. Often the difference between something working and not working is one stroke too many.

I never use a loaded brush over negative areas. Mainly I use a generous amount of paint where I feel a strong statement is needed because a heavy buildup of paint is difficult to paint over. I always like to keep negative areas understated.

When I find it necessary to lose an edge, I hold my bristle bright or Royal Sable bright at right angles to the canvas, gently merging the two edges. There again, always stop just before you think you have finished—almost always it is enough.

If I need to thin the paint, I use turpentine, never paint thinner, which prevents the paint from forming a proper film as it dries. I use medium only on the top layers. The rule is: fat (more oil) over lean (less oil). Since the paint mixed with medium dries more slowly, it should be the top layer. Whenever possible, I simply use the paint as it comes from the tube.

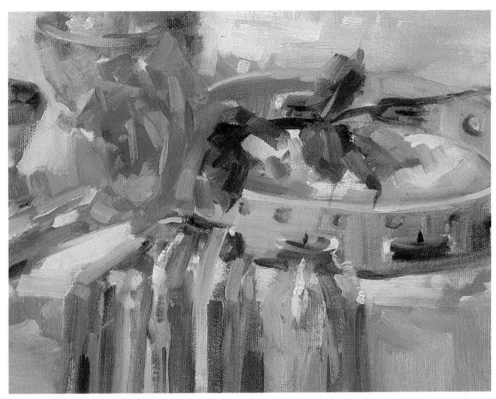

Details of brushwork

PALETTE AND PAINTING KNIVES

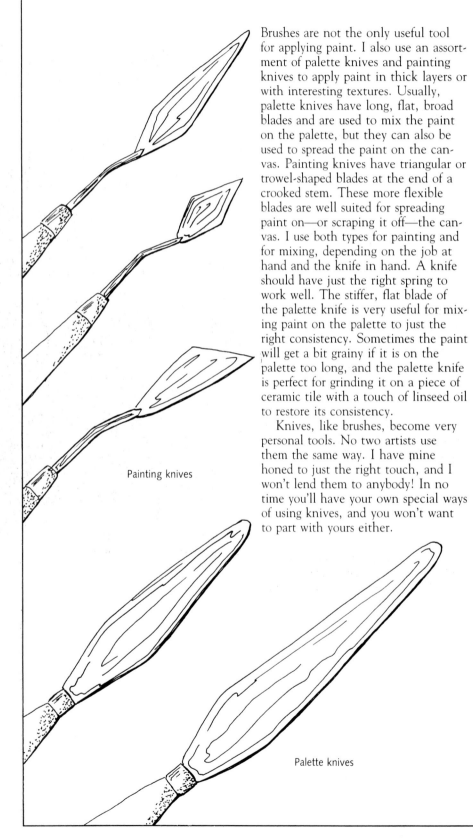

Brushes are not the only useful tool for applying paint. I also use an assortment of palette knives and painting knives to apply paint in thick layers or with interesting textures. Usually, palette knives have long, flat, broad blades and are used to mix the paint on the palette, but they can also be used to spread the paint on the canvas. Painting knives have triangular or trowel-shaped blades at the end of a crooked stem. These more flexible blades are well suited for spreading paint on—or scraping it off—the canvas. I use both types for painting and for mixing, depending on the job at hand and the knife in hand. A knife should have just the right spring to work well. The stiffer, flat blade of the palette knife is very useful for mixing paint on the palette to just the right consistency. Sometimes the paint will get a bit grainy if it is on the palette too long, and the palette knife is perfect for grinding it on a piece of ceramic tile with a touch of linseed oil to restore its consistency.

Knives, like brushes, become very personal tools. No two artists use them the same way. I have mine honed to just the right touch, and I won't lend them to anybody! In no time you'll have your own special ways of using knives, and you won't want to part with yours either.

Painting knives

Palette knives

Actual size detail of knifework

KNIFEWORK

Painting knives come in an assortment of shapes and sizes. I prefer the Italian knives. The steel is the right thickness for my needs—it gives me the proper spring as I place tension on the tip. It is also made of good steel that can be honed to a razor-sharp edge, should I desire to do so. This can be beneficial for some knifework.

I use three sizes for most of my work, but I own several, just in case I need a different size or shape for a particular problem. I've had my favorite knife for many years. I even keep it in a flannel bag when I travel to keep the point from getting bent.

My technique usually entails a combination of brush- and knifework. I usually work out my composition and color with a brush, setting the mood before I start to work with my painting knife. The knife makes clean, clear strokes, while the brush tends to disturb or remove underlying paint when it is dragged over existing paint. The flat, metal surface of the knife allows the paint to flow smoothly. When I use the knife, it's like putting icing on a cake! I usually save the sharp, deliberate strokes of the knife until last, and the paint *is* thicker. The knife strokes are the finishing touches, just like the icing.

The way I work with the knife is geared toward making sharp, clean strokes. I use the knife to mix a small quantity of paint on the palette until it's smooth. Then I scrape all the paint off the knife so it will be clean when I load paint on it. I load it from one side, much the way a mason fills his trowel. The loaded knife can now be dragged with a light touch over a passage or used to show texture on a larger area.

I also use the loaded knife to scrub or push paint around. I exert a lot of pressure, making the paint ooze over the edges of the knife. Pushing the paint around without taking the knife off the canvas, I can work interesting effects for foliage, clouds, rocks, grass, and many other things.

I can also feather the edges, when needed, or blend a sharp edge with the same controlled scrubbing stroke. The secret is pressure. Start with more pressure; then lighten the tension on the knife blade as you work out to the edge.

When I'm painting shrubs or bushes in a landscape, I often tip the edge with soft grayed-greens or clean color of any hue. *Clean* is the key word— the knife keeps the color super clean. The direction of the stroke can give a realistic look to trees, shrubs, water, or many other things. In general, the strokes should follow the form in order to describe the objects realistically.

Often you will find it necessary to show a sharp edge on an object, such as a bow of a boat, fence post, or strong light that needs to be really clean. The knife can be an effective way to go. For example, when I paint boats, I often use the knife edge to show rigging lines. These are sometimes difficult to place in with a brush. I'm not saying I don't ever use a brush—I use both.

Knifework is fun and really not difficult. You may find you like it better than brushwork. It certainly helps if you find you're getting mud. Like any other technique, plan your strokes, and don't overdo it. Too much knifework can make your work slick and dull.

Details of knifework from paintings

PAINTING SURFACES

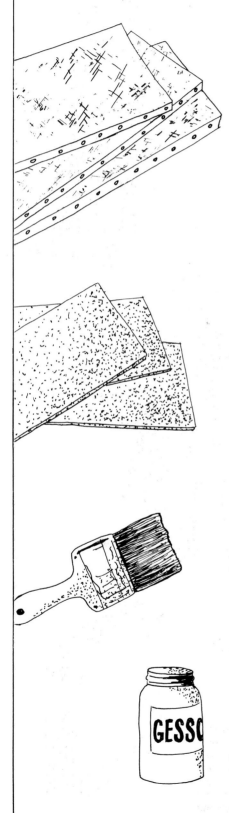

When painting in any medium, the surface you choose to work on can make a great deal of difference in the finished product. As you gain experience and confidence, work with the best as soon as possible. Most oil painters prefer to work on linen, the traditional painting surface of the Masters. I also enjoy working on heavy cotton canvas, which is cheaper and often an appropriate choice for beginners. After you have stretched the cotton canvas tight and stapled it to stretcher bars, you can prepare it by applying several coats of acrylic gesso directly to the raw canvas. I usually use two or three coats of gesso, allowing each coat to dry thoroughly, with a light sanding between coats.

The more traditional way to prepare either linen or cotton canvas after stretching is first to coat it with rabbit skin glue. This sizing can be purchased in several forms, but I prefer the powdered variety. The directions are printed on the box and are easy to follow. I usually apply two coats, allowing each to dry before the next one. After the second coat is dry, I paint the canvas with a layer of white lead paint. White lead is poisonous, so be careful not to ingest it. If white lead paint is hard to find, use flake white mixed with turpentine to a consistency that creates a bit of texture.

I use a large, old house-painting brush, which has seen its day, for applying either the gesso or the white lead. I smear the surface with the brush to give it a bit of texture. If a spot looks like it will be too thick, I smooth it over with a painting knife.

I find it best to take a day or two to prepare a number of canvases at one time; sometimes I do a whole year's worth. This allows proper curing time, since the canvases should dry thoroughly, at least several days, before they are used.

Untempered Masonite also makes an adequate painting ground. I usually work on 1/4-inch (6-mm) Masonite cut to standard sizes at a lumber yard. Although I like the extra thickness of 1/4-inch Masonite, there is nothing wrong with the 1/8-inch (3-mm) thickness. In fact, since it's lighter, the 1/8-inch is recommended for very large paintings, but it must be properly braced.

I gesso both sides of the Masonite using a large paint roller. I usually have two 4' × 8' (122 × 244-cm) sheets cut at one time and gesso them at the same time. It saves time and gesso since the roller soaks up a lot of it. Once the gesso is dry, I mix acrylic modeling paint with an equal part of acrylic gesso and use the still-wet roller to apply it to the front of the panels. I keep the roller in an air-tight plastic bag while the first coat of gesso dries and while I prepare the paste and gesso mixture.

Some of you may find it necessary to cut corners and buy canvas boards that are made from thin cotton cloth glued over cardboard and given a thin gesso finish. I hate these with a purple passion! I would rather have my students use oil tablets, which are sheets of simulated canvas that come in tablet form. They're not bad quality for practice, and can always be mounted and framed if you do something you really like.

EASELS

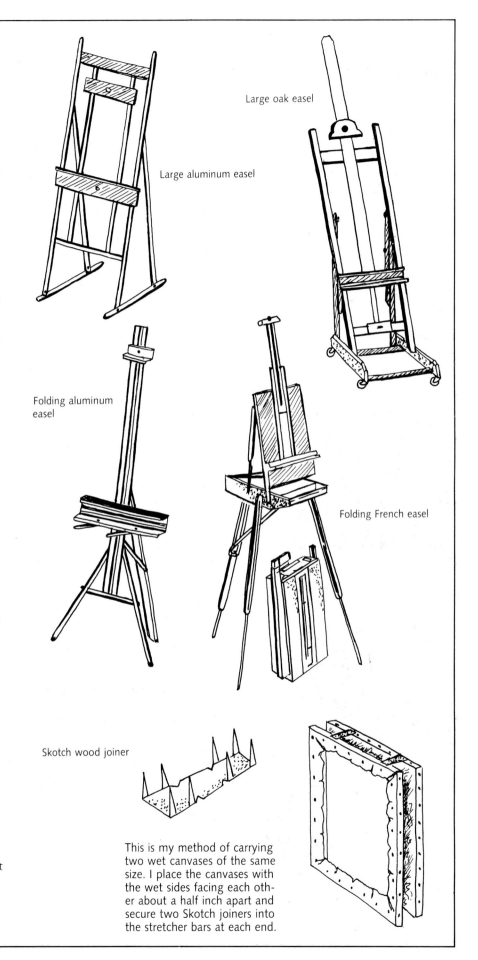

I have several easels, each of which has a special purpose. I have two large easels for painting in the studio. One is a large, tubular aluminum easel that can hold a 72″-high (183-cm) painting. The other is a large oak easel, which has a crank so it can be adjusted to the height of the canvas. When I use one to paint, the other holds a painting I have temporarily stopped working on or another painting I want to study.

For outdoor painting, I have a folding French easel with a built-in sketch box. The sketch box is well stocked with paint mediums, turpentine, brushes, and other equipment. This easel/sketch box is also my traveling companion. I have traveled all over the world with it stored under my airplane seat. When fully equipped, it can be a bit heavy, but I find it so compact that it's well worth the extra weight.

I also have a lightweight folding aluminum easel I use when I have to hike a distance to paint on location. I carry it in a heavy fabric bag secured on my back like a backpack. I carry the canvases I need strapped together in one hand and my paint supplies in a bag in the other. I look ridiculous, but it works. The aluminum easel also works well for painting with watercolors because it tilts to any angle.

I have a clever solution to the problem of carrying paintings home when they're still wet. I use a special kind of wood joiner called a "Skotch joiner," purchased at the hardware store. A Skotch joiner is a wicked-looking piece of flat metal with four nail-like protrusions extending from it at right angles on each end. To use them, I take two wet paintings that are the same size and place them so that the wet sides are facing each other about a half inch apart. Then I secure two Skotch joiners right into the stretcher bars at each end. When I get home, I just take the joiners off and there you are—two paintings in perfect condition!

Large oak easel

Large aluminum easel

Folding aluminum easel

Folding French easel

Skotch wood joiner

This is my method of carrying two wet canvases of the same size. I place the canvases with the wet sides facing each other about a half inch apart and secure two Skotch joiners into the stretcher bars at each end.

MY FAVORITES

I'll discuss my choice of colors on my palette completely in Chapter 3. For now, here's a list of my colors with the brands I prefer. Feel free to try others to discover which works best for you. Note that there is only one earth color—raw umber—in my palette. I've found that it's much easier to achieve the sparkling colors I want when working with pure, non-earth pigments. I make all my browns and grays by mixing the dominant colors chosen for the painting with their complements.

1. Cadmium red light: Grumbacher or Bellini
2. Alizarin crimson: Grumbacher, Bellini, or Permalba
3. Cadmium orange: Grumbacher or Permalba
4. Cadmium yellow light: Grumbacher, Bellini, or Permalba
5. Indian yellow: Winsor & Newton (only)
6. Sap green: Grumbacher or Winsor & Newton
7. Thalo yellow green (phthalocyanine): Grumbacher Finest
8. Viridian green: Bellini or Grumbacher
9. Thalo green (phthalocyanine): Bellini green or any name brand
10. Ultramarine blue: Bellini, Grumbacher, or Permalba
11. Cerulean blue: Bellini is my favorite, but sometimes I use Permalba
12. Thalo blue (phthalocyanine): same as Thalo green—most brands are okay
13. Cobalt violet: Bellini is the only brand I use to get a rich violet hue
14. Cobalt violet: Grumbacher—a much grayer and darker purple hue
15. Raw umber: my only earth color—any brand will do
16. Ivory black: any brand
17. Floral pink: Webber
18. Titanium white: Permalba or Pre-tested by Grumbacher

Since I often use acrylic paints for underpainting or to tone my canvas because of their rapid drying time, I also keep a selection of acrylics in my paint box. These include:

1. Titanium white: Hyplar or Liquitex
2. Cadmium red light: Hyplar or Liquitex
3. Cadmium yellow light: Hyplar or Liquitex
4. Ultramarine blue: Hyplar or Liquitex
5. Thio violet: Hyplar (only)

If I am going to use acrylics for the entire painting, I also use:

1. Alizarin crimson: Hyplar or Liquitex
2. Cadmium orange: Hyplar or Liquitex
3. Thalo yellow green: Hyplar (only)
4. Sap green: Hyplar (only)
5. Phthalocyanine green: Hyplar or Liquitex
6. Phthalocyanine blue: Hyplar or Liquitex
7. Cerulean blue: Hyplar or Liquitex

Palettes

There are many different types of palettes available, and most are suitable for your purposes. Traditional wooden palettes with a thumb hole are often beautiful objects in their own right and can make you feel like an artist in a romantic novel. Whatever palette you choose, it should have a neutral color so you can judge the color of the paint accurately. Some plastic palettes can be damaged by the solvents used in oil painting, so glass, enameled metal, or disposable palette pads are preferred.

My favorite palette is a fiberglass cafeteria serving tray. It's the right size and lightweight, has a rim and a flat, smooth surface, and can be cleaned with turpentine. It's not as picturesque as a wooden palette, but it's certainly practical.

Mediums and Brush Cleaners

I believe that paint should be used as it comes straight from the tube. However, some artists find it difficult to work with paint this thick. If you want to use a medium to thin the paint to a consistency you prefer, purchase a good medium at your art supply store or mix your own. There are many different formulas. I recommend Mayer's classic book, *The Artist's Handbook of Materials and Techniques* for complete information. I mix my own medium with this recipe:

Two parts turpentine

One part linseed oil

1/8 part damar varnish

I keep the medium in a small container on my palette table, ready for use when I paint.

I almost always use a thin wash to tone the entire canvas when I begin painting. This initial wash is either acrylic thinned with water, or oil paint thinned with turpentine. I allow it to dry or almost dry before I begin to paint the next layer. If I use oil paint, I only use pure spirits of turpentine. Anything else, such as paint thinner or kerosene, may damage the next layers of paint. One word of caution: Be sure to have good ventilation, that is, a source of fresh, moving air, in your studio when using turpentine or other thinners for oil painting. The fumes are toxic and flammable. I would recommend using acrylic only, and avoid oil painting fumes altogether if you are pregnant.

I use kerosene or paint thinner to clean my brushes when I'm painting. I keep a small can of clean turpentine handy to give my brushes a rinse before resuming work. Washing your brushes with soap specifically made for artist's brushes will extend their life.

STUDIO SPACE AND STORAGE

Ideally, the best place to paint is a room set aside for that purpose with good lighting. Having a place devoted exclusively to your art encourages you to paint. Unfortunately, sometimes the effort required to set up the equipment discourages the painter from starting when time (or energy!) is a bit limited. You should have enough space so you can set up your still life or pose a model and be far enough away to see it completely. Being right on top of your subject makes it difficult to see the whole and tends to make you paint as if you were wearing blinders. You also need to compare colors and values when you paint, so that's another reason it helps if you have enough room to step back from your canvas and view it from a distance. Sometimes we forget to see how the whole is going by focusing exclusively on the parts.

When working with natural light in the studio, I prefer north light. I often use a spotlight when I'm painting indoors, which allows me to control the lighting completely. I will discuss lighting in depth in the next chapter.

Over the years, I have accumulated quite a few objects for my still-life paintings. These items include valuable antiques as well as interesting junk. I selected them so I could have a variety of contrasting textures, colors, and shapes. I store my treasures on shelves in a special storage area, where I also keep my collection of fancy frames and finished paintings. Give some thought to suitable storage so you can begin gathering items to inspire and stimulate you.

My storage space includes shelves for still-life objects and racks for frames.

Racks for storing stretched canvases, wet paintings, or finished pictures save studio space and protect your art from damage. Space the shelves so you can store your favorite canvas sizes conveniently.

CHAPTER TWO

COMPOSITION

To paint directly, with vibrant color and without overworking your canvas, *you have to plan ahead*. I call it preplanning the painting. It's one of the most important principles of my method. I want my paintings to look fresh and pure, with just enough detail to suggest the subject matter. That means making a lot of important decisions before I ever begin to paint.

My very first decisions are about composition. Composition is arranging everything in a painting—the lights and darks, the lines and shapes, the warm and cool colors—so the composition does what you want it to. You can arrange these things so the picture is pleasing and attractive, or you can arrange them so it is disturbing and unbalanced. You can arrange them so the viewer's eye circulates around the picture and stays within its borders, or you can arrange them so the eye enters and leaves the painting just where you want it to. The choice is yours.

How you make various choices is your opportunity for self-expression. How your composition works is one of the most important ways you make a painting be your very own statement. The mood or emotional effect will be the result of how you compose your painting. It's how you express your own ideas, moods, and emotions. Composition makes your painting a unique creation.

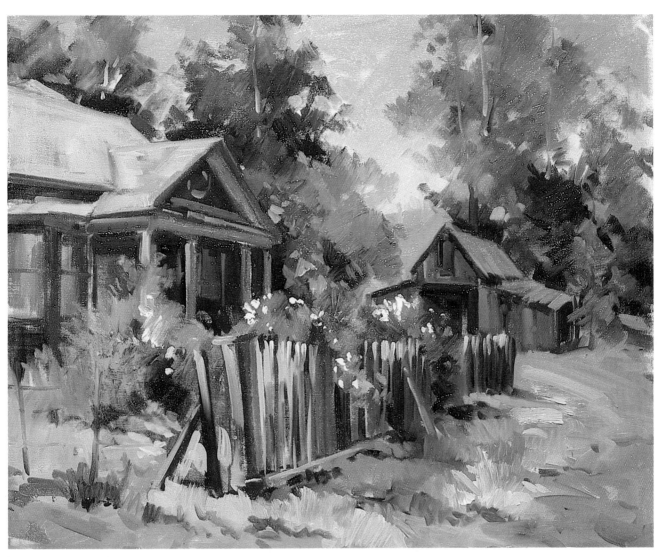

Composition is something that happens before you begin to paint. It should be the result of deliberate decision making as you plan your painting from the very beginning. In this painting, I planned a pathway for the eye into the picture. The eye begins its journey on the left, follows the fence back toward the barn, then back again toward the porch of the house, its starting point.

The Old House on Los Osos Valley Road
18″ × 24″

FOCAL POINT

I want my paintings to have a pleasing pattern of balanced lights and darks working together. To keep the viewer's eye engaged with the painting, I always plan a definite focal point in the composition, usually where the lightest light and the darkest dark come together. This spot should be located within the central area of the canvas, but not in the exact center.

The focal point acts as a magnet, constantly attracting the eye as it wanders around the image, to the interior of the picture. The focal point concentrates the viewer's attention and prevents the eye from wandering in a random way, right out of the picture. The focal point doesn't always have to coincide with the main theme object or even the center of interest. The focal point is a hook of strong contrast that catches the eye and sends it on its way through the painting. The center of interest is the payoff.

Your eye is naturally drawn to the area of greatest contrast. This spot does not necessarily have to be an object, such as an apple, vase, or tree. It could be the edge of an object brought into focus by strong contrast.

In fact, contrast in value is the most obvious way to create a focal point. However, color, texture, and detail can also be adjusted to attract the eye. For instance, an area of red or yellow in a predominantly cool painting creates eye-catching color contrast. An area with a distinctive texture or pattern also attracts attention. Like the image in a camera's view finder, a painting can be focused so there is one area of distinct, sharp detail surrounded by soft edges and blurred detail. The eye will naturally rest on the area of sharpest focus.

I always think of my compositional balance as an abstract form. The composition should work, regardless of what I'm painting, making the eye go where I want it to. If I allow myself to think for even a moment of the subject matter I'm painting before I've planned my composition, I tend to become so involved with it that I get distracted from making the strongest possible composition.

However, strong doesn't always mean obvious. The focal point in one painting may be screaming for attention, while it whispers in another. Often, its strength will be tempered by the other elements in the painting.

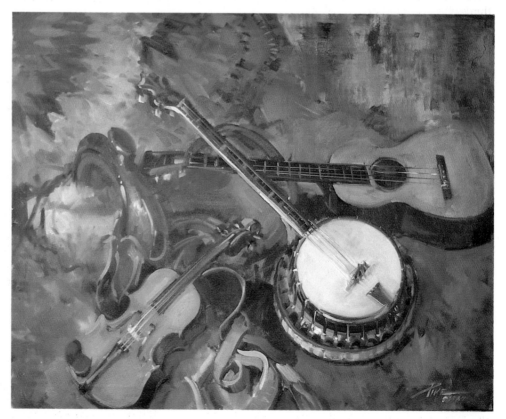

The focal point acts as an anchor for the viewer's eye as it explores the painting. The area of greatest contrast, especially a light against a dark such as the banjo in this painting, is a natural point of focus for the eye. The eye keeps returning to this spot as it circulates throughout the image.

Bluegrass Music
24″ × 30″

HIGH OR LOW KEY

Because our eyes see so much detail, it's easy to be overwhelmed by it, or to be so involved with it that we forget the basic underlying patterns that are so important in composition. Thinking in simple terms of high key or low key will help you keep an underlying pattern in mind when you're confronted with all the details of the subject matter in front of you.

High key describes a painting that has mostly light values, with only a small amount of dark. Low key refers to a painting that has mostly dark values, with only a small amount of light. Remember: Value means how light or dark a color is, compared with white, the lightest possible value, and black, the darkest possible value.

I usually think in terms of this proportion for a balanced picture: When I work in a high key, I have about two-thirds of the values light and about a third of them very dark. When I work in low key, it's the opposite—two-thirds dark and only one-third light. I distribute the midtones so the very dark values don't clash with the very light ones. I keep the midtones closer to the lights for high key, closer to the darks for low key. By placing the midtones in a pleasing, rhythmic pattern, I let the lights and darks flow around the focal point.

When you're planning your composition, it helps to make small thumbnail sketches without color. Begin with just black and white, and make a small sketch that shows the abstract pattern of values reduced to blacks and whites. The pattern should have a pleasing flow or balance.

Balance doesn't mean that there should be equal parts of light and dark. When everything is equal, the pattern is dull and boring. It's better to have the value scheme be mostly dark with a small amount of light, or light with a small amount of dark. The small area of light or dark against its opposite will attract attention and function as the focal point. Its small size will be balanced by the visual impact it creates.

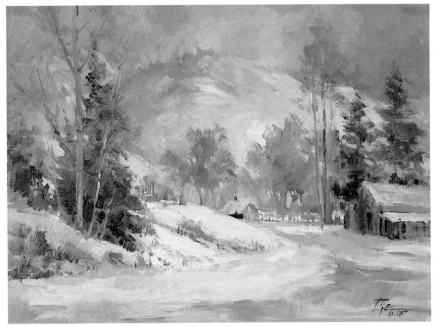

Snow in the Rockies
20″ × 24″

This is an example of a painting in a high key. The values are mostly light, with only a small amount of dark.

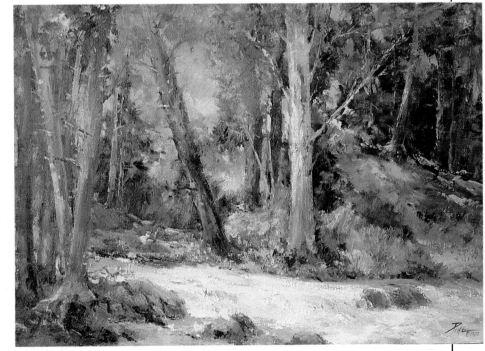

After the Thaw
18″ × 24″

This is an example of a painting in a low key. Because there are more darks than lights, the picture has a more somber and quiet mood. Your decision about high or low key has a significant effect on your painting's emotional impact on the viewer.

LIGHTING

The pattern of light and dark values that you need to consider for a pleasing composition is largely the result of how your subject is illuminated. When you are arranging a still life, for instance, where the shadows fall will be as important as the placement of the various objects in the composition. The illusion of depth in your picture will also be determined by how the light reveals the forms in your setup.

An important part of my still-life painting process is adjusting the lighting. I use a 100-watt spotlight mounted on a photographer's light stand. (These stands are somewhat expensive, but they're well worth it: they never need to be replaced.) This is my main light source. Occasionally, I'll use another light to throw a strong accent in the shadows. I often do this when illuminating a model for a portrait.

There are no set rules for positioning a light source. It's best to keep an open mind and experiment. Play with the lighting. Unusual lighting can be very exciting, so try different lighting angles until you find one that creates a pattern of lights and darks you like, always keeping in mind the focal point. Don't get stuck putting your light in the same old place all the time.

You should also consider the lighting on your painting as you work. Everyone develops a preference for the amount of light they like on their painting. Some prefer a room flooded with light. I personally like less light. I know this is a bit unusual, but I don't like the glare on the wet paint. I also like fluorescent overhead lighting. In my studio there are three 4-foot fixtures with two tubes: one's cool, the other warm. There's a perfect balance of light, so the colors are true on both my palette and my canvas.

Working with filtered light from the outside is still my absolute favorite situation. Working near a window is ideal, but an ever-changing light source also creates a big problem. You must work quickly to take advantage of the subtle values. The light also appears cool from the reflected sky, making the dark values appear warmer in contrast.

This 100-watt spotlight is mounted on a photographer's light stand.

SELF-EXPRESSION

You may be wondering how you're supposed to think of all these things when you're just trying to paint what you see before you. Why can't you just paint what you see and not worry about a focal point or low and high key? If you thought about your setup, whether it be a still life, floral arrangement, or figure, and you've done a few thumbnail composition studies and thought about your lighting, all you need to think about is painting. However, there are often flaws in an arrangement that might make for a weak composition if you copied it exactly, or there is something you could add or leave out to improve the picture's balance. After all, if we wanted an exact copy of what we see, we'd get a camera. Sometimes we need to improve on what we see, or deviate from it, to make a more expressive picture. That's why no two students' paintings look alike, even when we're all painting the very same setup.

For instance, when you set up a still life or floral arrangement, your backdrop will often determine whether the painting will be low key or high key. It would be next to impossible to do a high-key painting with a dark or even midtone drape in the background. You might need to adjust the values differently from the way you see them to strengthen the focal point. While you're still painting what you see, you're making decisions to improve on what you see to make the best painting. With some experience, you'll be making these decisions unconsciously because you'll be thinking automatically like a painter.

Your painting can be based on what you see, but it shouldn't be an exact copy. When I have planned my composition carefully, established a focal point, determined in what key my painting will be, I then concentrate on being *unique*. I think of what I can do that will be different, unusual, mine alone. What can I do that will make this painting a Joyce Pike? I use the term "self-expression" for this because no one can put brush to canvas like anyone else. My work should be my signature, just as your work should be yours.

Here's a word of advice: Don't waste time looking for shortcuts. Be patient. Enjoy where you are, and concentrate on painting. Try to be the best you can be, not better than the next guy. Compete with yourself.

USING A VIEW FINDER

A view finder is a simple tool you can use to help you select what you want to place on your canvas. It's a compositional device. The view finder has two main uses: one, to select subject matter, and two, to relate objects for placement or drawing. There are a few on the market, such as the one that watercolorist John Pike designed. I prefer to make my own, which I can do in a matter of minutes.

I cut two Ls of heavy cardboard, each forming a right angle, 12″ (30 cm) along each side. I have mine marked like a ruler, with a tick at each inch. I use paper clips to hold the two Ls together, so that the proportions of the opening are the same as that of the canvas I'm planning to use. The actual size of the opening is not important if the proportions are the same, since you can adjust the image size. I then tape two pieces of string diagonally from corner to corner across the opening, forming an X in the center. As I stand in front of my subject, I close one eye. I look through the view finder and move it away from me or toward me until I see exactly what I plan to place on my canvas. I also find it good to move the view finder around to see the different compositional possibilities I can come up with for my painting.

The view finder also helps me block out the surrounding area, making it easier to see exactly what I want on my canvas, so I can find just the right composition. Some painters need to do a line drawing first to relate objects and secure shapes. Of course there's nothing wrong with this approach, but I find it has a tendency to tighten my work, and I like to relate abstract shapes with little or no contour drawing.

Once I have decided on the composition, I start to draw the area where the two strings intersect. This is the center of my canvas. It may be simply a flower petal or a side of a vase. I now know what is directly in the center of my composition and proceed to place all other objects in relation to that.

If you find it difficult to keep looking through the view finder to relate objects as you draw, I have another suggestion. Take a few Polaroid photographs of your setup from different angles or with different arrangements. Don't worry if the Polaroid shots are off color or slightly out of focus. The purpose of the photos is to make sure you know where to start and how to relate objects on your canvas. The Polaroid is only a tool; it's not a substitute for the real setup.

The two halves of a view finder are shown here.

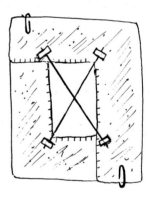

This assembled view finder has cross strings.

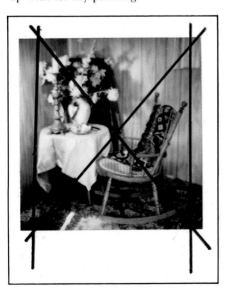
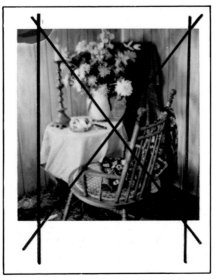

Here are examples of Polaroid photographs used for planning composition. Note how I used a felt marker right on the photo to mark my canvas's actual proportions and to locate the center of the image.

This is an overview of the arrangement I was working with for my painting.

CHAPTER THREE

COLOR

Color never fails to fascinate the student, but all too often it mystifies and confuses. I don't think there is a painter yet who doesn't fret over how to mix that color! In fact, understanding color sometimes feels like learning to play an organ with a thousand keys.

No matter how complicated it might seem to you, understanding color and making it work for you when you paint has a simple beginning. As you know from grade school, we start with a one-, two-, three-color concept called the primaries and then move on systematically to a myriad of possible color mixtures. Each mixture has a purpose, but with a few simple concepts in mind, you'll soon feel confident about your ability to mix color.

Actually, it's not the act of mixing colors that's important, but what you do with the color after you've mixed it that counts. Color is a painting's most important feature that attracts and pleases the eye of the viewer. Much of the joy others will experience when viewing your work will be the result of your ability to make colors work together. Again, the key to successful color is the thought and planning you do before you paint. Once you have decided on an appropriate color scheme, all the colors you mix for your painting should be selected or adjusted to it. So let's begin with the most basic aid to mastering color, the color wheel.

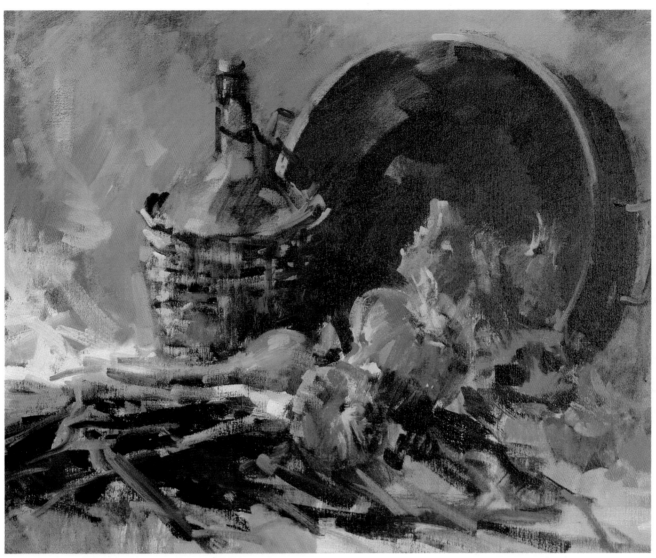

Color is one of the most ex-
citing and challenging aspects
of painting. The secrets to
making color work for you are
planning your color harmonies
before you paint, eliminating
earth colors from your palette,
and not overblending your
paints on the canvas.

Exeter Onions (Detail)
24″ × 48″

THE COLOR WHEEL

The color wheel is the best way to make concepts about color *visual*. Even if you feel familiar with the color wheel, actually *making* one with the very paints you will use will really educate your eye. So here's how to make a wheel.

First, make a large circle. You can use a compass, but I just traced around the bottom of a large coffee can I found in the studio. It's better to use canvas or canvas board rather than paper or cardboard, which will absorb the oil from the paint and stain it.

We'll begin with these three colors:

Red (Grumbacher red) Blue (cobalt blue)

Yellow (cadmium yellow light)

As you know, these are the primary colors, or the primary triad. These are closest to true spectrum colors and can't be duplicated by mixing other colors together. Put one swatch of color at each of three equidistant points on the circle to form an equilateral triangle. Mix equal parts of red with blue, blue with yellow, and red with yellow to form purple, green, and orange. Place them between the two primaries from which they were mixed. These are the three secondary colors, or the complementary triad. Each primary color has a complementary color, made up of the other two primaries opposite it on the color wheel.

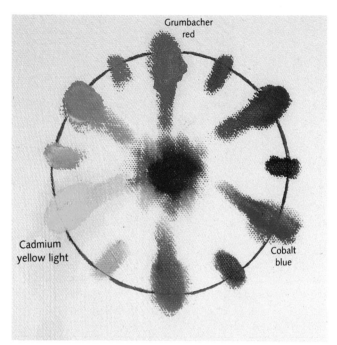

Red, blue, and yellow form the primary triad. Orange, green, and purple, each mixed from two primary colors, form the secondary triad. All three primaries mixed together make a neutral in the center.

COLOR TEMPERATURE

There are many different properties of color that can be understood by studying a color wheel. The most useful concept for beginners is what's called color temperature. Often artists talk about warm colors or cool colors. Basically, all the oranges, yellows, reds, and purples are called warm colors, probably because fire and hot metals glow with a reddish color. The blues, greens, and blue-violets are called cool colors, probably because water and ice are cool and bluish. Thinking about color temperature is a good way to relate the colors. A green is warm compared with blue, but cool compared with yellow; a purple can be warm compared with blue or cool compared with red; and so on. Cool or warm indicates on which side of the color wheel a particular color appears.

The next color wheel I want to show you is made with the colors I use on my palette. As you can see, the colors I recommend form a wheel very close to the first one we discussed. Notice that the tube colors in the second wheel are purer and more intense (less gray).

I left out sap green, which is really more of a gray, and some other colors that I do not consider my regular palette, but use occasionally. Ivory black is in the center because it is the most neutral color I use.

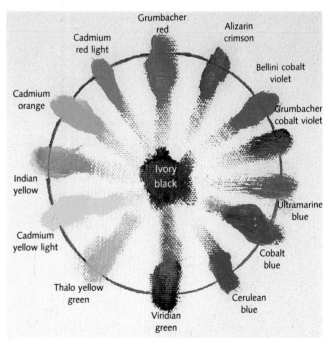

The pigments from my palette are arranged in this wheel.

COLOR HARMONY

Another useful concept illustrated by the color wheel is color harmony. Here is a partially filled-in color wheel that shows color relationships: The three reds at the top form pie-shaped wedges with the complement green at the bottom. Red is the dominant hue. The reds are all related (analogous) but different enough to create some contrast. The green balances the dominant red by completing the triad (green is blue mixed with yellow) and by toning down the pure reds (red mixed with green will make gray).

When planning the color scheme for a painting, I choose a dominant hue; for this example, I selected red. The colors on either side of red on the wheel, in this case, red-orange and red-violet, are my adjacent hues and belong to the dominant color. Because they are closely related on the wheel, they form an overall color unity. But alone, without any contrast for relief, they would dominate the painting so much that it would be boring. So I select two "discords"—colors that are equidistant from the dominant color and each other. In this case, yellow and blue are the discords. Green is the complement.

Discord colors add a touch of excitement against dominant hues. For instance, if I used touches of pure blue and yellow in a predominantly red painting, it would add the excitement I want. However, discords should be used carefully and with restraint so they don't threaten the prominence of the dominant hue.

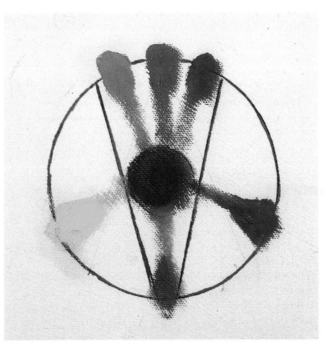

This wheel shows how to select a color scheme for your paintings. The colors form a pie-shaped wedge with red and its adjacent colors as the dominant hue. Opposite red, at the point of the wedge, is green, its complement. Equidistant from the dominant red and each other are its discords, yellow and blue.

MY PALETTE

My palette, as I lay it out from left to right, is as follows: alizarin crimson, Grumbacher red, cadmium red light, cadmium orange, cadmium yellow light, Indian yellow, thalo yellow green, sap green, viridian green, thalo green, cobalt blue, ultramarine blue, cerulean blue, thalo blue, cobalt violet (Bellini), cobalt violet (Grumbacher), raw umber, ivory black, titanium white. I supplement my palette with Permalba floral pink and Shiva red crimson, which I segregate from the rest of my reds. I use them in pure form and want them uncontaminated.

I place the colors in the same place all the time, with the warm ones on the left. Working with the same placement each time makes it easier to work once you're familiar with a color's location.

I keep white and black on the far right, with black behind the white because I use it very rarely.

I am a stickler for keeping muddy or dirty colors out of my painting. Notice that I have only one earth color, raw umber, and I use that only for toning my canvas when I do an underpainting or a monochromatic painting.

My success with color, I believe, is mainly because I avoid mud by not using earth colors. Instead I prefer to mix my own neutrals and grays.

1. Alizarin crimson
2. Grumbacher red
3. Cadmium red light
4. Cadmium orange
5. Cadmium yellow light
6. Indian yellow
7. Thalo yellow green
8. Sap green
9. Viridian green
10. Thalo green
11. Cobalt blue
12. Ultramarine blue
13. Cerulean blue
14. Thalo blue
15. Cobalt violet (Bellini)
16. Cobalt violet (Grumbacher)
17. Raw umber
18. Ivory black
19. Titanium white

COLOR CHARACTERISTICS

Let's explore the mixing possibilities of each color on my palette and I'll describe briefly how I use them.

Alizarin crimson (transparent): A cool, deep red, it can be used for glazing and mixes well with most colors to make vibrant color mixtures. For example, when mixed with cerulean blue, it makes a beautiful violet hue. Another mixture is with sap green, which makes a beautiful mahogany tone. Alizarin crimson also works well when added to other reds on my palette.

Grumbacher red: The most true red on my palette, Grumbacher red mixes well with most greens to produce a variety of grayed greens and with blues to make various purple hues. I rely on this red. Without it I could not achieve the brilliant reds in fruits and flowers.

Cadmium red light: A slightly red-orange hue, cadmium red light mixes well with all colors, especially blue to make a grayed purple and greens to make beautiful grays. When mixed with white, it makes a soft glowing pink, which is great for portraiture.

Cadmium orange: This traditional opaque orange mixes well with blues for good grays. Added sparingly to white, cadmium orange will produce a more vibrant white. I also use it for most landscape grays. When mixed with ultramarine blue, I get what I call "elephant gray," which is a true

gray. The possibilities of color mixtures with cadmium orange are too numerous to mention. I suggest you experiment by adding various amounts of it to your regular palette colors.

Cadmium yellow light: This opaque, true yellow mixes well with other colors to make beautiful earth tones. For example, the combination of cadmium yellow light and Grumbacher cobalt violet makes a beautiful yellow ocher substitute, which is more brilliant than tube yellow ocher. I do not use premixed earth tones on my palette as they are derived from mineral, not pure pigment, paints. You will find mixing your own earth tones from pure pigment exciting. When you try it, you may never want to go back to earth colors again.

Indian yellow: This vibrant, transparent yellow is great for glazing and mixes well with alizarin crimson to produce a brilliant orange. I use the mixture to put in my first step in some flowers such as roses. The glowing underpainting makes the flowers more alive. Mixed with white, Indian yellow makes a brilliant yellow hue.

Sap green: My love, sap green is already a gray and can be used straight from the tube or mixed with almost every color on my palette to produce various exciting grays. I also use sap green when working flesh tones. It is the one green I would not want to get along without. If you should run out of sap green, mix Indian yellow and thalo blue to make a reasonable facsimile.

Thalo yellow green (phthalocyanine): I use this semitransparent, warm yellow-green to show sunlight in my landscape painting. It can also be used as it comes from the tube for strong yellow-green accents. By adding reds or violets you can make rich grays. Thalo yellow green mixed with Bellini cobalt violet makes a great dark flesh tone, useful when doing portraits. It can also be used to gray light flesh tones. The pigment is actually a combination of thalo green and cadmium yellow light, but it's much easier to use when it's already mixed in the tube. For me, it has many uses. I'm sure you'll discover many for yourself.

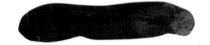

Viridian green: I often use this transparent green to gray flesh tones. I find viridian green a perfect hue when mixed with white to show distance in a sky as it meets the horizon. Viridian green, both in pure form and grayed with reds, can also be used to paint water. A touch of alizarin crimson and white mixed with viridian green are great to paint the soft grayed shadows seen in clouds. It also mixes well with yellow to make a strong, true green (which resembles permanent green light). In addition it works well with blues to make various blue-greens and great in shadows for landscapes when mixed with cadmium red light and white.

Thalo green (phthalocyanine, transparent): A very strong green, I use thalo green sparingly, yet it is a must for such things as transparent water or transparent glass. When white is added, it takes on a brilliant green

hue, which is great to paint highlights on clear glass objects. It is a difficult color to use, so go easy when you work with it.

Cobalt blue: A bright clear blue hue, I consider cobalt blue one of my three primaries because of its true blue color. It's really useful for such things as a blue garment worn by my model or a brilliant blue seen at the apex or upper part of the sky. This true blue also mixes well with each color on my palette to produce a variety of mixes and also beautiful grays.

Ultramarine blue: A reddish blue, this is the most-used blue on my palette because it's easy to handle. Ultramarine blue mixes well with all other colors and makes a variety of exciting color mixtures. For example, when mixed in equal parts with alizarin crimson and sap green, it makes a vibrant dark (I call it my black). I use ultramarine blue to some degree in most gray mixtures, since all grays are a mixture of all three of the primary colors. Ultramarine blue can also be used in its pure form.

Cerulean blue: A ceramiclike pigment useful for blue skies, it is also great to show reflected light when mixed with Bellini cobalt violet. Cerulean blue can also be used to bring touches of sky color into the landscape. It will also show distance when grayed and lightened.

Thalo blue (phthalocyanine): This very brilliant blue I use mainly when doing seascapes. Since I find it hard to

control for masses, I use it primarily for accents. Even though thalo blue is hard to control, there is no other blue like it. When it's needed, it works great.

Cobalt violet (Bellini): When mixed with other hues, this beautiful violet-purple makes beautiful flesh tones. Cobalt violet Bellini also works well to clean up mud, and it's also great for reflected light when added to cerulean blue and white. You may have trouble getting this color since many small art supply stores do not carry it. I suggest you order it directly from a large mail order supply house such as Artist Supply Warehouse.

Cobalt violet (Grumbacher): I use this dark, slightly grayed, rich blue-purple pigment mainly when I want a strong dark purple. I usually use it straight from the tube when doing fruit and flowers and I want a strong purple hue. Cobalt violet Grumbacher also works well when mixing grays.

Raw umber: I use this semitransparent earth tone of yellowish hue mostly for toning my work surface or when I work monochromatically. I never mix raw umber with my palette colors.

Floral pink: This premixed light pink is intense in hue, yet not considered permanent. It's great for pure accents on flowers, fruit, or wherever a strong pink is needed. Floral pink is also good when doing a portrait if the model is wearing a pink garment.

Red crimson (Shiva): This is a strong dye and is not totally permanent. I use a thin application of Shiva red crimson in pure form to give a strong, bright red-violet tint to the canvas in areas where red flowers will later be placed. I also use a wash of Shiva red crimson and Indian yellow to give a brilliant underpainting to some flowers or fruit.

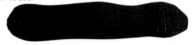

Ivory black: A true black with good mixing qualities, ivory black makes a beautiful blue-gray when mixed with white. It can also be used straight from the tube when strong darks are called for, or mixed with alizarin crimson to make a warm dark hue, or cooled when thalo blue is added.

Titanium white: The whitest of all white paints, titanium white mixes well with all colors. It also gives less transparency to mixtures.

MIXING GRAYS

Since I do not use earth colors or black and white to mix grays, I need to rely on mixtures of the purer, more brilliant pigment colors on my palette. The basic formula is mixing pure color with its complement. We know from the color wheel that the complement of a color is on the opposite side of the wheel. Mixing equal amounts of a color and its complement will make a neutral gray, but by varying the amounts of pure color and its comple-

ment, all sorts of rich and subtle grays are possible.

I can successfully control and balance the pure colors used in a painting by mixing them with a special gray made by mixing the dominant color I have chosen for a painting with its complement. Since this gray is livelier than a gray made of black and white or with earth colors, it enhances and enlivens the other colors.

It is worth taking the time to ex-

plore all the possible grays you can make with your palette. Knowing the subtle variations possible and their influences on pure colors will give you command over your colors. As you discover the special qualities of your gray mixtures, you will soon develop your own preferences. My favorites include reds grayed with sap green, a truly versatile color, as well as with ultramarine blue, cadmium orange, and white.

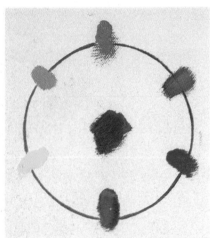

These grays were mixed from each primary with its complement. White was added to show the character of each gray.

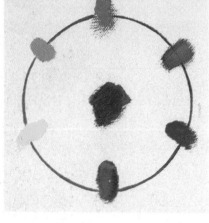

Red plus green Yellow plus violet Blue plus orange

Here are a few of my favorite recipes for grays. Varying the formulas results in a variety of rich neutrals.

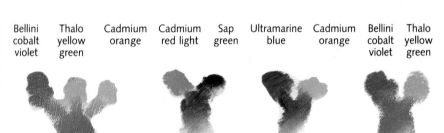

Bellini cobalt violet | Thalo yellow green | Cadmium orange | Cadmium red light | Sap green | Ultramarine blue | Cadmium orange | Bellini cobalt violet | Thalo yellow green

Cerulean blue | Cadmium red light | Sap green | Alizarin crimson | Cadmium yellow light | Grumbacher cobalt violet | Grumbacher red | Sap green

COLOR COMPS

My favorite way to plan a color scheme for a painting is to do a small color composition. The color comp, as I call it, is a small [2- or 3-inch (5- or 7-cm)] abstract study of color. It helps you make important decisions about color for a painting without getting caught up in painting *something*. Doing a color comp is also an occasion when learning can be just plain fun. Each time you do one, you will become more familiar with how colors and values can be used in painting.

Here are some examples. The first set has red as the dominant hue, with red-orange and red-purple as adjacent hues. Green is the complement.

The one on the left is high key, which means the painting is mostly all light with a small amount of dark. The one on the right is low key: a dark painting with a small amount of light. For both examples I put in discords, which are equal amounts of the remaining two paints on the triangle, used in small, equal portions, as clearly shown in the example. With red the dominant hue, the two discords are blue and yellow. Also in the examples is a touch of the complement in a pure form. This is optional, since the complement has already been used throughout the painting as a graying agent.

For the second set of color comps, I chose blue as the dominant hue, with blue-purple and blue-green as adjacent hues and orange as the complement. The discords are red and yellow.

The third example was planned with yellow as the dominant color. I decided to use the three primary colors as examples to show the obvious temperature changes. A painting should not be equally warm and cool, or equally dark and light. The dominant color need not be a primary. It could be a secondary color, or even an intermediate color between primary and secondary. As the triangle of analogous colors turns within the color wheel, it always shows us the dominant hue, its complement, and the related discords.

Red dominant High key Low key

Blue dominant High key Low key

Yellow dominant High key Low key

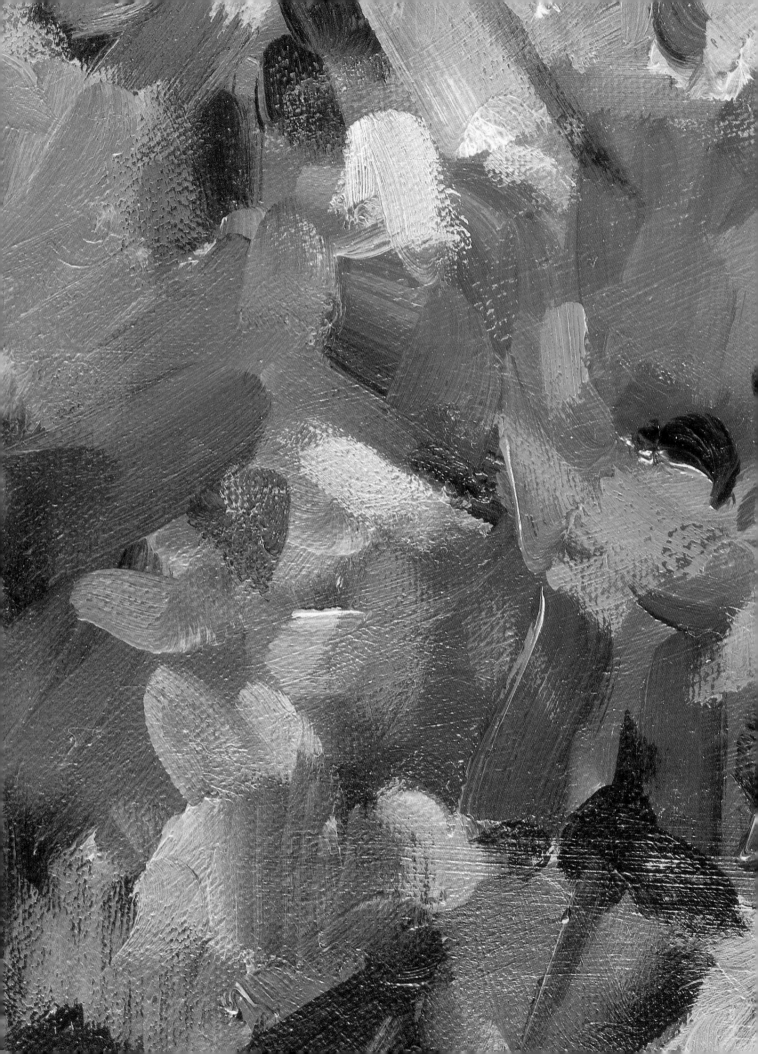

IN THE STUDIO

Now that you know about the materials I use and how I set up my studio, we're ready to begin painting. We'll work in the studio first, so you become familiar with the actual process of painting. I'll demonstrate painting still lifes to begin and then show you how the same concepts and methods are applied to painting the human form.

I'll emphasize my direct approach to painting. As you'll see, the key to this approach is *thinking*. A good painting is the result of making a lot of important decisions. Before you paint, you should decide on your subject matter, your point of view, the size of your canvas, the painting's overall tonality, the color scheme, and so on. The more considered and informed these decisions are, the better the resulting picture will be. Too many painters don't make these decisions with the right goals in mind, or they just don't make them at all. For instance, some painters always put their canvas on the easel horizontally, out of habit, without first thinking if that format is best for their subject matter. Or they don't plan out a color scheme for their pictures; they simply try to match the colors they see piece by piece.

With the right thinking before you paint, the process of actually painting *can* be direct. I use an acrylic underpainting, which will be dry when the next layer of paint—in oils—is applied. I keep my line drawing loose and sketchy, just enough to secure the placement of my subject on the canvas. Then I block in the whole painting with my overall color scheme in mind. Finally, I determine where the details and finishing touches belong. Usually, I only need to detail the important areas of my composition. You'll be surprised how few details you really need; you don't have to paint everything in sharp focus.

CHAPTER FOUR

THE STILL LIFE

Still-life painting is an excellent way to really sharpen your painting skills. Because the subject matter is under your control, you can concentrate on your painting. You can take your time and select just the right objects to get a nice balance of shapes, colors, and textures. You can play with many different arrangements and possible compositions until you find the best one. You can experiment with different lighting conditions so the shadows define the forms and create an interesting pattern. When you're painting a still life, you can relax and think properly without the demands of trying to paint something quickly before the sunlight changes or your model has to go home!

In this chapter I'm going to examine my painting process in greater detail than elsewhere in the book. All the demonstrations apply to the material in subsequent chapters as well. Later, I'll discuss special problems that you will encounter when painting the figure, a landscape, or a seascape, but the basic process is the same as when you're painting a still life.

One of the joys of painting still lifes is the opportunity to select objects that have personal meaning or tell a story. I have a collection of antiques, curiosities, and just plain junk that appeals to me. When I'm assembling a set-up for a still-life painting, I like to think about how the objects relate to each other, not just in terms of size, color, or shape. If I'm not really turned on by the things I'm painting, I just can't get excited about doing my best. Painting an arrangement of personal treasures or mementos makes the painting more than just an exercise. It becomes a statement about who you are and an expression of your unique personality.

Improving your painting only comes through practice. Unless you really love what you're doing, you won't be able to put in the time behind the easel that you need to improve. So it's important to have fun. Practice shouldn't be hard work. And paint things that mean more than just a pretty arrangement. It will show in your final results.

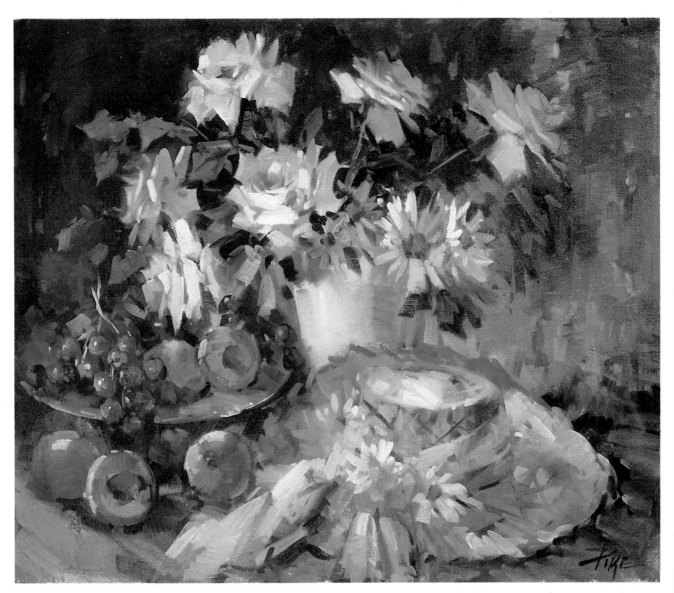

White Roses, Daisies, and Hat
22" × 28"

The still life is the perfect subject matter for perfecting your painting skills. You can control many of the variables such as the arrangement of the objects and the lighting. Working on a still life gives you the opportunity to think carefully about the entire painting process. This painting may look spontaneous, but it is the result of careful planning. I was able to achieve a loose, brushy style and balanced, interesting composition.

PRELIMINARY PLANNING

Let's begin by focusing on the preliminary decision making of an artist before he or she even begins to put paint on canvas. The importance of decision making is hard to underestimate. A lot of problems the beginner encounters can be avoided by sound thinking in the preliminary stage. I often spend twice as much time considering a still-life arrangement as I do painting it. I may spend several hours working on a setup that may only take one or two hours to paint. While I want my painting to be appealing to the viewer, my main thoughts in the beginning are really about satisfying and pleasing my own eye. I must be turned on, or I can't do my best work. The best way for me to please the viewer is to make sure I please myself.

I usually start teaching a class with a demonstration painting, but once I asked a class to begin on their own without the preliminary demo. As I walked around the classroom, I was fascinated by all the different ways the students were approaching the day's subject matter. Except for one student. She was standing in front of a blank canvas. When I asked what the problem was, she gave me a frustrated, almost tearful look and said, "You know, Joyce, I really am trying, but I do not seem to know how to start. I really do not know how to begin without you guiding me." After helping her get started, I thought about her predicament. I realized then how important it is for the student to learn (and for me to teach) what to *think* about when you start painting. There's more to it than just knowing where and how to smear the paint on the canvas.

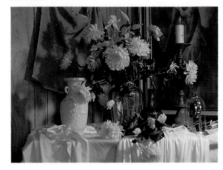

Here's the arrangement used for the painting *Still Life Aglow*.

So let me walk you through a painting. I'll think out loud as I paint, so you can see what I'm really doing—the "why" behind the "how."

I suggest you follow the same basic procedures carefully. This is the way I work all the time. There are no short-cuts. Why take chances? After all, it's the planning and thought beforehand that really ensure a successful experience.

We'll start from scratch. First, I need to select an object to paint. When I'm standing in my studio looking at my shelf full of interesting things to paint, what am I thinking about? I know several objects will go together, while others are less compatible. Generally, I avoid picking or placing objects together that are the same size, color, or value. Too dull! We need some variety for interesting contrast.

Sometimes I use my color wheel when selecting the right things. I think about what analogous colors I want to include and whether I'm doing a high-key or low-key painting. So I choose objects related by color, but

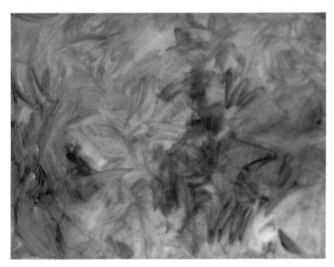

I first toned my canvas with an acrylic wash, showing rhythmic strokes of warm orange and red-orange acrylic slightly grayed with cerulean blue. I used a bit of alizarin crimson on the right of the canvas. I like to keep one area of my background a stronger color. It gives a beautiful glow to the painting when grays are layered around it.

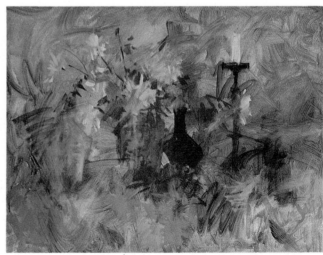

After the acrylic was thoroughly dry, I switched to my oil palette and suggested the placement of each object by color, size, and value without doing a formal drawing. My aim was to establish the location of the many objects as soon as possible. Besides, it would not have given me value and color—only placement.

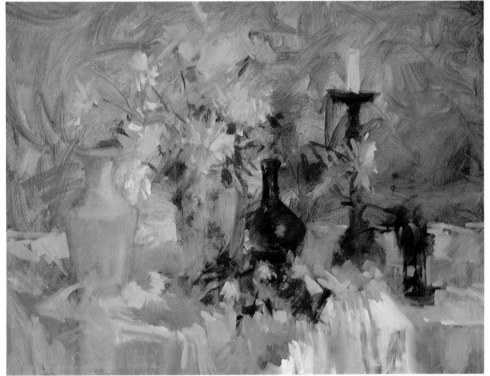

I worked from one object to the next, moving on before I overworked the first. Most objects were painted with only a few well-chosen brushstrokes. That way the painting was fresh and descriptive, but not belabored. Take the anniversary clock, for instance. The clock has a brass base and brass works, which can be seen through a clear glass dome. I painted the works and base as if the dome didn't exist. With a touch of darker tone, I gave a hint of transparent glass—only a hint, never an entire outline. Most students try to be too literal; they want to paint all the detail they see. Instead, I squint to see the underlying pattern more clearly.

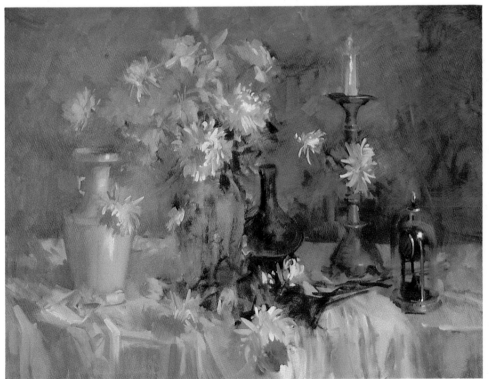

At this point I have indicated each object's correct placement, color, and value. No details yet. Then I go over the painting again, developing and detailing the whole painting. First I work the object or area that will be my focal point—the white chrysanthemums—making it easier to select the rest of the value changes. I brought more petals to completion on them than on any other flower, and I used my darkest dark behind them as well.

I blocked in the tablecloth with animated brushstrokes. Now is the time to bring each fold or drape to the proper degree of finish. I had already suggested the drape falling over the table edge. I proceeded to paint about half of what I actually saw of the drapery. Notice how I played it down. I did not want too much white.

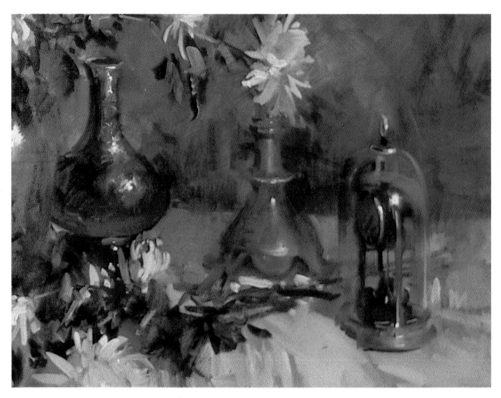

In this detail you can see how my brushwork suggests the features of each object instead of depicting them exactly. Every detail was painted with an eye on how it fit in with the painting seen in its entirety.

not identical, and within the general value range. Also I see if the shapes work well—I like shapes that are related, but not too repetitive. For this painting, I gathered up a group of objects and kept them within easy reach while I played with various arrangements on my stand.

I put a white tablecloth on the stand and started to arrange objects. I tried several different-shaped vases until I found the ones that looked best to me. I often paint vases without flowers in them to avoid the overly predictable. As I tried different placements of the objects, I noticed that the tablecloth looked too uninteresting. By playing with the folds and draping, I came up with what I considered a much more lively pattern.

When I selected the background, I considered value first. I didn't want it too dark because there would be too much contrast with the white table-

cloth. Such strong contrast would have competed with the flowers as the center of interest. So I selected a rust-colored drape, which made a suitable middle-value dark for the background.

After I had carefully arranged all the objects and placed the flowers at a pleasing angle, I considered lighting. I placed my light stand on the left at first, but moved it to the right to see how that looked. After final adjustments, I liked the light on the right best. I considered the options and made a conscious choice.

My next thoughts were on color. You can see everything took on a warm glow in the photo. The rust tones of the background blended well with the pale yellow to white chrysanthemums and the brighter yellow of the day lilies, which were the secondary flowers. Since the warm rust and yellows formed the dominant color element, I needed a cool complement

for balance. The blue of the transparent vase, with touches of blue and blue-violet throughout the painting, completed my color scheme.

I was now ready to paint! Notice that nothing was really left to luck. What might appear to the viewer of the finished painting as a casual, informal still life is the result of deliberate thought and consideration on my part. There were many more decisions I made before I finished the painting, but the really important matters of composition, lighting, color, and value were addressed before I ever put brush to canvas.

The actual painting happened rather quickly. I toned the canvas, loosely indicated the placement of all the objects, and defined or detailed the important areas, particularly the focal point. It happened in a straightforward manner because I was very conscientious in the preliminary phases.

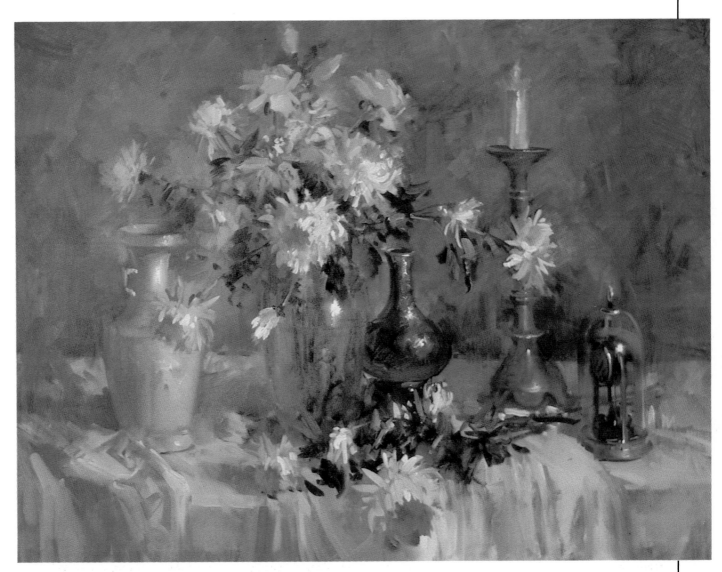

At this point, I sit back and study everything. The painting must work as a whole. Never should any one area look as if it does not belong. When the background is dark, the highlights become important—mainly because they are so prominent. I placed in highlights by first wiping the intended spot slightly to remove any excess buildup of paint. Then with a *clean*, small no. 4 brush, or an even cleaner finger, I place on a small amount of clear color. Pure white can be used, but I find it works best to slightly tint the white.

Still Life Aglow
30″ × 40″

THE BASIC PAINTING PROCEDURE

Since we've already talked about the preliminary planning and the arrangement of the setup, I want to focus on the actual painting procedure from beginning to finish. In this painting I used several objects in my compositions—I find it easier to balance negative space with other objects—although it could have been just a vase of flowers. Whenever I paint a vase of flowers, I feel like something is missing. Nevertheless, even with a simple composition such as a vase of flowers, darks and lights must still be balanced correctly.

I use a drape for the background most of the time, but for this painting I preferred the neutral background that allowed me to control the value as well as the hue of the painting. Actually, the background is the paneled wall behind the model stand in my studio. When I chose the paneling for my studio, I purposely chose a neutral background in value and color for just this purpose.

I am now ready to begin the painting. Toning the canvas is the first step. I use cadmium red light and Thio violet acrylic thinned with water as a wash over the entire canvas. While the canvas was still wet, I added a few touches of sap green to soften and gray the wash. I chose redorange as my dominant hue. I could have gone anywhere on the color wheel, but my choice was made by the pink-orange of the main flowers, which are geraniums.

I now have the canvas toned, and I'm ready to suggest the location of each object with a linear drawing. I never spend a lot of time at this step of my procedure. I find doing a meticulous drawing takes precious time away from actually painting. The initial drawing is really only a sketch where I establish relative locations of the objects. It is also mainly to suggest balance, to make sure I have room for the objects I plan to place in my

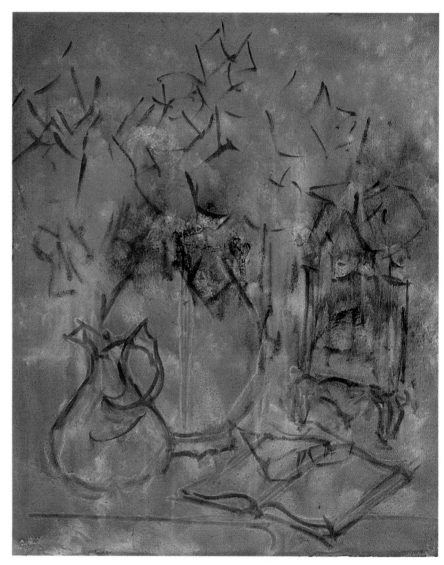

Toning the canvas is the first step. I use cadmium red light and Thio violet acrylic thinned with water as a wash over the entire canvas. While the canvas was still wet, I added a few touches of sap green to soften and gray. I chose red-orange as my dominant hue. I could have gone anywhere on my color wheel, but my choice was determined by the pink-orange of the main flowers, which are geraniums.

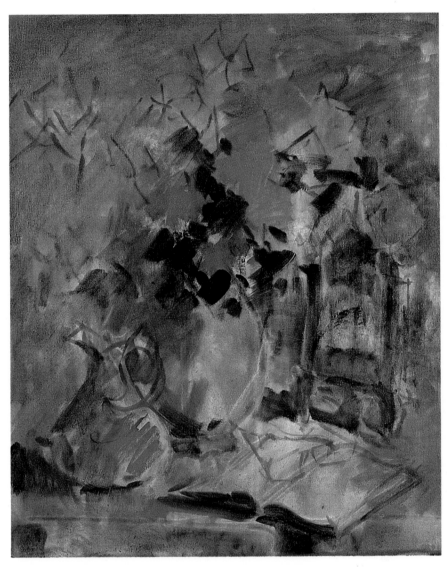

When I have the canvas toned, I'm ready to suggest the location of each object with a loose linear drawing. The drawing is mainly to suggest balance and placement. I will have room for the objects I plan to place in my painting and also to secure my perspective. At this point I only suggest the placement of the flowers.

painting, and to secure the perspective. Usually I only suggest the placement of the flowers. As I proceed, I can add or delete any flower as needed to make the composition work better. Painting is really a process of adjustment. As I proceed in the painting, I can make judgments about what to include or exclude based on the painting as it develops in front of me. That's why I don't do a complete drawing in the beginning.

Now I'm ready to block in each object with an approximate hue and value. I mix all my colors to work with the dominant hue that I have chosen, using the complement to gray and adding white where necessary to lighten a tone.

I find it is better to have only one main color balance. Although we usually do use all three primaries when we work on any painting, only one should predominate. The remaining two keep the main hue from becoming boring. Thus we create a symphony of color, making the painting a pleasing, soothing object to view instead of a confusing mess when too many colors are used equally.

I am now ready to refine each object. I go back and work on each object until it is complete. I can do this because my composition has now been secured. I try at this stage to make each statement with as few brushstrokes as possible, which gives a more painterly quality to the finished work. Often the strokes only suggest detail, rather than presenting the object in full detail.

As I paint, I use a range of brushes from 1 inch (2.5 cm), or no. 12, to a no. 4. I applied the background by using the side of my no. 12 brush to scumble over the acrylic toning with subtle grays, allowing a bit of the background to come through. This activated the color of the top layer. Note that I carefully soften my shadows into the areas of light. Usually I

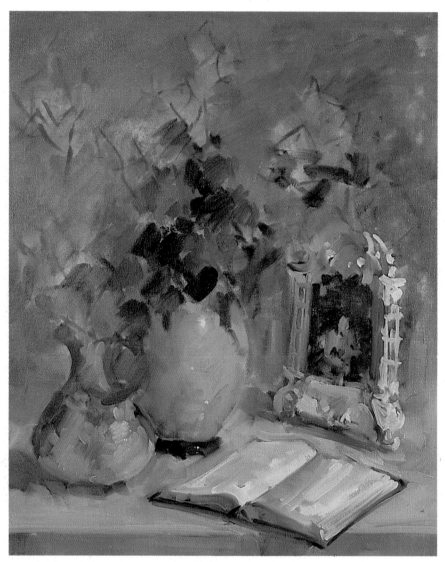

I block in each object with an approximate color and value, while mixing all my colors to work with the dominant hue and using the complement to gray and, where necessary, white to lighten. I will go back and work on each object until it is complete. I try to make each statement with as few brushstrokes as possible. Often the strokes only suggest the detail.

include less detail than I actually see. Notice how little detail I used in painting the photo in the frame on the table. I merely suggest the face.

I continue refining and adjusting the various areas of the painting. The tablecloth was carefully painted so it wasn't too light. The pages on the book were slightly lighter than the tablecloth because they were more important. After I painted the geraniums loosely but directly using pure color in the shadows and adding pink and white in the light, I added the secondary flowers, losing most of them into the background and bringing only a few petals into stronger light. Here again, less is more. I secured the focal point by placing dark foliage against the geranium mass to provide proper contrast.

Once all the forms have been sufficiently refined, I am ready to add highlights and other details. I added strongest highlights in the flowers, vases, and any object that needed a final adjustment. I also added the eyeglasses on the book. A very important part of the glasses is the cast shadow. Never forget small details that play an important part in telling the story of your painting. At this time it's best to walk away from your painting for at least half an hour and return to get another look. Oftentimes the flaws will show up at a second viewing.

Another thing you can do to view your painting more objectively is to look at it in a mirror. You can take a small pane of glass, say, 5″ × 7″ (13 × 18 cm), paint it black, and then use the shiny side to view your work the same way you use a mirror. You will find that the diffused glass makes mistakes stand out prominently. Once you've corrected these mistakes, the painting is finished.

Once all the forms have been sufficiently refined, I add highlights and other details. I added the strongest highlights on the flowers, vases, and any object that needed this last adjustment. I also added the eyeglasses on the book.

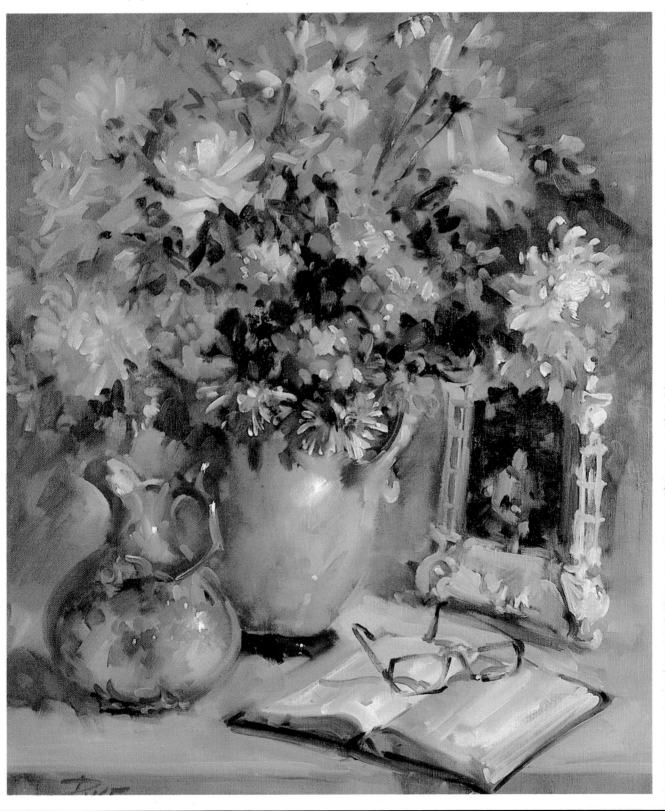

THE FIRST STATEMENT

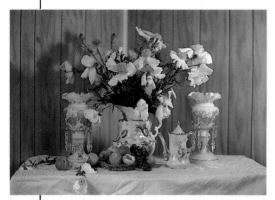

A photograph of the arrangement used for *Matilija Poppies*.

As you can see from the previous two demonstrations, my painting procedure has four basic steps: The first is the undertoning. The second is the drawing. The third is establishing all the objects. The fourth and final phase is detailing, in which I very selectively place important details on certain objects. In this demonstration let's look at the third step more closely and see how it makes the last step a simple matter of adding key details to finish the painting.

All painters have one subject that they enjoy more than any other. Flowers do that for me, especially in the delicate, but relaxed beauty of matilija poppies, the subject of this painting.

As I planned the setup, I tried several different objects with the delicate flowers and decided to use porcelain objects because their delicacy struck me as appropriate for the poppies. I also thought it would be interesting to use several similar objects that could be a problem because they were so similar. I wanted to see if I could give each object an interesting identity, with its own color and texture. I feel I accomplished just that.

I first toned my canvas with an acrylic wash using mostly warm tones. I carefully controlled my brushstrokes as I applied the wash, allowing the paint to drip in places while modeling the lights and darks. Some of these effects will be visible in the final painting. I used pure reds and orange where the fruit goes, graying the pure reds over most of the remaining canvas. Using a simple acrylic palette of ultramarine blue, sap green, and cadmium red light, I broke up the overall red tone with a soft grayed-green on the upper left of the canvas and in the areas where the leaves are around the flowers. I mixed cadmium yellow light with the red for an intense orange, while I created subtle violet tones by mixing Grumbacher red and ultramarine blue. As I often do, I worked out all my color in the wash or toning, which was color balanced from the beginning.

Next, I merely suggested placement of objects by first using white and then reemphasizing a few areas with a darker paint. I always set out my entire palette. I like to be prepared whenever a color may be needed.

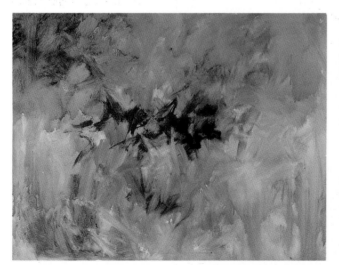

I first toned my canvas with acrylics, using mostly warm tones. I distributed the colors according to my plan for the overall color scheme and for the objects which I would paint over the various areas of the underpainting.

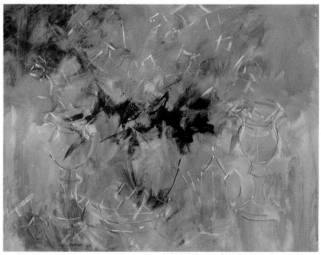

I kept the sketch in oils very simple, just to indicate placement. I used white and a bit of darker paint to define a few areas.

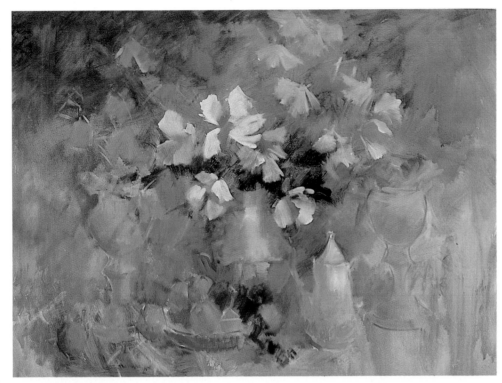

This is the first statement in which all the major shapes are blocked in. I first established the focal point, the lightest light of the flowers. I painted the background, progressing from the same colors I used for the objects, which kept the picture unified.

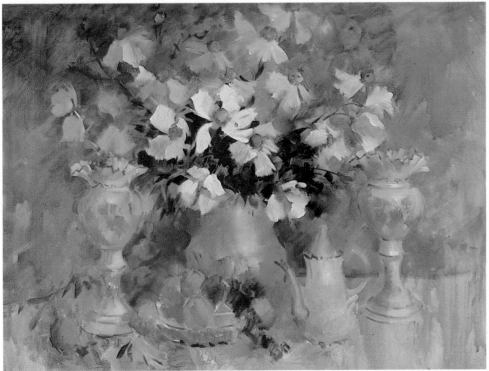

I continued developing the basic shapes in the composition, defining them with carefully considered strokes of paint. I don't do much blending here, allowing the strokes to retain their individual identity.

As the painting became clarified, I gave more thought to the value contrasts in the composition. I placed darker values behind the objects I wanted the viewer's eye to linger on, still retaining the strongest contrast around the poppies in the center.

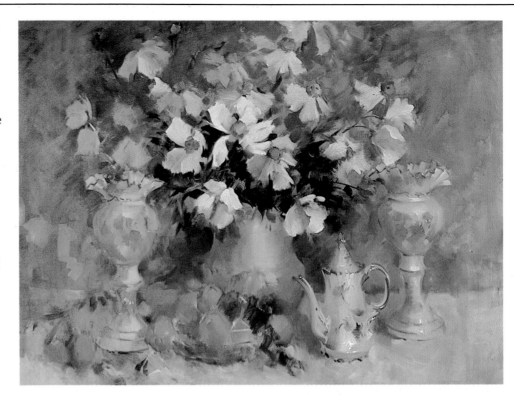

The last step is the detailing. To avoid muddiness, I thought about the placement of each stroke so I wouldn't stir up the paint already on the canvas. I used pure color for the fruit and added the highlights on the pot, vase, and porcelain objects.

Matilija Poppies
30" × 40"

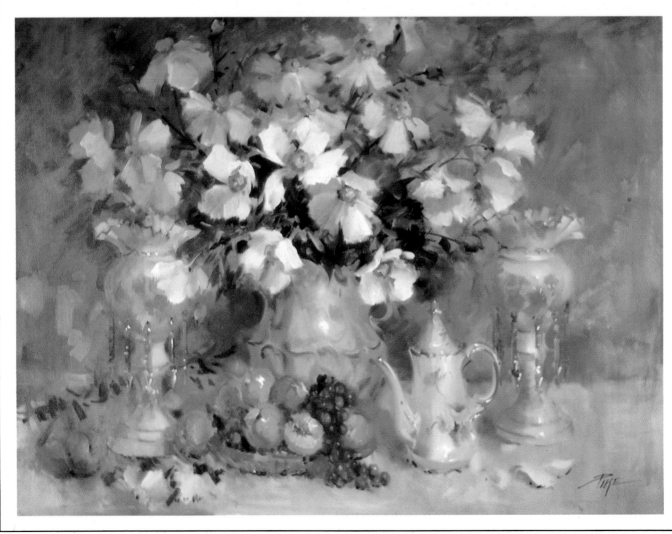

Now that I have done the initial drawing, I am ready to make my first statement. I will block in most of the major shapes, though not including detail. I first place in the lightest light of the flowers to establish my focal point. This light area will be key to subsequent values in the painting. I then painted the turning of each flower, showing its relaxed form. Some of the forms are in shadow, others in direct or partial light. Next I painted the porcelain objects using subtle color and value changes, which at this stage are barely detectable. Then I turned my attention to the coffee pot and developed it more fully. The vase and the luster on its surface were painted next because of the vase's prominent position in the composition, but I was careful not to overpower the flowers.

Here we have an example of several objects of the same hue and similar value that must be varied. I handled the problem by changing the value slightly on some of the objects, only bringing a few of them into more complete detail. As the painting progressed, I painted the background with many of the same colors used for the objects. This unified the painting.

Next I painted the centers of the poppies, showing light and shadow. Then I started to form the fruit from the shapeless pure color mass I placed there during the toning process. I used warm gray tones to keep everything in unison. I then used pure color and refined the fruit, including the highlights. At this point I established all the elements in the picture, and I have not yet included any of the final touches.

Finally, I made a complete pass over the entire painting, thinking about each detail. I included more detail on some objects in order to emphasize them. It's not necessary to paint every little detail. Once the first statement had been made, all the objects were in place. The rest of the painting was simply a matter of adding a few more touches for clarity, contrast, and sparkle.

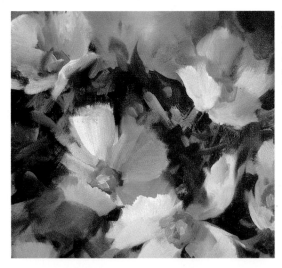

This detail shows how I formed the flowers with just enough brushstrokes to describe them without overworking.

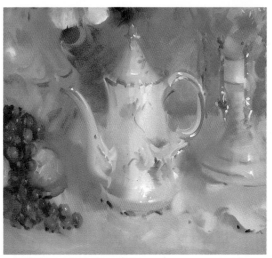

This closeup shows how little detail is necessary to make a complete statement. It helps to step back frequently from your work to see how much has already been said *before* you overdo it.

I painted the bowl of fruit with pure colors applied with direct, unblended brushstrokes.

PULLING THE PICTURE TOGETHER

Marie, one of my students, brought some of her antique treasures for me to paint. The day before, I had mentioned I wanted to do a dominant red painting and I would love to use some antiques with pink and red roses. Marie surprised me with these beautiful art glass pieces. Thanks, Marie. I took about an hour to arrange the setup. By taking extra time to do it, I could be sure I had no flaws and could proceed with more confidence.

I moved the bowl of grapes all around the setup. They read as a dark, and they play an important part in the compositional balance. I chose to use them where I did because I wanted a strong dark to break up the stark white of the tablecloth. This value change is the next stop for the eye after it leaves the focal point.

It really bugs some of my students when I move things around so much. "It looked fine the way it was. Why do you keep moving things around?" they ask. My answer is that you never know unless you try, and if I don't like it after I move it, I can always put it back. I will not start a painting until I am absolutely sure of the placement of each object in the composition.

We can get started after I make sure each rose is turned the way I want it. I do not want to guess the shape or angle of the flowers. Sometimes I mix silk flowers with real ones; today, I'm using light pink silk roses and real red roses. Note the difference in the buds, or partially opened roses. The real ones look more convincing.

I first toned my canvas with Grumbacher red, alizarin crimson, and Thio violet slightly grayed with cerulean blue and sap green acrylic. I used the pure reds in the area where I planned to place the pink and red roses. I did not worry about using a strong red in the areas where the glass objects would be placed. I could paint over the grayed undertoning without a problem. I did keep a bit of the white canvas showing through the area where the tablecloth would be.

Sometimes I do not make a preliminary line drawing. This was one of those times. I had taken enough time arranging the setup so that I memorized where I wanted each object on my canvas, eliminating the necessity of a line drawing.

Changing now to my oil palette, I used pure Grumbacher red oil paint to place in all the glass objects as well as the red and pink roses. For the pink roses I used a thin wash of color since I would be using white over the red and didn't want a heavy buildup of paint.

I used alizarin crimson to show the shadow side of all the red glass objects as well as the darks in the red roses. I

I first toned my canvas with acrylic using Grumbacher red, alizarin crimson, and Thio violet. I kept the pure reds in the area where I planned to use the pink and red roses. However, I did not use the red where the glass objects would be placed, since they could be painted over the grayed undertoning. Since I had used so much time in arranging my setup and I knew where I wanted each object, I skipped a line drawing.

seldom use gray when painting flowers, and I usually use pure paint for both light and shadow. Since I want my flowers and fruit to look as real as possible, the only way to achieve this is to use pure color and vary the hues from light to dark. For example, alizarin crimson works as a cool and dark shadow when Grumbacher red or cadmium red light is used for the light side. I now have a warm red-gray over my entire canvas, with brilliant reds where the red glass objects and flowers go.

There are a few grayed objects, such as the candlesticks and the silver base and handle on the antique pickle jar. For these, I use a blue-gray mixture of Grumbacher red with a touch of sap green and cerulean blue. I started the painting with loose, broad brushwork, and as the painting progressed, I brought each object into its own degree of importance.

Now each area is working to support all the other areas. For example, the background is the proper value to show the flowers correctly. The vase is the correct value to show the light of the tablecloth and so on around the entire canvas.

I now have reached the stage of my painting where each brushstroke counts. I try to use control and not give even one swipe of the brush too many. A few closeups show you how controlled the finish really is. I suggested the table edge to include a straight edge, not to show the corner of the table. This is all part of the compositional balance and should be planned from the beginning.

My students are often surprised at how few strokes it takes to paint a bunch of grapes, for instance. If I turned away or blinked an eye, you should have them done before I could really see what you did. If it takes a long time to paint a bunch of grapes, you're probably trying to paint each grape. It's far better to show only one large mass that goes from light to shade. I paint only what I see through squinted eyes. Then I finish by choosing to bring a few to completion. On these, I show shadow light, reflected lights, highlights. As I complete the highlights, I see them in various hues and values. Some are more yellow when viewed against a gold rim or porcelain. Others are almost pure white, as on the silver of the pickle jar.

First I formed the roses from the outside edge. I painted each rose by carefully studying and reproducing its contour; then I used straight strokes. I shaped the petals carefully, controlling the direction of each rose.

I used white over the red underpainting for the pink roses and white tinted with cerulean blue for reflected

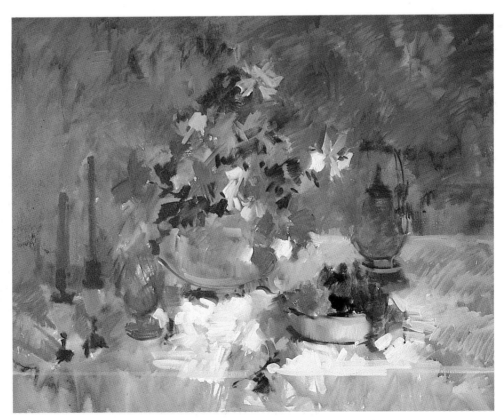

I started the painting in oils using loose, broad brushwork. As the painting progressed, I developed each object in proportion to its importance in the composition.

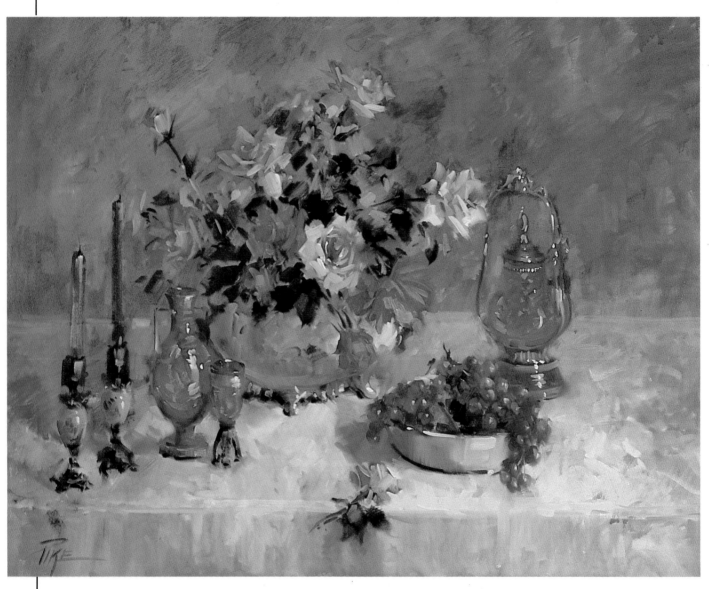

Marie's Antiques
30" × 40"

Now I have reached the stage of my painting where each brushstroke counts. I consider each brushstroke carefully so there's not one swipe of the brush too many. It's hard to resist the temptation to overwork the details.

light on the pink roses. The deep centers remained the original toning. For final touches, I slightly darkened and grayed the centers with a touch of ultramarine blue. I almost always play the leaves down in my paintings. They are there mainly to create the strong contrast needed to bring out the focal point. In this case, though, I did use a bit of bright green where the leaves catch the light.

As I painted the tablecloth, I felt it had little character. So I decided to control my brush and add more excitement with my brushwork, creating a more lacy look than a plain, flat surface. I also placed a small pink rose on the table edge, which cast an interesting shadow down the side of the tablecloth. This helps break up the straight line of the table's edge, which would otherwise be a distracting element in the composition. This edge could also be softened by blending.

The cast shadows were slightly violet. This is one of the adjacent hues, with the red-orange of the art glass the other. I used subtle suggestions of discords in the touches of blue in the background and in the yellow in the highlight on the vase.

When I finished, I was pleased. So was Marie. She told me that she liked how I showed off her treasures. I did make one final change, however. I had made the red roses too close in color to the red art glass objects, so I added floral pink to highlight the red roses.

In this detail, the economy of brushwork is visible. The value of each stroke and the direction in which it is applied were carefully chosen to capture the essence of each flower.

When painting something like a bunch of grapes, don't bother to paint each grape. First, paint the grapes as a single mass; then use a few darks and a few highlights to define a few individual grapes. That's all you need.

STILL-LIFE VARIATIONS

There may be times when you may find it necessary to use the same objects over again in a new still life. Someone may admire a previous painting and want something similar. Some artists will not even consider doing a similar painting, but I have found it is almost impossible to be a completely original artist and not encounter using the same objects or nearly the same arrangements more than once. I never literally copy a painting, but I find it necessary many times to paint similar objects. If I didn't, I would be either out of work or living with wall-to-wall still-life objects.

One solution to the problem is to vary the composition; another is to vary the color scheme or values. I did that for the two examples shown here.

For the first painting, *Fu Dogs and Lilies*, I used a dark background to bring out the calla lilies. A potential buyer saw this painting at a show and expressed an interest in it. However, this painting was not for sale. I like to keep a few of what I consider some of my better works for shows—at least for a while.

My admirer asked me to do another painting like it for her as a commission. We talked about what she admired most in the painting. She loved my fu dog figurines; in fact, she really liked everything in the painting. There was nothing she wanted changed, if I were to do one for her.

I started making suggestions: "Would you disapprove of me using a light background?"

Her answer was, "I don't know, I guess not."

Fu Dogs and Lilies
30″ × 24″

Golden Glow
30″ × 24″

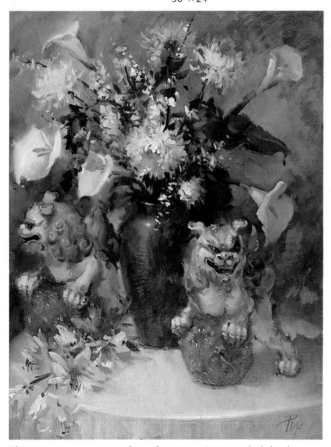

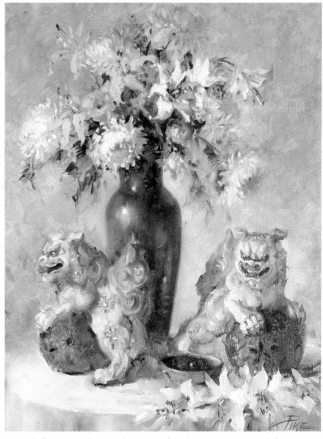

This painting was one of my favorites. Using a dark background enabled me to emphasize the white lilies. There is a nice balance between the fu dogs and the bouquet.

I used the same basic elements for this variation. I didn't want to copy the exact arrangement, so I altered the position of the dogs, used a different flower vase, and changed the background. Notice what a difference in mode the value of the background makes.

My next question was, "What parts of the painting would you not be able to live without?"

She studied the painting and mentioned that she particularly liked the mums, the fu dogs, the round table, and the soft lights on the tablecloth. "Would you be able to come up with a good composition," she asked, "and still include these elements?"

Sure I could! It really was not a problem. Although I still wasn't sure she would be happy with the finished work, all I could do was try. At least, I could sell it to someone else if she was not happy! I took down as much data as possible, such as her favorite colors, where she intended the painting to hang, the type of decor she had in her home, the color of her walls, and the amount of light in the room. These were all important factors that would help me paint a picture she would enjoy in her home.

With these things in mind, I arranged a still life using as many of the same elements as possible. About the only thing I could change with the fu dogs was to move them slightly to a different position, since they tend to dominate any setup. When I did the commissioned painting, I changed the flowers, using tiger lilies instead of calla lilies for two reasons. One of her favorite colors was yellow, and since I planned to use a light background, I did not want a lot of negative space.

It's only natural to want to repeat a successful formula when painting. However, think carefully about copying the same elements over and over. You will surely be bored and miss opportunities for development as an artist. Besides, you don't want to get a reputation as a copyist. Who wants to buy a painting knowing the artist is going to do the same thing again and again?

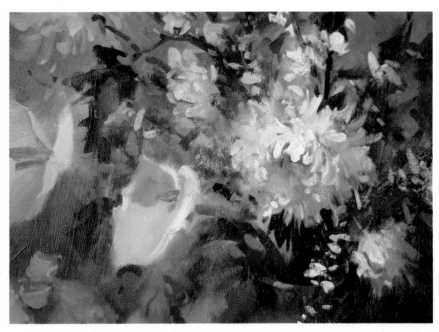

This detail shows some of the flowers from *Fu Dogs and Lilies*. I applied the paint in short strokes, each one often describing just one petal. Yet they all contribute to produce an attractive image of the flower as a whole.

A close up of the fu dog from *Fu Dogs and Lilies* shows how I used contrast of value and color temperature to paint the snarling face of a fu dog. I used a cool mixture of white and cobalt blue for the reflected light on the right, which contrasted with the warmer tones on the left.

UNUSUAL SUBJECT MATTER

There are times when you will want to paint unusual subjects. Actually, this can be fun. Never let yourself get into a rut of doing the same thing all the time. Challenge yourself! Search for different subjects to paint or different ways of painting more familiar subjects.

Here's an example of when I needed to paint an unusual still life. I belong to a group called Women Artists of the American West who paint Western subjects. When we show, everything must have a Western theme.

I composed *The Red Saddle* from various objects found on a ranch. The need to have all the elements working as a unit is just as important for this painting as any other, only now the emphasis will be on the subject matter as well as the composition and color.

Let's consider the selection and placement of the objects for a moment. First, I need a main theme object. The saddle was ideal. It was a bit unusual because it had a bright red seat—beautiful to look at, but a challenge to paint! Because the saddle looked unfinished by itself, I also selected several compatible objects to complete the composition. Luckily, I have been collecting interesting objects with a Western theme for years. These objects ranged from old rusty milk cans, Indian blankets, an old plow, to a broken wagon wheel. Here, I was careful to select objects that would work together in both color and value.

Now that I have selected several objects, I started placing them around the saddle until I felt good about the balance. I liked the idea of keeping most things closely related, so I chose to use a dark background. I also used a view finder to block out the surrounding area.

The first things I put in my arrangement were the Indian saddle blankets: one as a backdrop, the other on the model stand. I moved the saddle several times before I decided to bring the leather trappings and stirrups into the composition. The saddle was

Don't confine yourself to the usual and traditional. This still life was composed of unusual items, all with a Western theme. When you are working with unusual subject matter, take extra time to plan the composition carefully to showcase what is special and interesting about the items you have selected.

The Red Saddle
24" × 36"

so interesting I decided to make it show.

Then I wanted to select an object light enough *to show the focal point* and still keep the theme. The old whiskey jug was perfect. My biggest problem was finding subject matter light enough to break up all the darks and still stay Western. I finally found some corn husks that were the proper value and color.

Since all the colors were warm in the setup, I selected red-orange as my dominant hue. Blue-green was the complement. I used a small blue drape behind and to the right of the jug and saddle to add a touch of the complement to the setup and break up the all-over warm red hue.

Now let me describe about how my brain was plugged in while I painted. First, before I even started to work, I made several color compositions. When I have unusual subject matter, placement can be critical, so I take the time to plan what I will do before I tackle the canvas. My final decision

was to let the seat of the saddle go off the canvas at the top, giving more emphasis to the hand-tooled side of the saddle and stirrup. I toned my canvas with a thin acrylic wash of slightly grayed reds. After the acrylic had thoroughly dried, I went over the entire canvas with a very thin turpentine wash of Grumbacher red oil paint—giving it only a tint. The purpose was to have a wet surface to work on so the strokes of paint would be soft and blend together better. I often do this when I work on a darker painting and do not want sharp edges.

In this painting, the jug acts as the focal point and the rich textures of the saddle the center of interest. I deliberately made the jug smaller, so it didn't compete with the saddle, but I gave it the strongest value contrast.

I completed the painting by studying each area, adding a color here, graying a color there, while blending and detailing where necessary to give the proper degree of importance to each area of the painting.

USING OUTDOOR LIGHT IN A PAINTING

If you don't watch out, you can run out of ideas for doing interesting still-life arrangements. I often stay awake nights trying to think of ways to change things or come up with an original idea for a still life.

When we lived in Culver City, California, I had a large window at one end of my studio, which I often used as part of my composition. This can be really exciting, since bringing the out of doors into the painting gives the viewer the feeling of space. I especially enjoy using natural light filtered through a window. This light will seem cool with warmer shadows—a light combination desired by most painters. Natural light is much softer and cooler than artificial light, so if you're used to using a spotlight with warm highlights and cool shadows, you must reverse your thinking before starting to paint with natural light.

A test I have all my students do is hold a white vase near a window and then hold it near a warm spotlight. The temperature change of the light is obvious. To make any object appear three dimensional, opposite color temperatures should be used on the illuminated and shadow areas. For example, if you use cool natural light, the shadow side of the object will appear warmer in contrast. The same rule applies if a warm spotlight is used. The shadow side will appear cooler in contrast. Cast shadows follow the same rule as well.

When I selected each object for *Looking Out the Window*, my first concern was value. I already knew I would use green as my dominant hue because of the outside foliage. Blue-green and yellow-green were my adjacent hues. You can detect the complement only in the form of the grays I used, which were very warm. The giant magnolias were almost entirely in shadow, with a rim of light hitting a few petals. I did the same thing in the few white roses that I used to break up the massive white magnolia blossoms. This painting became a study of values, with the outside light the principal source of contrast between light and dark.

So for a very interesting way to create exciting color activity in a painting, consider placing your still-life composition near a window. Actually including the window in the painting also adds a very convincing sense of deep space to what is usually a shallow spatial arrangement.

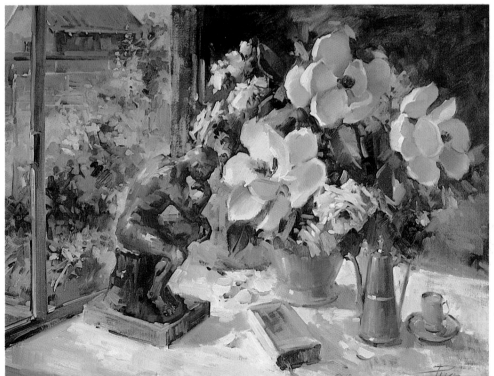

An interesting way to create exciting color activity in a painting is to place your still-life arrangement near a window. Including the window in the painting adds a very convincing sense of deep space to what is usually a shallow spatial arrangement by bringing the out of doors into the painting.

Looking Out the Window
30" × 40"

TELLING A STORY

One of my favorite subjects is a table, chair or chairs, and other objects arranged to resemble the corner of a room. This makes a perfect setting for flowers when I want to get away from the usual formula of a table with a vase of flowers and a few interesting objects for balance. I find that including the room helps tell a story or create a mood in a painting.

We all have subjects we like better than others—things that appeal to our personalities. As I have noted before, your painting should be your signature and so should your arrangements. This is part of the total expressive statement you make when you paint. Props are important. I have a few old chairs—one old wicker chair and an old oak rocker. The wicker chair is green, and it's one of my favorites. To me, each chair is out of the ordinary and has definite pleasant associations. I suggest you collect props that mean something to you or inspire you when you paint. I keep a round table on my model stand that can be converted to a square or oblong table by simply putting another top over the round one. I do find the round table works best when I place a chair next to it.

Telling a story is the main thing I try to emphasize when I include the room in my painting. I want it to look as though someone has momentarily left the scene and plans to return. The only thing that is not present is the living person. That way the painting becomes more than just a collection of pleasantly arranged things.

Let's now consider three paintings that include the room and discuss the story each one tells. First is the painting entitled *The Lace Tablecloth*. I think the title tells the story—the painting is really a portrait of a lace tablecloth, with such supporting objects as the chair, flowers, fruit, and painting hanging on the wall. The objects not only tell a story, but balance the composition. The lace tablecloth is not the focal area, but supports the center of interest in the platter of brilliantly colored fruit.

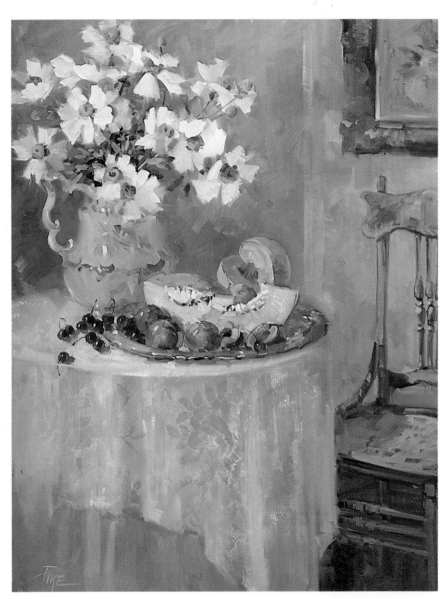

The Lace Tablecloth
40″ × 30″

The title tells the story: the painting is a portrait of a lace tablecloth. I shifted the attention to the tablecloth by placing the table higher in the picture than usual so it's more prominent and by placing my spotlight so the light directs the eye toward the cloth.

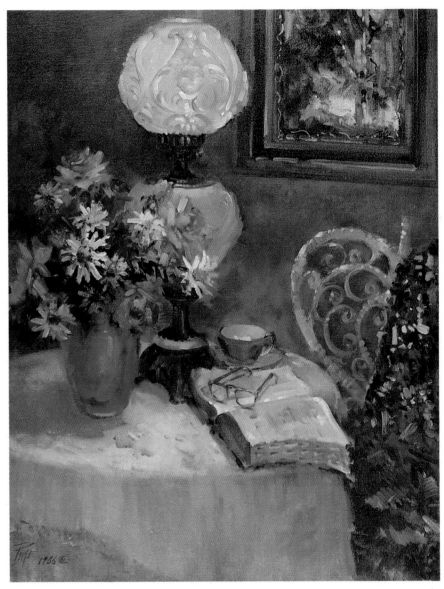

In this painting I suggested an unseen human presence with the open Bible and an old granny square shawl draped over the wicker chair. I wanted to create a very definite mood, so I used an old kerosene lamp on the table, with only the light from the lamp to illuminate the objects in the painting.

Bible by Lamplight
30″ × 24″

This is one of those unusual examples where the negative space around the objects is more important than the objects themselves. Sometimes, something without strong contrast commands attention, just as a whisper can be more powerful than a shout. I shifted attention to the tablecloth by placing the table higher than usual in the picture so it is more prominent. I placed my spotlight so the light directs the eye toward the cloth, but not so that it looks like it's in a spotlight. I wanted the light source to appear to be in another part of the room. This device helps give the viewer the impression that he or she is "inside the picture." It suggests that the viewer is in the same room as the light in the picture.

Even though the tablecloth is the subject of the picture, I still need a focal point to start the eye exploring its many textures. In this instance, the fruit acted as the focal point. When I selected my colors, I planned an overall gray tone, with the fruit as a spot of brilliant color. I could have chosen either a warm color scheme or a cool one. My choice was determined by my decision to emphasize the fruit. So I chose a cool scheme with blue as the dominant hue, blue-violet and blue-green as adjacent colors, and orange as the complement. The orange mixed with blue gave me useful varieties of gray. I chose the matilija poppies because their beautiful white petals echoed the white of the tablecloth and made the fruit attract the eye.

In the painting *Bible by Lamplight* I also suggested an unseen human presence. In this picture you see an open Bible with an old granny square shawl draped over a wicker chair; the painting has an antique frame from my collection. Here too I wanted to create a very definite mood, so I did something I'd never done before—and really enjoyed doing. I put an old lighted kerosene lamp on the table and used only the light from the lamp to illuminate the objects in the painting.

It was fun working with the lamp. I

Here my little dog contributed to the overall mood—serenity. Keeping this mood in mind, I did not make a strong, obvious focal point. I wanted the viewer's eye to amble through the picture easily. Green is said to be a very restful color, so I selected a yellow-green for my dominant hue, with green-yellow an adjacent one and a red-purple providing the complementary accent.

Dolly's Nap
40″ × 30″

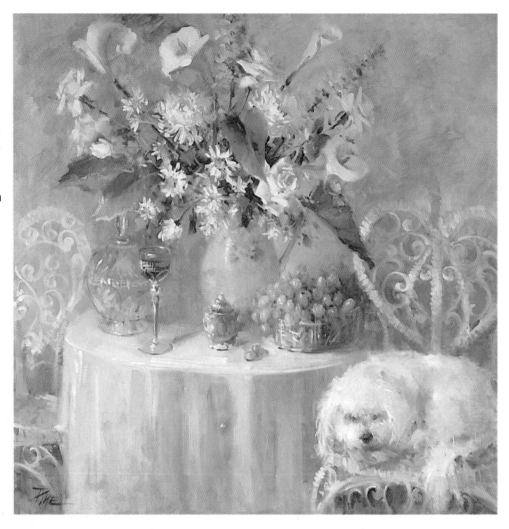

liked the way the lamplight struck the painting on the wall and made it shimmer as the flame flickered. The white study was done in subtle grays, even down to the wallpaper behind the lamp, to create the warm, inner glow of the light. The quality of light on the carefully selected objects enhanced the mood I wanted for this picture story.

My third example, *Dolly's Nap*, uses less contrast than the previous two. The day I painted it, Dolly got up in the chair to take her nap, and she looked great with the rest of the arrangement. If I had asked her to cooperate, no matter how politely, I'm sure she would have had other ideas. Thanks, Dolly! My little dog contributed a wonderful quality to the overall mood of the painting—serenity. What could be more relaxing than an adorable dog sleeping contentedly? I like creating paintings that people can

enjoy—they're sort of like sinking into a nice easy chair.

Keeping the mood I wished to create in mind, I did not make a strong obvious focal point. Rather, I wanted the viewer's eye to amble through the picture easily. The stongest contrast occurs where I painted the daisies in detail against the green foliage behind them. Green is supposed to be a very restful color, while warm tones generally are inviting. I selected a yellow-green to be my dominant hue, with green and yellow the adjacent ones. A red-purple provided the complementary accent, which I used in almost pure form for the wine in the glass.

Before you paint, I strongly suggest you consider the question, "What do I want the viewer to feel when observing the picture I paint?" Then think about how to tell a story. Create a mood. Including the room in your picture is one great way to do this.

COLLECTING OBJECTS FOR STILL LIFES

If you enjoy doing floral or still-life paintings, you'll need an assortment of different objects to choose from when arranging setups. If you keep using the same things over and over, you will quickly become bored and so will your viewers.

Luckily, I enjoy collecting junk. My husband might like to have me committed with what I bring home from garage sales, junk stores, flea markets, and so on. It's easy to become addicted to collecting junk. Oh, well, it keeps me out of trouble and helps me grow old gracefully.

What you collect does not need to be expensive. Antique stores often have broken objects that they will sell at reduced prices. An object does not have to be in perfect condition to be used in a painting. Many of my treasures have been broken and mended. For instance, I often use an old porcelain clock that I bought minus its face. I merely painted a face on a piece of cardboard and taped it to the spot.

Look for the unusual when going to garage sales. The other day I found an old toy cradle and about a dozen old assorted stuffed toys that I plan to put in a painting. All of it cost me the enormous sum of $3! Remember: Anything that *holds still* can be used in a still-life painting. Being creative is part of the business.

Another thing I do is borrow objects from good friends. If you're careful about what you borrow, your supply is limitless.

I try to collect an assortment of different sized and shaped objects, especially vases. I have several clear glass vases of different tints, as well as many colored ones that are not transparent. I have an extensive collection of metal objects—old pots, urns, and samovars in an assortment of metals, most of which I paint with a patina. Unfortunately, when the object is too shiny, it tends to dominate. It's also fun to have a few unusual objects on hand such as old worn boots, garden tools, and hats of every shape and gender.

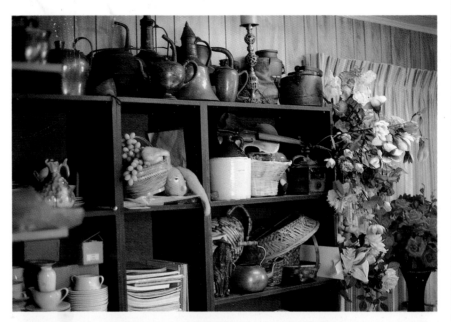

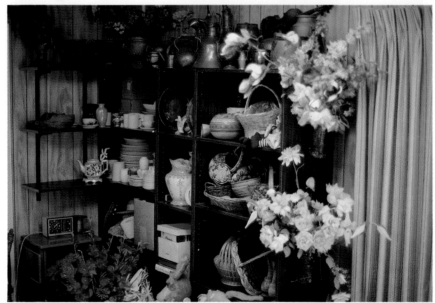

These two photographs show my studio storage area. You can see the variety of colors and textures I have to choose from when I set up an arrangement for a still life. My collection helps inspire me to paint.

CHAPTER FIVE

THE HEAD AND FIGURE

The purpose of this chapter is to teach you the important aspects of painting people. I'll be building on the painting procedures I developed in Chapter 4 as I explain how I paint the head and figure. It's the same basic approach whether I do still lifes or landscapes for that matter! My direct method involves careful preliminary planning, establishing an underpainting, sketching in the elements, blocking in the color shapes, and the final detailing. As you will see, however, there are some important considerations and exciting possibilities with figure painting that make it different from a still life or landscape.

Many artists find painting the figure a bit intimidating. This may be due to having to capture an exact likeness in a portrait. But painting people and painting portraits are two very different activities. At first glance this may sound contradictory. A portrait is a painting of a specific person, with the emphasis on making an accurate record of the sitter's facial features, while a painting of people may deal with a generalized figure or features stressing a situation or design and having very little or nothing to do with an exact likeness. A good example of this is painting the human form in expressive poses or gestures, while de-emphasizing individualized features. That's exactly what I'm going to elaborate on—expressive design with the figure.

THE BASIC PROCEDURE

After I have arranged the pose, adjusted the lighting, and planned my color scheme, I'm ready to start painting. My first step is the undertoning.

When the undertoning is dry, I sketch in the figure so I know where it will be on the canvas.

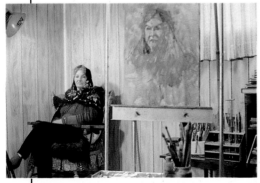

Next, I block in the light flesh tones. I try to indicate the basic pattern of colors and values quickly, during the first twenty minute pose.

The most important part of your painting isn't the model, but the whole concept—not a part, but the whole. Don't get hung up on the traditional pose—model in a chair. Think of different or unique ways to arrange the elements incorporated in your painting, including the model. They should all work together to build the whole. Being happy with one small section of your painting won't do. The entire composition must work. Never be satisfied with mediocrity.

You want to capture a natural look, so never settle on a pose that looks strained. Besides, your model is a human being and a difficult pose can cause pain. Be considerate. Take the stress off a standing pose by supplying a stool so the model can have something to lean against.

As you pose the model, think of placing him or her at different angles to the light source in order to create interesting light and dark patterns on the face and figure. To pose the model in a more relaxed position, try turning the lower body slightly in one direction while turning the upper torso a little in the opposite direction, allowing the head to slant a bit, too. These angle changes help your model look natural. A very straight pose tends to look stiff or awkward.

One additional tip: When I'm ready to draw my model on the canvas, I exaggerate the angles I just mentioned even more because there's a natural tendency to paint the figure stiffer than you see it. Exaggerating helps alleviate this.

Props help make a situation more interesting. Tables, chairs, vases, hanging objects (such as the painting behind the model) all may help fill a negative space. Remember: Select props that complement the expressive mood you want to create with a model.

Since props include clothes, I also collect interesting garments, which I store in a large box in the garage. I often find treasures by going "sailing," that is, "garage sale-ing," or shopping at thrift stores. Many of my friends save discarded garments for me that have character.

You should carefully consider the backdrop or background as well. The color and value will have a strong influence on how you see and paint all the other values and colors in your setup. Assess how the background colors work with the model and the surrounding objects. Drapes of varying color, value, pattern, and texture are a good choice for a backdrop. They provide an appropriate setting for the figure without calling attention to themselves. Begin collecting old curtains, sheets, even rugs for this purpose. Choose the color and value that work best with the overall tonality and color scheme you have selected. For instance, don't use a red drape if you plan to paint a cool background. That would be an impossible problem even for the most trained painter!

When you've chosen the pose, arranged the objects, and set the lighting to create the perfect amount of light and shadow on your subject, take out your view finder and familiarize yourself with what you plan to incorporate in your composition. But don't start yet!

Take the time to plan your color harmony. Make sure you have worked out the analogous colors you intend to use before you paint. *Now start.* Call your model back on the stand and get going. (I see so many of my students putting out paint and doing preliminary planning while the model is posing. It's far better—not to mention more considerate—to make productive use of the model's posing time.)

I use a large brush to establish color and value, usually with an acrylic or

oil wash underpainting. This procedure takes about five minutes, providing I have my paints on my palette and everything else at hand.

If you use acrylic for your underpainting, you're ready to start applying oil pigment as soon as your canvas is dry to the touch. The underpainting is meant to eliminate guessing as to where the model will be placed on your canvas or what your color scheme is. It's not necessary to cover every inch of the canvas with oil overlay. Many times, a bit of acrylic peeking through is exciting.

When the model is taking the first twenty-minute pose, I work fast to indicate the placement of the model and the objects I intend to use with the model, quickly working out my design or composition. I like to keep this step somewhat abstract. If you work fast, you can establish your composition in the first twenty-minute sitting. Now give your model a rest and let him get off the stand to stretch his legs and back. It's a good idea to mark the spot where his feet are with either chalk or a bit of masking tape, and also make sure he remembers where and at what he was looking.

With the model back in the pose, I continue to relate what I see through my view finder with what I've already suggested on my canvas. At this point I check my drawing, concentrating on the correct features and anatomy of the figure.

With my drawing correct, my color scheme and my design well worked out, I then proceed to bring areas of my painting near to completion. This step can take varying lengths of time since I'm dealing now with subtle value changes.

I always try to keep my brushstrokes fluid and loose, so they never become overworked at any stage. Think of the model as shapes of color and value—and have fun.

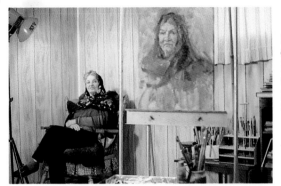

I continue to suggest the larger pattern of lights and darks. I make sure my drawing is correct as I continue to compare my painting to the model.

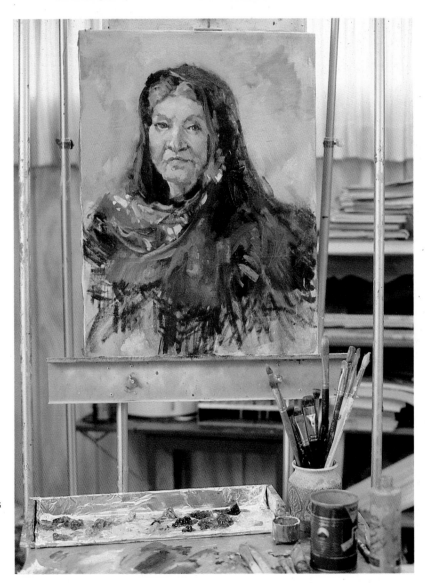

Señora Jessie
24″ × 18″

In the final step, I refine details or add subtle touches. I kept the areas around the face looser and less detailed, so the focus would be on the face.

CREATING A POSE

Avoid a typical pose whenever possible. If the pose is either stiff or uninteresting, the painting will lack the excitement every painter should achieve. Use the same concept for setting up your model as you would for a still-life arrangement. Balance your objects, including the model, in a pleasing pattern of light, dark, and color. Design is the word. Think shapes only. The model is part of the whole concept, and how you integrate him or her with all the elements can make the final image exciting or boring. To make the painting work for you, you may want to incorporate the personality of your model in a situation pose. When you plan a portrait, whether it be a commission or whatever, also think about related background objects. You may be requested to use specific objects when you do a portrait commission. I know I am.

The painting of Carolyn (*below*) was conceived in just this way. Objects such as the lamp and the painting in the background were positioned for balance, but selected to establish historical authenticity. I try, when possible, to find actual antiques. It's exciting to take an old object and make it come alive on canvas.

If you are interested in the field of portraiture, I suggest you study the works of artists already successful in the field. You can learn a great deal from such great illustrators of our day as Cornwall or Rockwell who have been well schooled in design and composition. There are also many good books on the market, including such works as *Drawing the Human Head* by Burne Hogarth, or *Constructive Anatomy* by George Bridgman. There are also many good books specifically on portrait painting. A great one is John Howard Sanden's *Painting the Head in Oil*.

To me femininity is soft and delicate. Carolyn has those qualities; she is petite and very much a lady. She selected the garment herself. It was easy to place her in these surroundings as her clothing and hair style were obviously from a bygone era.

Carolyn
30″ × 40″

SITUATION POSES

Situation poses—ones that tell a story—have always intrigued me. *Woman at the Well* is a Biblical story. I required a model who was beautiful, with expressive eyes. I found her among my close friends—a sweetheart of a girl living just across the street from me. For authenticity I may have cheated on her coloring a bit, considering the historical origin of the story. I'm sure the story would have been as easily told with a brown-eyed brunette, but I did not have one living across the street.

I used the same procedure to secure my color and composition as for the portrait of Carolyn. Only now I planned to use a dark background for a low-key painting to bring out my model's beautiful blond hair and fair skin. The undertoning was mostly blue and violet with touches of green. When I used my oil overlay, I scumbled a touch of alizarin crimson throughout the dark background to keep it from becoming too solid and dull. Remember: A little alizarin crimson goes a long way. The water urn was sap green and cadmium red light with ultramarine blue for the dark shadows. I made the urn dark for design balance. The warm flesh tones complement the cool blue-violet dominant hue, and the blue-violet shadows of the blouse tie in with the background tones. The highlights of the blouse were painted a warmer hue than in real life to make the large white mass of the blouse area exciting and minimize its stark whiteness.

Even though I show a suggested hair mixture in the color chart, there is no one formula for all hair tones. Usually, the hair will work best if it is the same mixture that is used in another part of the painting. For instance, the shadow side of the hair is the same mixture I used for the urn, while I used almost the same mixture for the lights in the hair as I did for the flesh tones.

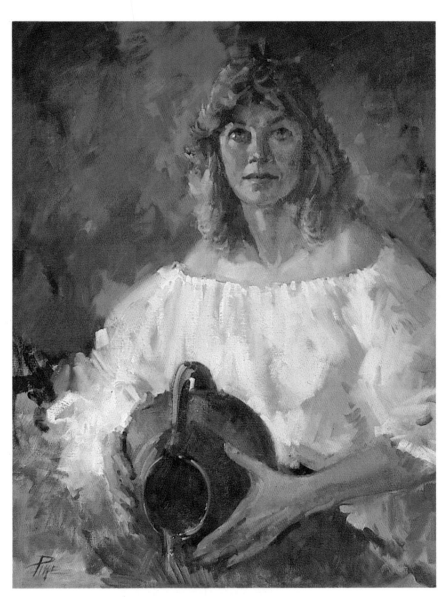

Woman at the Well
30″ × 24″

With just a little imagination and some well-chosen props, you can convert a pose into a story. Here, I selected one from the New Testament. My model's beautiful and expressive eyes were just right for illustrating a dramatic incident from the Bible.

DRAMATIC DARKS

Drama is the theme for this painting. Every portrait painter has a dream of finding the perfect model for a particular story. Of all the interesting Biblical characters, I enjoy King Solomon the most. Not only did he write beautiful poetry, but any man with one thousand wives must be something special! I met the perfect model while teaching at Northridge School of Art. After I did some research on the type of clothes worn by royalty during this period, I made his costume myself.

While the blue brocade fabric was done laboriously by hand back in Solomon's day, I was able to secure a beautiful modern machine-made fabric that looked great. The small ermine collar was one of my treasures. A bit of jewelry added a definite but not overdone touch.

I wanted the painting to reveal the familiar story of Solomon's wisdom. When two women both claimed to be a child's mother, Solomon ordered to a guard: "Go get my sword. I will cut the child in half." One woman cried, "Spare the child and give it to the other woman." Wise King Solomon then knew who was truly the child's mother.

I kept all emphasis on the expression in the head and hand to tell the story. The dramatic dark background draws the viewer's attention to that area. Although my model was crippled with arthritis, I painted his hands as I really saw them. They told the entire story.

The main color I used was cool, with blue to green and touches of orange complement for the jewelry. It's easy to get carried away with the excitement of your subject matter and forget the most essential part—the balance or design and the necessity of losing or finding edges to help make a statement. Remember that an area cannot be emphasized with the edges blended out. After I had selected my pattern of design and color, I spent several hours working on the correct expression and gesture. The rest took only a few minutes. Whenever hands are involved in one of your paintings, plan to take as much time on them as you would on a head. They should show personality as much as a face.

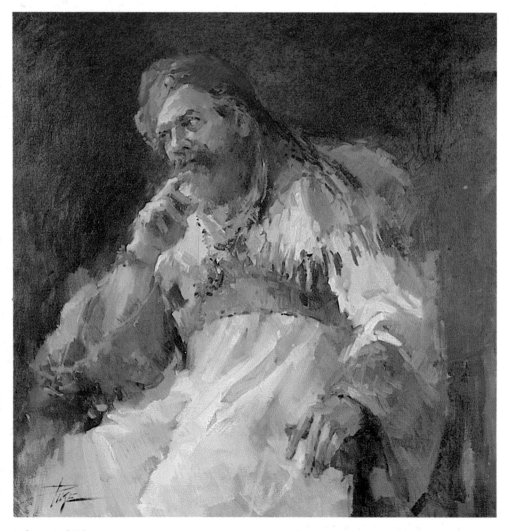

Judgment of Solomon
36" × 36"

SHOWING EMOTION

Emotion can be anger, love, hate, fear, and so on, or it can be what you see deep within the person. To paint any model without this inner feeling would be like painting a store window mannequin. One of my painter friends modeled for this painting. Betty is not only a great painter, but a super model, so much so that I have painted her several times.

Let's see how I painted this portrait to develop the sense of inner emotion I wished to express. The light pattern behind her head on the left creates a strong contrast, while the darker pattern behind the head on the right blends in value with the hair, softening the edge. The hair ornaments work the opposite way, for a good balance of dark and light. They work with the highlighted areas of the garment, but do not form a stronger contrast than the light on the hair against the dark background. I carefully mixed and placed midtone grays to keep the viewer's eye contained within the canvas. I applied all my brushstrokes loosely, even on the face. Little blending was done throughout this entire canvas.

I used a warm underpainting to establish the temperature of the painting and then added a soft gray overlay in oil. Whenever the subject warrants, I like to scumble soft grays over a bright underpainting. The effect can be exciting.

The background is part of the portrait and should never look separate, but should flow without being obvious. The touches of blue add a complement to balance the overall warm hue.

Touches of the background red and green-grays were used to create the pattern in the blanket. They draw up the eye at the lower left corner, creating a pattern of movement that allows the eye to travel upward instead of falling out of the canvas.

The play of light both on the face and behind the head gives strong support to the head at the same time that it emphasizes the feeling of emotion.

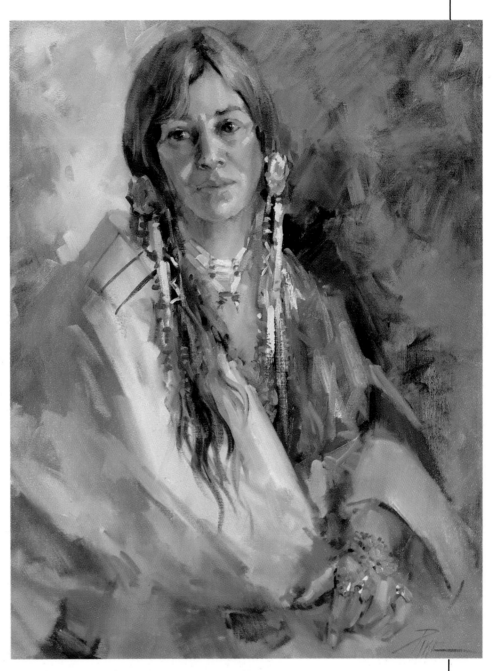

Desert Madonna
30″ × 24″

In order to express inner emotion, I made the eyes the center of interest in this painting. The direction of the lines in the painting moves the eye up and into the composition, keeping the viewer's attention focused on the face.

THE VIGNETTE

One of the most useful compositional formats for painting the figure is the vignette. A vignette is a picture in which the focal point or area of interest is located more or less in the center of the design, with the surrounding space fading off at the edges with no definite border. It's a natural composition for a painting that emphasizes the head and facial features. Since the viewer's eye is naturally drawn to the center of a composition and is also attracted to faces in a painting, placing the head near the center produces an almost irresistible attraction for the eye.

When you create a vignette, be careful not to place the head or face in the exact center of the canvas. Instead, the face should be placed slightly above or to one side of the center. If it is a three-quarter view, leave a bit more space on the side to which the figure is looking. It's oddly disconcerting to the viewer for a figure to appear to be eyeing the frame around it!

When planning a vignette, think about which of the model's features you would like to showcase. *Bonnie's Girl in Profile* was a painting I did at a workshop at the Art League of Los Angeles. Once the pose was set, I studied the model for something interesting to focus on. She was thin, with long straight hair. Her unique features were high cheekbones. Then my eye caught the pink satin ribbon that had fallen down her shoulder so I decided the vignette should focus on the shoulder and cheekbone.

The hair was lost in the background, except for a few strands that fell over her slender neck and shoulder, there again vignetting everything but the focal area where the satin strap catches the light. I blended the flesh tones to bring out the porcelain-like highlight on the shoulder and cheek and to attract more attention to the strap falling over her shoulder.

Using a vignette helped me once when I called a model agency to hire a cowboy type for a workshop. The agent read off a list of names available and Gunnar sounded Western. But when he arrived, he was 100 percent Swedish. Although he was great as a model, he was definitely not a typical Western subject. Nor was he a large man. The vignette helped keep that a secret. Remember that a vignette focuses the attention on the face.

In my third example of a vignette, *Old Lady in a Bonnet*, I wanted to emphasize just the facial features of my model because I found them so fascinating. By painting the bonnet with the same values and hue of the background, I was able to frame the face effectively. Since I also kept almost all the warm hues for the skin tones, the contrast with the cool blue-grays of the bonnet and background also added emphasis, which contributed to the strength of the face.

First I used an oil wash of blue-violet grays over my entire canvas, modeling a bit of soft pink into the cool blue. The flesh tones were more yellow than pink, so the yellow-orange flesh tones worked as the complement. Some of the flesh tone was also used in the background to make a neutral gray in the vignetted areas. When I started to finish the painting to the degree I wanted, I felt I needed a bit more detail in the profile. I used cerulean blue and white in the background to outline the features.

Bonnie's Girl in Profile
24" × 30"

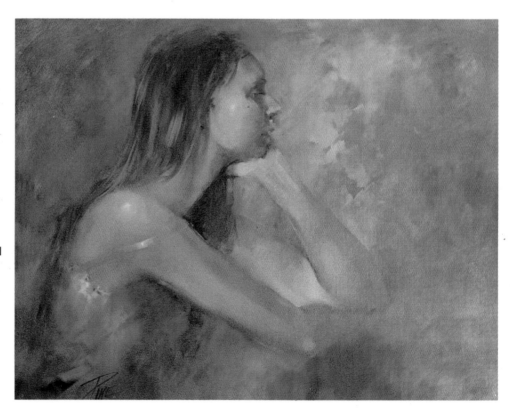

When I saw this handsome, fair-skinned Swede, I knew I had to use strong color to make him seem more outdoorsy. By using red-orange, I could keep the flesh tones warm, giving more drama to his beautiful white hair and mustache. I used the blue-green complement in the reflected lights in the face, shirt, and hat. This is a good example of not painting the flesh tones as you see them. Flesh is not always a pink-gray; it can be done with any color on your palette. Notice how little of the face is in light and how much color was used. I tried to do the shirt warmer, but the warm tone started to scream so I went to a soft blue complement to quiet down the strong red-oranges.

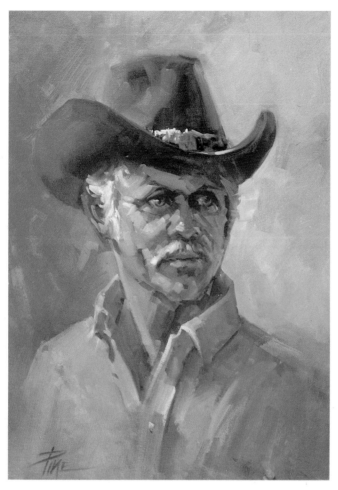

Gunnar
24″ × 18″

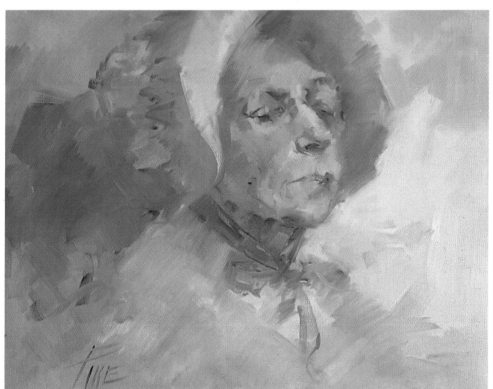

The model had been a bit player for the motion picture industry and now works as a model. She is a great model and holds a pose well. I enjoy her every time I work with her. She has a thin, exaggerated bone structure, which makes her interesting in many costumes.

I enjoy painting people when I can understate my brushwork. Showing more emphasis on a nose or mouth can be far more exciting than always painting the model with large staring eyes.

Old Lady in a Bonnet
14″ × 18″

GETTING A LIKENESS

I am a people watcher. When I go to a ball game or anywhere there's a crowd, I spend most of my time watching people, especially if they do not know they're being watched. Once when I was doing a painting demonstration and lecture for the Beverly Hills Art Association in California I spotted this lovely lady in the audience. After the demonstration, I asked her to pose for me sometime and she agreed. She had the look of someone who might once have been a beautiful young actress. Her lovely skin tones remained as fresh as in her youth. Her large eyes still sparkled with a mischievous glint. I could not paint her cute little giggle, but the rest of her was within my reach.

For this study, I was careful to draw or map out the features exactly as I saw them, using cadmium red light and ultramarine blue thinned to only a tint of color. I never use charcoal to draw with, as it is messy and fragile. By using paint instead of charcoal, you can erase whatever you wish by just rubbing off the unwanted area with a rag. It will also blend better with the overlay paint. Remember that it's not necessary to put in every detail you see. Your drawing is for you alone and has only one purpose—to keep you from losing your way.

Placement of the head on your canvas is of utmost importance. Try several small sketches before settling on a pose. I can't stress enough that planning will save precious time, not waste it. To work for a likeness, you should be sure of your placement of the features at this stage. A three-quarter view of the head is always good when

you're working for a likeness because it shows the features of your subject clearly and naturally. If they aren't right, you will not achieve a likeness. If you find it necessary to move something even a little bit later on, it will take time and may be difficult to do.

When I have the correct placement of the head on the canvas and I feel good about my drawing, I mix several flesh hues on my palette. You can adjust all these premixed hues slightly. The purpose of premixing is to have paint available when you need it. It's easy to make a slight adjustment by adding a touch of another color to the premixed paint.

Here I massed in the shadow tones first and went a bit darker than what I thought I saw. It's easier to create a lighter tone later, if needed, than to go darker. I then placed in the light masses, avoiding detail at this time. However, I did place in the cheek area and mouth before I started to look for subtle changes of color and value in the lights and shadows. I blocked in the eyes at the same time I blocked in the rest of the features, but I did not finish them until last. The expression of the eyes is of utmost importance, and I can concentrate better on them when the values around the eyes are more complete.

When I was satisfied with the placement of paint and brushwork, and feeling good about what I'd done thus far, I then carefully planned how *little* detail was needed to finish—not how much. I could see tiny touches of dark at the corners of her mouth. Using alizarin crimson, I carefully suggested them, going a bit lighter as the

thin upper lip came closer to the light. The lower lip was lighter and redder, but because of her age, I went slightly gray.

For her blue eyes, I used a blue-gray. On the opposite side from the light, I used a touch of cerulean and white slightly grayed to show the light passing through the lens of the iris. The highlight in the eye was the same mixture as a light flesh tone. Note that a pure white makes the highlight look unnatural.

The eyelids cast a soft shadow in the upper portion of the open eye and darkened slightly as the curvature of the eye receded at the corner. I used a dot of grayed red at the corner of the eye nearest the nose. The nose was a bit warmer than the surrounding flesh tones and carefully studied for individuality or it would not look like the model.

The hair was gray, yet subordinate to the whites. I was careful not to show a lot of detail in the hair, only suggesting a few soft curls. The lace needed only a few quick touches of almost pure white to give it a finished look.

The all-over hue was blue with blue-violet and blue-green in minimal amounts. The light flesh tones read as the complement, yet touches of blue-violet were used in the shadow to show reflected light and also to keep the color balanced throughout the painting.

Portraiture is great fun. Getting a likeness gives you a marvelous feeling of achievement and satisfaction. But there is only one way to get there— hard work.

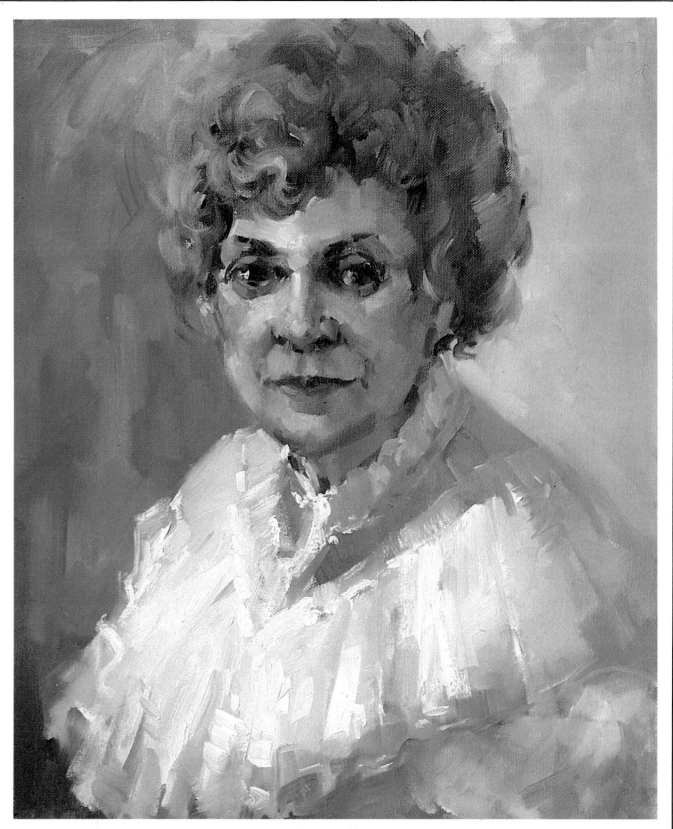

To achieve an accurate likeness, you must draw or map out the features carefully. Use paint rather than pencil to sketch in the face so corrections are easier. Once the drawing was done, I painted in the darker tones first, followed by the light ones. Then I blocked in the other features and added details, doing the eyes last.

Lemonta's Mom
24″ × 18″

QUICK STUDIES

One of the very best ways to master painting the face and head is to do a series of quick portrait studies of anybody who is willing to sit for you. Use your family as practice subjects; they're often easily persuaded—and if not, maybe they can be bribed. Quick studies are great practice for painting children—they don't sit still for anything else! The quick study is not an elaborate or highly finished portrait. Instead, it's a less formal, more relaxed attempt to paint in a direct, unlabored manner.

The purpose of doing quick studies is not to see how quickly you can make the portrait look like the person you're painting. The purpose is mastery of the basic procedure—what to think about and when. There are many steps to follow before the problem of a likeness should be considered.

For instance, check to see if the light is correct. I usually use a light stand with a 100-watt daylight flood lamp at the correct distance and angle to give the cast shadow under the nose the desired length. Adjust the light until you find its best placement on your subject. There are cool light bulbs available if you wish to simulate north light. When I paint cool light, I prefer actual north light from a window, but when going cool, you may not be able to use filtered light. If not, get a blue 100-watt light bulb.

Check your model carefully for a relaxed, well-planned pose. Have your model twist and turn in several direc-

Ricky
12″ × 9″

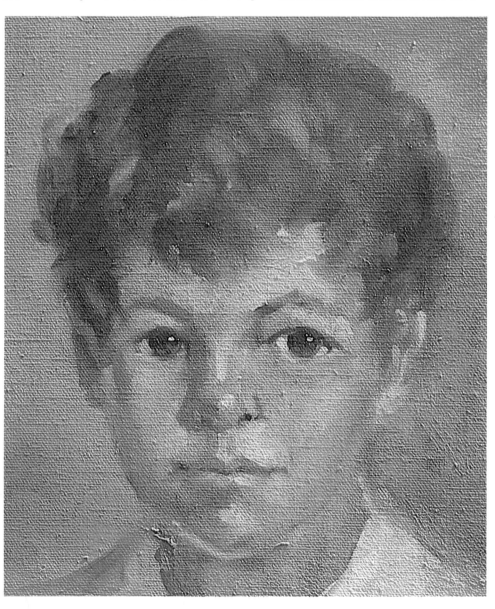

Ricky is a grandson and a curly-headed little doll. I got him to sit for about an hour the last time they visited. What a job it was for him!

He was a wiggler, so I chose a front view. Using a front view is much easier if your model moves because you can work the conventional feature placement on the oval. If your model is young, it is better not to make him, or yourself, frustrated by choosing a difficult pose, such as a three-quarter view or profile.

After I drew an oval on my blue-violet oil-toned canvas, I drew in the eyes, nose, and mouth where they should go for a child of eleven, then modified the features to Ricky's actual features when I had him on the stand. I had three pots of paint premixed: *light, midtone,* and *dark* flesh tones as close as I could get to Ricky's coloring.

I covered all light areas with the midtone flesh mixture; then quickly I placed in the dark areas such as eye sockets, nose shadow, and shadow areas on the face and neck.

I then went to the light areas of the face with my light flesh mixture. No strong highlights at this time.

tions until you and your model agree on a good, comfortable pose. I have seen models so uncomfortable they looked like they were sitting on a razorback mule. Even if you only plan on doing a head study, turn or move the head in several directions before settling on a pose.

I make my decision as to the technique I plan to work in and proceed to cover my canvas with a toning. I am now ready to begin the business of painting. When doing practice sub-

jects, it's good to emphasize bone structure. You can always soften an edge later if it seems too harsh. Think of your model as planes, never as a person, or you will tend to get hung up on likeness. The likeness will be there if the color and structure are correct.

I often think of my model as a lump of clay. As I paint, I sculpt each separate plane, creating form where none existed. Once I have established the forms of the facial features, I start

to make the study become an individual.

Consider the hair as a single shape, never as individual strands. The overall pattern of lights and darks, if properly placed, will be all that's needed to describe the hair convincingly.

After the form has been modeled and harsh brushstrokes softened, I place in highlights on the face, hair, or wherever they appear. Always make sure a highlight is actually there. It's easy to be fooled.

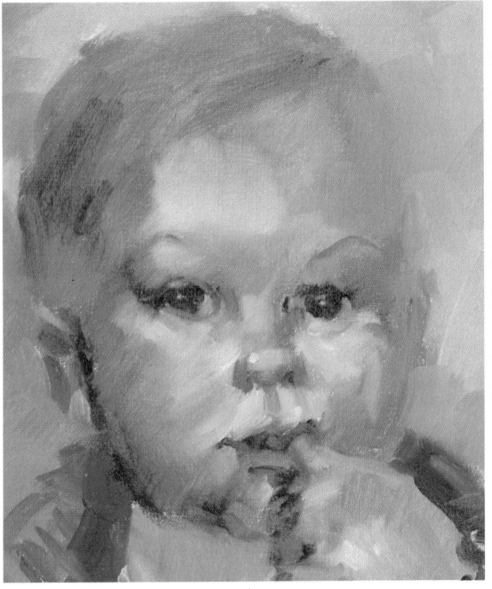

Jason
12″ × 9″

Jason is my littlest angel. He is the youngest of the Pike clan. I did this quick oil sketch from a photo since it's all but impossible to get a baby to hold still for even a second.

The trick of painting from a photo is to plan a skull structure first before relying on the photo. It helps avoid a photographic look. Staying loose also makes it look like a painting from life rather than a copy from a photo. This quick sketch took under one hour, yet I made a complete statement.

When you're doing a quick sketch, don't keep messing around with it until it's past repair. This is one point where many of you may go wrong. In this painting I felt if I had carried it further, it would have started to look more like a photograph than a painting of a real baby.

Girl With a Hood
20″ × 16″

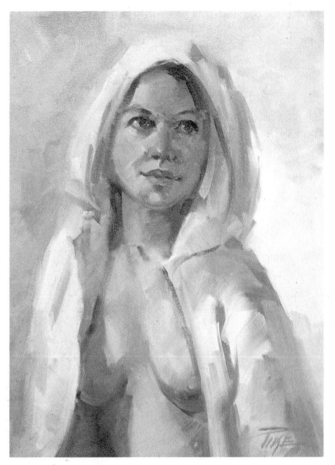

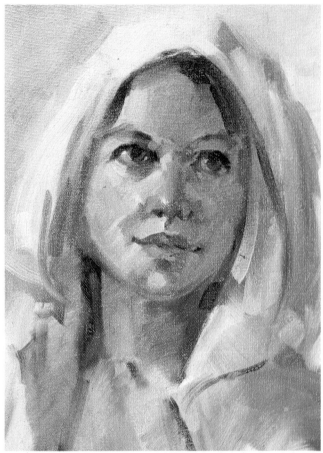

This painting illustrates modeling with the brush. That means carefully merging one premixed value with another, or placing a value next to another without blending. I carefully premixed every value change on my palette from warm to cool, using various degrees of mixtures. I then carefully place each premixed hue next to the desired color and value I see in the model. Beautiful women are often best painted in soft muted tones allowing the brushwork on the features to stand out. The finished painting is high key, with a feeling of softness about it. Notice that I didn't do any blending, yet it appears to be blended.

In this detail, you can see that I did not blend at this point. The main idea is to see if I can make the face appear blended without actually blending. I painted the background by scrubbing on values. I only wanted to cover the area. The brushwork was not important in the background. I find this better for me because I don't want to overwork the painting. I painted the garment with various mixtures of gray, using close values next to each other much the same way I painted the face.

In setting up the model, I chose green as the dominant hue with warm flesh tones suggesting the complement. By making the background dark or low key, I made the entire profile stand out. I used a lighter background against the hair, which was dark. This formed a balanced contrast between the face and the hair against the background values, giving the whole composition an appropriate balance.

I deliberately left the canvas unpainted at the bottom to carry the eye to the background. I felt that if I covered the entire canvas with paint, I would lose something. There are times you will need to make a decision like this. Do not jump too fast to cover the entire canvas and then wish you had not. Remember Mama used to say, "Haste makes waste."

The Old Lady in Profile
12" × 9"

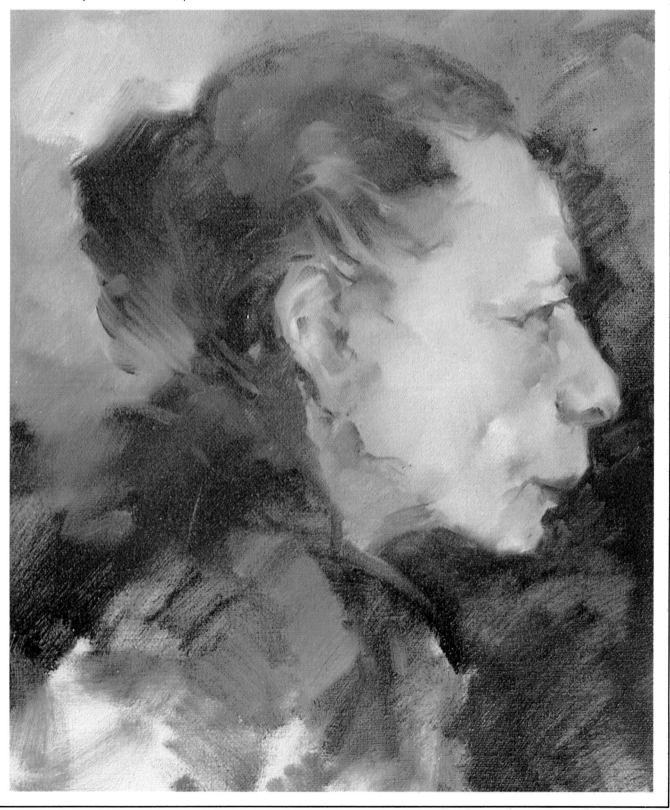

CHARACTER STUDIES

Quick studies are great fun and great practice. They can be even more fun if they are also character studies. Often when you're working quickly, you can capture character and personality more easily, perhaps because there is less concern for photographic accuracy and more attention to the qualities that make the sitter a unique individual. These studies will often turn out better than something you labored over. This painting of the old sea captain started out to be a preliminary study for a painting I would do later. I took an old canvas and covered it with just enough white paint to plan the head study and not be confused by the painting already on the canvas. Using direct, loose brushstrokes, I quickly worked out my composition and color, keeping everything in gray except the flesh tones. I painted the face with more vibrant color than what I actually saw, giving it a rosy glow. The grays that dominate the entire painting remain warm, with touches of orange complement showing through in the jacket area. The overall warm glow makes the painting hold together. Plan color for every composition even when painting in gray as in this sketch.

I completed a more finished painting from the study, but I felt my second effort lost something in translation. Ultimately I disposed of the finished painting and kept the sketch. I like the freshness and the mood that came through in the sketch.

Tim Padilla posed for the painting entitled *The Sheriff*. He was a much sought-after professional model. Every school of art in California put him at the top of their list. He had interesting costumes, but best of all, his face could depict a range of personalities from a Spanish Don to a humble monk. He may be gone now, but he will continue to live not only in the hearts of those who knew him, but through the many paintings done of him by many great painters—what a legacy! There are great models, but none greater than Tim.

I approached the painting much the same way I do most of my portraits. I tried to capture his personality first. Red was my strong color, and I used it in both the shirt and the face, with a bit scumbled over grays for the background. The hat was a mixture of the three primaries, with a bit more of the yellow. The vest was painted with sap green and cadmium red light, with a bit of the same mixture used in the shadow area of the hat. The underside of the brim reflected orange and red from the shirt. Tim's white hair and beard were almost violet in shadow, with many subtle variations. I used a warmer tone where the light struck the mustache and hair.

The Sea Captain
24" × 30"

Quick studies are great practice. I did this painting of the sea captain on an old canvas as a preliminary study for a different painting. I worked fast and loose and ended up keeping this study and throwing out the more finished version.

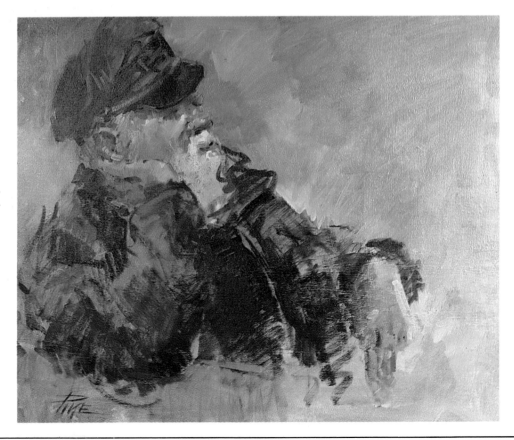

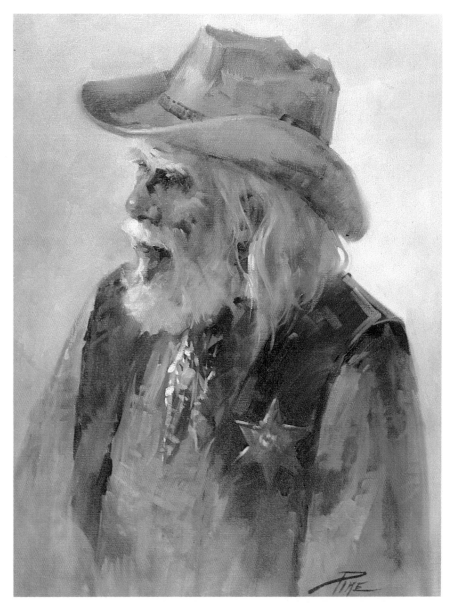

This sketch was done in one sitting. Tim had strong bone structure with smiling eyes that made you wonder what devilish thing he was thinking. Stories he told of his youth would curl your toes!

The detail shows the loose brushwork on the face and head. You can almost count each stroke. Notice how they all add up to a convincing portrait with a great deal of character.

The Sheriff
24" × 18"

WORKING MONOCHROMATICALLY

Preparing for the Dance
36" × 24"

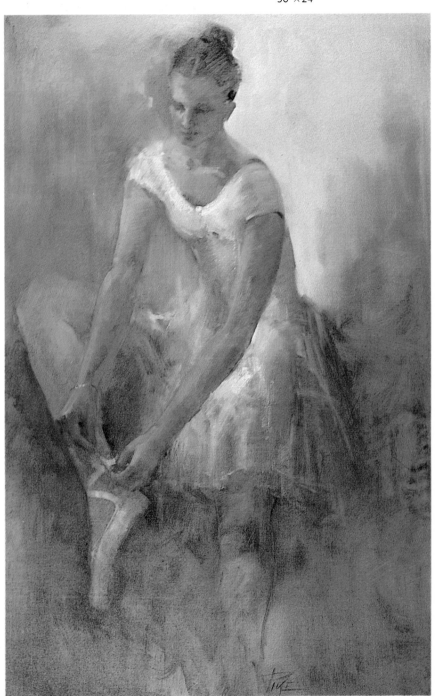

Monochromatic means "one color." I use the term "semimonochromatic" as a way of explaining the use of several grays. Creating form, or establishing value changes, can often be done more easily when you're not concerned by color. I often say, "One thing to think about at a time is easier than two." What a simple statement! Yet simple as it sounds, it makes sense.

When learning to create form, that is, make objects appear to be three dimensional, try using only raw umber thinned to a workable consistency. Raw umber is the only earth color I have on my palette, yet one I use many different ways. For instance, I use it to tone my canvas when I want an all-over gray; I work all my colors into a thinned application of raw umber. In *Preparing for the Dance* I used it as an overall wash, then wiped out the lights and midtones while the canvas was still wet, thus leaving various degrees of value changes.

This painting of a ballerina preparing to dance has a pattern of light and dark, yet almost no detail, especially in the face. When planning this composition, I mainly wanted to capture the mood. The figure is slightly exaggerated. By making the head smaller than life size, I could create a feeling of extended length, with the figure appearing to be gracefully tall.

Without the use of strong color, I could also emphasize the value changes to create a stronger compositional balance. After I had wiped out all values to the correct degree while the canvas was still wet, I carefully started applying flesh tones, which were more gray than usual. The garment was white, yet understated

In this painting, I used a technique called the "wipeout method." I toned my canvas with raw umber; then I used a rag to wipe away the paint for the light and middle tones. After I had wiped out all the values, I then applied the flesh tones. When the entire painting was dry, I scumbled soft blue-gray tones over the face, the garment, and the background in the shadow areas.

against the soft pink-toned background.

After the entire painting had dried, I scumbled soft blue-gray tones over the garment, face, and background in the shadow areas. Since it was dry, I could scumble over the surface, allowing color to show through the softly applied overtones, never losing the ethereal mood set in the beginning.

In *Reclining Nude*, my other monochromatic example, I first tried to think of where I wanted the eye to go. Then I worked out an unusual composition by placing the hip area near the center of the canvas. I played down the head and played up the protruding hip, using the rest of the figure as a subordinate area.

I first tinted the canvas with raw umber mixed with a touch of alizarin crimson. I added sap green for the darker areas. I was careful not to allow one hue to become prominent, keeping all the tones grayed. To achieve various value changes, I carefully wiped out light areas using a soft, clean cloth with just enough pressure to take a limited amount of pigment off the canvas. This is a great procedure to use instead of drawing when doing a model, because it's easy to rub out and start again if it doesn't work the first time. After the composition has been established, you can refine the anatomy by doing a more complete drawing.

I never use a smooth coverage of pigment on my canvas. The excitement of texture helps stimulate my thoughts about the subject placement. Many good things can happen by accident when you start with an animated feeling of movement in an abstract pattern.

Reclining Nude
24″ × 12″

I used the wipeout method for this painting too. It is ideal for depicting form. In fact, the procedure reminds me of modeling in sculpture because of the ease with which I can push and pull form forward and backward by adjusting value.

I directed applications of flesh tones carefully over the natural curvature of the hip. I used tints of warmer tones to show reflected lights as the hip recedes into shadow. The strong spot of direct light striking the protruding hip depicts form.

Nude with a Hat
18″ × 30″

Painting form is more important than painting detail. Lost and found edges, the direction of the brushstrokes, the thickness of the paint, and value contrast all contribute to the solidity of the forms in this painting. Detail is subordinate, with a minimum of strokes used to suggest those areas not in the focal area.

PAINTING FORM, NOT FEATURES

Detail is not a requirement for a successful portrait or figure painting, but convincing form is. Details are the last things you put on a painting, but they are not the most important. If you correctly establish the form of the subject in a painting, you will be surprised how little detail you really need to make a finished painting. If you fail to establish the form, no amount of detail will turn it into a successful picture. More than likely, it will be an overworked disappointment.

In fact, painting form rather than detail really separates the student from the professional. Unfortunately, it's the details that are often the most seductively attractive aspect of our subjects. It takes real discipline to ignore the superficial details and attend to the underlying form.

Let's look at *Nude with a Hat* to see how I handled form first and then detail. To begin, I chose a reclining pose, which often presents the forms of the figure in a really interesting manner. Actually, it's difficult to have a bad or boring pose when the model is lying down. The reclining pose makes it easier to think about the body as a grouping of forms rather than as a person or collection of anatomical parts. We are so familiar with the standing or sitting figure from everyday life that we rarely just look at a body in these positions and think of

them in a purely artistic way. With the reclining pose, the figure can be seen from angles that are enough removed from normal experience that we can focus on the forms.

When I planned the composition for *Nude with a Hat*, I chose the torso as my focal point and decided to play down all the surrounding areas. I emphasized the torso by making it the area of the lightest values and sharpest definition. Light, soft flesh tones of yellow and pink highlight the breast and abdomen, with cool violet shadows amplifying the roundness of these forms. By keeping the edges very soft, I allowed the arms and legs to melt into the background. Bringing some of the cool blue-green background into the flesh tones also kept the focus on the upper body of the figure.

All the other elements in the picture, such as the hat ribbon, were suggested with some strategically placed brushstrokes. As I refined the painting I softened edges, especially around the face, which has only a slight delineation of features. All in all, I kept brushstrokes to a minimum. Having a clearly defined center of interest makes it possible to decide what details to leave in and what to leave out. When you think of form as your primary concern, and features or details as subordinate to it, your painting will have a convincing solidity.

TWO MODELS

The opportunity to paint more than one model can be a very exciting experience. I occasionally treat myself and arrange to have two models pose. When painting two models, one has to resist the temptation to paint two unrelated studies on one canvas. It's easy to fall into that trap because each figure attracts the eye. Therefore, when you're using two figures, it's best to work with them as one unit—touching or merging lines to create an overall feeling of unity. It is best to allow one figure to dominate the composition, as the female figure does in *Muna and It*.

The two beautiful black models in *Muna and It* were like black gems in their colorful garments. Muna is one of my favorite models. She has a regal beauty that commands attention when she walks into a room, but It—yes, that's his name—is a happy-go-lucky man who would do anything for attention—even to his unusual name.

Posing them was as much fun as painting them. It kept me laughing until I finally made him get to work. He brought a guitar as one of his props, so I used it in the arrangement.

I posed Muna higher than It to emphasize her grandeur and also to be able to drape her beautiful slender fingers over his shoulder. Muna's profile is more interesting than her front face view because of the beautiful curves in her skull structure. Her slender neck tends to enhance her skull even more. I used It more as a pattern of dark.

Their costumes guided me to color choices. I continued the bright pink and orange tones from their clothing into the background. I also kept the background light to silhouette the dark flesh tones. The animated darks of the figures against the larger light background worked together dramatically.

Working with two models can be very exciting, but you have to be careful lest you create two competing centers of interest. I chose Muna to be the center of interest by placing her higher on the composition and giving her a more detailed treatment.

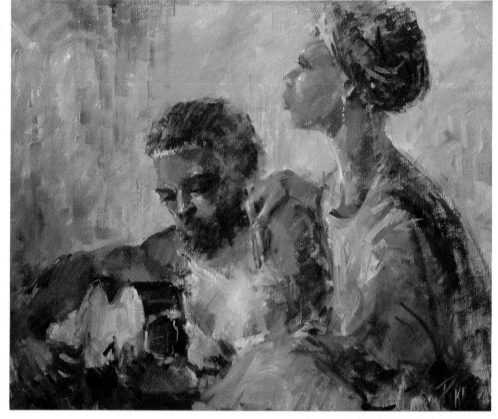

Muna and It
30″ × 40″

CAPTURING PERSONALITY

Our son, Richard, is a great big hunk of a man, and I have used him many times as a model. This painting was done as a portrait for his home. It was realistic in every way—he's an outdoorsman and loves to hunt and fish. It's often interesting to paint your model in conjunction with his or her hobbies.

Richard is large—6'8". By keeping his head a bit smaller than normal size, I could show his height. Also, elevating his right leg slightly to give him something to lean his arm against helped keep the pose more natural and make the sittings more bearable.

When posing your model, keep the length of the pose in mind. If your model gets too uncomfortable, he or she will show strain and you may capture that in your painting. The usual time is twenty minutes on the stand, five minutes off, with a fifteen-minute coffeebreak during the three-hour sitting.

Rich was wearing blue denim. It worked best for me to use blue-violet as the dominant hue. I could have chosen another color, but by choosing blue, I could paint more of what I actually saw. I used a view finder to tell where each part of his body would be placed on the canvas. I had a lot of arms and legs to get properly placed!

I used a grayed yellow-orange as the complement in the background behind his head. Keeping the background hue mostly in gray tones brought the color of the entire painting together.

I played up details of the hands and face by keeping all the surrounding areas played down. The hat was dropped down over one eye to create a more relaxed, natural gesture.

Flesh tones are seldom ever the same, although the mixes I use are generally of the same three or four colors. I adjust them to complement the dominant colors of the painting and also add touches of other colors from my palette when needed.

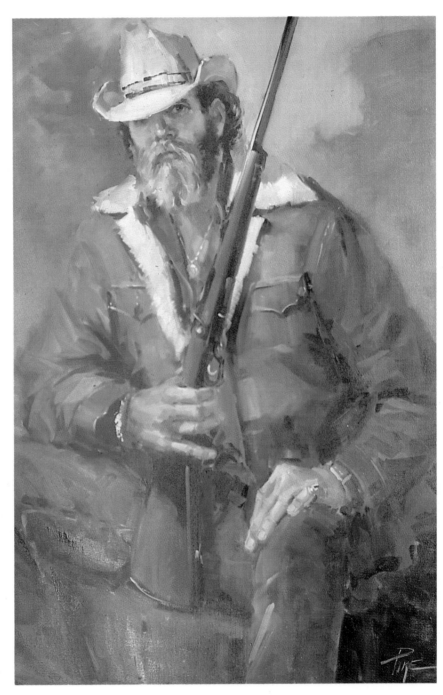

Rich
40″ × 30″

My son Richard is a big man who loves the outdoors. I wanted to capture his personality in this portrait, so I kept that goal in mind as I painted. I proportioned the head so it emphasized his stature and posed him in a relaxed manner to create angles that worked well with the edges of the picture. I wanted him to look relaxed, but robust.

SECTION THREE

PAINTING OUTDOORS

I don't know anyone who doesn't get excited by traveling around this beautiful planet of ours and viewing the ever-changing landscape. Somehow the sight of skies, trees, the sea, even humankind's own creations, has a marvelous effect on your mood. I really believe that getting out of doors to look around can boost your spirits. A person just feels better after spending some time in the open air. I'm particularly lucky here in California. I'm able to paint snow on the mountains, flowers in the desert, and surf on the Pacific coast all by traveling only a few miles.

Everyone can enjoy a day in the country and get the benefits nature has to offer. For the artist, though, painting out of doors is an even more powerful experience. The artist must look at reality in a special way. If the painter sees more deeply and intensely, it's because he or she must look harder. Artists need to train their eyes to see beyond the details and beneath the surface.

In reality, there are three dimensions. But when we paint, we are limited to two dimensions. The dimension of depth is just an illusion. Somehow we must look at our three-dimensional world and understand it so we can transpose it on to our canvas so convincingly that the viewer *sees* the missing dimension. If we succeed in creating an image of nature with the magical illusion of three dimensions, our pictures should have some of the same restorative effect on our viewers as a walk through the park or a seashore drive.

CHAPTER SIX

LANDSCAPES

Painting the landscape can be a very rewarding adventure. Once you've become familiar with the basic process of painting in the studio, you're ready to venture out of doors with your easel. Because there are more variables when painting outside than in the studio, it's even more important to do the right planning. Being able to work purposefully and effectively is necessary, and this skill comes with practice. Never feel discouraged by your first efforts. Give yourself time to learn. It gets a little easier and more satisfying each time.

As you travel around the country, keep a sketch pad handy. Make quick sketches whenever possible, or make mental sketches when you can't put them down on paper. Make a permanent record of what you saw as soon as possible, as our memories tend to evade us.

Anytime I sketch, I'm careful to show light direction. I make sure the shadows are placed in, including cast shadows. Not only does this complete the sketch, it helps me later when I develop a sketch into a painting. It's easy to switch the direction of the shadows if the light source is different.

My goal is to give you the advice and instruction that will make your experience of painting the landscape as pleasurable and rewarding as possible. I'll begin by analyzing the elements of a landscape—trees, rocks, clouds, sky. Then I'll show you how they all go together as I paint a variety of landscapes.

Remember that what we see—the reality out there that we want to paint—is a tool to creating a successful painting. We can never make an exact record of what we see, nor would we want to. If we wanted a mechanical image, we'd use a camera. But a painting is not a photograph. When we paint we must pick and choose from what we see, selecting those aspects of reality that will make an exciting painting. Every painting, regardless of subject matter, must start out with a good design. We have the freedom to be creative; we can improve upon what we see. Do not become so hung up recording reality that you forget to make a good painting.

Painting a landscape is more than just a great opportunity to create a good picture. There is something refreshing and invigorating about the special contact with nature painting out of doors provides. This majestic rock near Morro Bay has inspired me to paint it several times.

Hollister Peak
18″ × 24″

PAINTING TREES

We'll begin with trees. Although all landscapes have skies, it's easier to paint an adequate sky than fake a good tree. The trick to painting trees is learning to see them as shapes. Before thinking about how to match the green or how to render all the little leaves, think about what *shape* identifies the tree or trees you wish to paint. Pretend the tree is a flat silhouette and analyze which features give it a distinctive character. Every species of tree has its own general shape. Some are round, some triangular, some oval. Once you've identified the characteristic shape, think about what makes this *particular* tree unique. Trees, like people, have their own personalities; no two are ever alike.

Within the larger overall shape, can you identify the bigger masses of leaves? Rarely do you want to paint each leaf. Instead note how the leaves form big clumps and shapes. Some trees have masses of leaves like balls of cotton, others are more rectangular, and so on. Examine the way the trunk divides into limbs and branches. Again, each species is different. Look to see how the limbs appear and disappear within the masses of leaves. Don't be afraid to simplify. Often deciding what you'll leave out is more important than what you'll leave in. Many students overpaint the details on trees; they see too much! Or I've had students say, "I was only trying to fix it." Of course, you know what happened. They went too far.

Distance will also determine how much or how little you leave out. A stand of trees in the distance may best be represented by a few large shapes of color, sufficiently neutralized by the intervening atmosphere. A tree in the immediate foreground may need well-developed detail, unless, of course, it distracts from the center of interest.

Value is the next consideration. How light or dark your trees should be is all relative. If you want the trees to be noticed, greater value contrast will

This is a photograph of the scene that inspired the painting, right. Note how I simplified or altered what I saw to create an effective painting.

be needed. If you want background trees to act as a backdrop for an object in the foreground, they should be the opposite value. Atmospheric perspective will cause distant trees to be lighter in value and probably bluer in color.

Color, like value, is also relative. Tree color must be related to the colors around the tree shapes. The green of trees varies from tree to tree, and season to season. Matching tree color is one time to be sure to have your color combinations chart handy. In general, the greens of trees should be thought of mainly as grays—there are few pure green colors in nature. The color also needs to work with the rest of the colors in a painting's color scheme. Areas of color that are strong in reality may need to be adjusted for the sake of the picture. Good design takes precedence over copying reality.

In my first example, *Eucalyptus Trees*, I focused on one main tree in the composition. You can compare it with the photograph of the scene to see how I simplified and altered what I saw to create a more effective painting. In reality, the main tree was almost straight. I slanted it to give it a more interesting angle. I also placed more light behind the dark trees on the left of the canvas. The foreground was varied in value. I also showed the foreground grass taller to create more interest in the boring foreground. Cast shadows helped to keep the focal point secure. The light and shadow where the light is striking the main tree trunk tell the time of day and should read correctly.

In *Tree with Bay in the Background* I am dealing with a composition that involves a group of trees. Different from the first, this composition is more ordinary. The low horizon line shows most of the tree shapes and almost nothing is left out.

The day was slightly overcast, making most of the shapes appear two dimensional. Because the values were so subtle, I worked my composition to show three areas: the background where the bay and sand dunes are behind the trees; the foreground where the dark shadows come forward to the bottom of the canvas; and the middle ground where I emphasized the strongest lights and details. The trees group together to make an interesting pattern of trunk and foliage variations. I used stronger darks on the trees to the left. Also, the left tree mass is larger, since I did not want to center the light area where the bay is visible.

The branches are typical of a eucalyptus tree. I painted several young trees around the larger mature ones to give a more natural look. The day was cool, and the painting looks like it was. As I painted it, I was bundled up; the breeze coming off the water made me work fast to finish and get home.

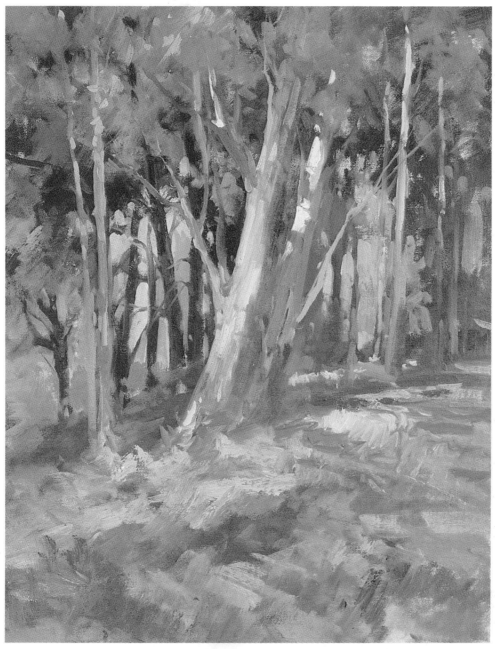

The road to the golf course in Morro Bay is lined with beautiful eucalyptus trees. They are an evergreen, but change a bit with the season. Their general color is a dark grayed-green hue, going a bit to the blue. The lighter overtones are warm, with touches of orange added to the dark undertones. Their bark has an interesting twisted appearance, which sometimes includes variations of colors. The bark appears light on most eucalyptus trees, but there are times when the trunks vary in value, going much darker. This twisted effect can be applied with a brush or overlaid with a touch of brighter color using a painting knife.

The all-over hue of the painting was obviously green, yet grays are of utmost importance. Without the various gray hues, the greens would not be believable. Soft blue-violet reflected light on the shadow side of the tree trunks created the illusion of turning. It also carried the blue of the sky throughout the painting.

Eucalyptus Trees
28″ × 18″

I enjoyed doing *Sweet Springs Pathway* because the composition is a bit out of the ordinary. The trees are located high on the canvas with very little foliage; only the tree trunks say they are trees. There is a feeling of solitude to this painting, so I would call it a mood painting. When I planned this composition, I had originally decided to put a figure or two walking on the path. When I completed most of the composition, I felt that had I used figures as I originally intended, I would have spoiled the feeling of serenity.

To reinforce the mood, I wanted to give the painting a feeling of deep space. I wanted the viewer's eye to be pulled into the composition. The pathway making a zig-zag curve is an easy entry into the composition. Areas of light formed carefully-placed, imaginary stepping stones for the eye to follow on its way into the picture. At the same time, I located a darker mass behind the trees on the left as a rest-ing point for the eye, so it would not wander out of the scene on that side. To keep the focus on the end of the path, I placed a patch of sunlit foliage as a magnet for the eye—the payoff for the viewer after the journey down the pathway. I painted the distant trees a light, cool hue so they blended well with the background sky color. Had I painted them in stark contrast to the value of the sky, they would have formed a very strong, visually distracting pattern.

The trees are subtle, yet I grayed and lightened the more distant foliage, bringing the darker foliage closer to the viewer. Color changes were subtle, yet deliberately painted. I did not merge the values even though they were subtle. My overall palette for this painting consisted of cerulean blue, viridian green, cadmium red light, cobalt violet, cadmium yellow light, and, of course, sap green and alizarin crimson. I used white throughout to keep the soft gray feeling of an overcast day.

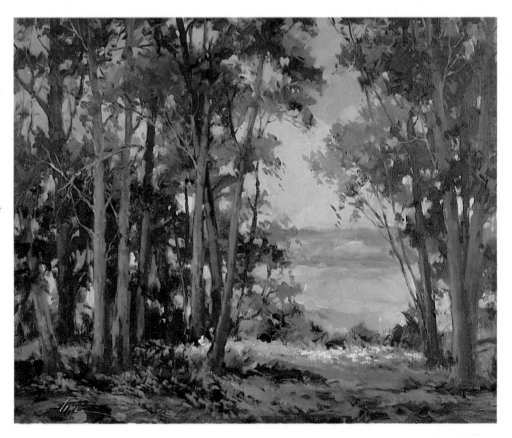

Trees With Bay in the Background
24" × 30"

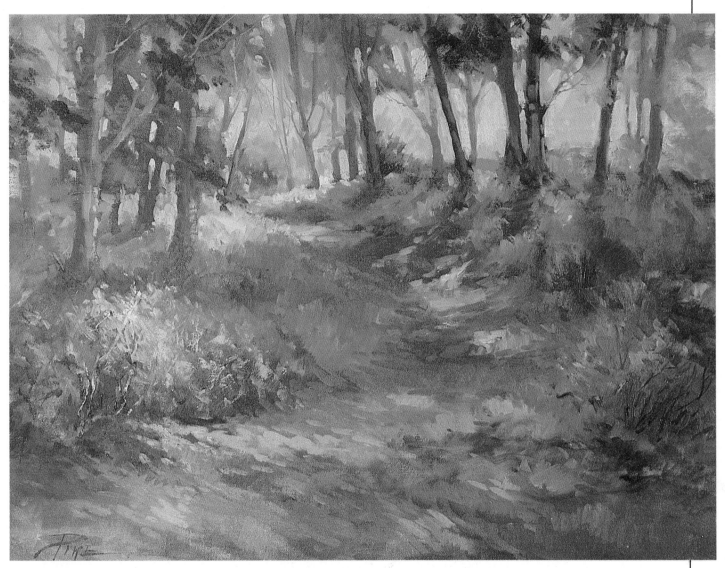

Sweet Springs Pathway
24″ × 20″

I first toned the canvas with a dark red-violet acrylic. When it was dry, I switched to oil paint and placed in the blue-gray sky area using cerulean blue grayed with a touch of cadmium orange and lightened with white. The purpose of the dark red-violet undertoning was to keep the painting dark, yet allow a beautiful violet hue to peek through. As I scumbled green shrubs over the tree-shaded foreground, I varied my mixture, using viridian green grayed with either cadmium red light or cadmium orange. I added some blue tones for variation, as well as to tie the sky color with the foreground. The pathway had bits of the original wash peeking through as I scumbled grays over the intense color. I varied the tree trunk values by using a dark mixture of sap green and alizarin crimson for the darkest trunks and adding white where lighter tones were needed.

I grayed the foliage area of the trees to show distance. For this I used ultramarine blue, cadmium red light, cadmium orange, and a bit of white. The blue must dominate, yet stay a soft gray. The tree trunks held the main interest with their strong contrast against the lighter sky. Touches of sunlight hit the green grass near the focal area, adding light to break up the dark masses.

PAINTING ROCKS

Rocks can range from giant granite cliffs or large boulders to the tiniest pebble on the beach, so it's difficult to generalize about rock formations. Every situation is different.

Rocks are often used to break up negative space in a painting. They can also become the main subject in your painting. Whatever subject we paint, we must understand our object's basic form before we can attempt to paint it.

Most rocks are loaded with angle changes. Some take on the shape of a wet cardboard box, slightly square or rectangular with rounded corners. Some rock formations have a shalelike appearance, showing layers of compaction that took thousands of years to make. It would be difficult to draw each individual rock separate from the mass. It's better to select only a few to show the angle changes.

A good way to plan and proceed when painting rocks is first to decide on angle and size. This can be done either as a definite line drawing or as suggested shapes using the brush and paint. The next step is to separate values. Without this, you have only masses, not form. Rocks should first be considered only as lights and darks. They almost paint themselves if you think of them as only values—not objects.

Color is the next step and can differ depending on location, situation, and dominant hue of your painting. Some geological locations will show rocks as reds, while rocks in another location will take on a blue hue. Value is another big factor. Rocks near the sea often look very dark, while rocks in the desert may be almost white. I have found it beneficial to add a tiny bit more color to rocks than what I actually see. It seems to make them more believable.

A good way to practice painting rocks is to collect a few interesting rock shapes from about 6 inches in diameter to some a bit smaller. Arrange them in an interesting, natural way and place a flood light to one side.

I have always been intrigued by rocks that hang precariously over a cliff or rocky ledge. Some look like they will fall with the slightest disturbance. On one of my trips to New Mexico I spotted some interesting rocks that hung out far enough to show a beautiful warm reflected light on the underside of the large protruding boulders. As I planned my composition, I decided to show the protruding rocks high on my canvas. By using a low horizon line, I could exaggerate the angle and place more emphasis on the height. I played down all the ground cover by going gray and using vertical strokes to suggest brush.

I left out a few rocks on the hill to make the large boulders more important. The entire painting is in various grays, which support the grays used for the rocks. The painting is dominant blue to blue-green in the brush to blue-violet in the sky. The complement orange is subtle, except in the main subject—the large boulders.

Then suggest them in many different size studies, from huge boulders with a running stream to a small group of rocks that may be surrounded by shrubs. Remember that rocks should be relative to what is around them. There are many different structural conformations. Take a sketch pad on a walk and draw rocks from nature.

If you plan to paint rocks in your studio from a photograph, it's always best to research the real thing as much as possible. The tool used to paint the rocks can greatly change the effect. A loaded brush gives one effect, while a painting knife can give another. Many people love to work with a painting knife. I enjoy both. However, I like to establish my main value structure before I overlay with a knife. I use a knife mainly when I'm painting a landscape, but I do not have any hard and fast rules.

Here we have a good example of rocks that are massed together. To make them work in a painting, I needed to bring another element into the composition.

I chose a slide from my file with water as a supporting element. Notice in the photograph that the rocks are all of the same importance across the top three-quarters of the picture. When I composed the painting, I had to make one side dominant, letting the other side drift into shadow. I chose the left center for my focal area—this would have the strongest statement or detail in the rocks.

In this study, eye level is of little importance. Each rock is turning in a different direction, and distance is not a factor. Each rock must still be seen in perspective; yet it is not necessary to know where each angle meets the horizon.

I chose to go slightly warmer in color than what I saw in the photograph, which seemed a bit colorless. I used an oil wash of cadmium red light and sap green over my 16″ × 20″ canvas (40 × 50 cm), mixing more red than green. I added enough green on the right corner to create the proper dark, as well as go gray. I then started selecting rock shapes out of the mass, giving the rocks in the foreground the most importance. Three sides of most rocks will usually be visible, depending on the angle at which you see them. The value change will be slightly different for each side, but this is necessary to make the rocks believable. Rocks do not have to be painted in detail to work. They will work even if only a few well-chosen strokes are painted correctly.

When I painted the water, I used softly grayed greens beneath the light foam overlay, mainly to keep the water a supporting object and not take the eye away from the rocks. There is not even a twig or blade of grass in this study, yet it sets a mood.

I know you'll enjoy painting different kinds of rocks. They're all around us when we paint outdoors. We can't really avoid them.

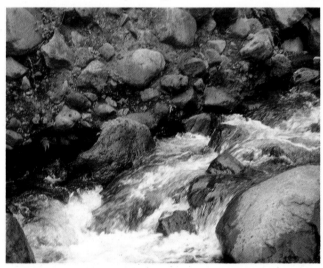

Because sunlight can be very diffuse, it is sometimes necessary to strengthen the contrast of areas in light and shadow to create a definite direction for the light source. In this photograph, it's not clear where the light source is. Nor is the scale of the rocks easy to determine.

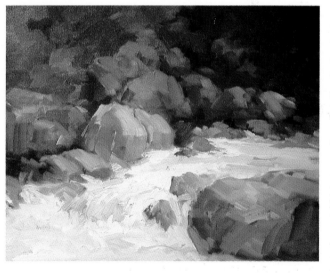

I altered both the overall coloring of the rocks, making them warmer than what I saw, and the contrast of values to make the rocks more believable.

Rocks and Water
14″ × 18″

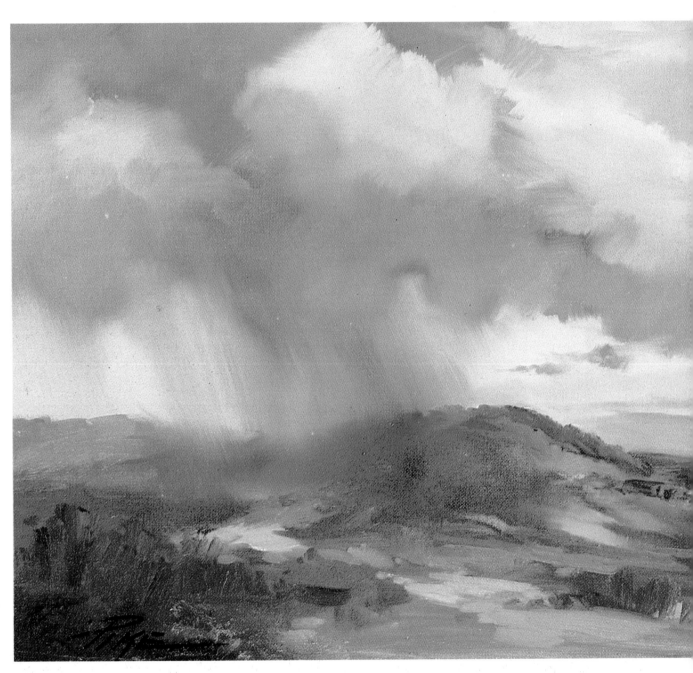

I did this painting on one of the trips I made to Santa Fe, New Mexico, with three friends. We had been driving around trying to decide what the weather was going to do before we got out our gear. We had driven up a road that gave us a beautiful view of the valley. Dianne was driving, and she stopped the car so we could get out and take pictures. I pulled out my French sketch box easel and quickly set it up. I had a 12″×24″ (30×60 cm) canvas board in the car, and with bold, quick strokes, I captured the oncoming storm. This painting was spontaneous, but I didn't want to miss anything important, like the cloud shadow pattern on the hills. This was meant to be a record of what I saw. When I got it home, I didn't touch it, even though I'd done it in fifteen minutes.

CLOUDS AND THEIR MOODS

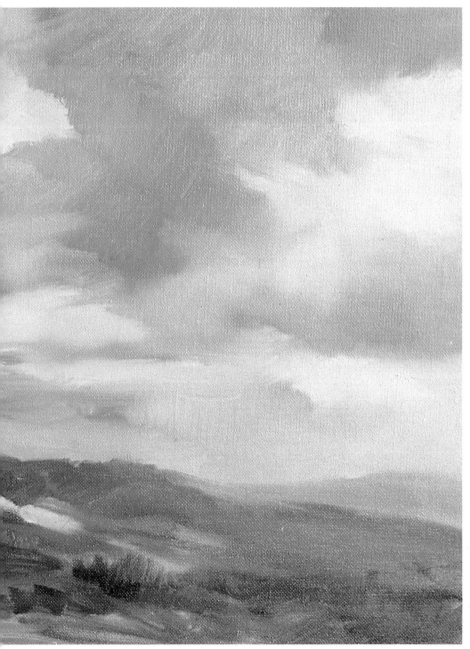

Stormy Sky in New Mexico
15″ × 30″

The sky is as much a part of the land-scape as the ground. Think of the sky as a dome, much like a huge overhead bowl. The most intense color is near the center of the bowl, or what would be the overhead sky, with value and color diminishing as we look to the horizon.

There is a mist or vapor that forms over the earth, making the values merge in the distance. Color changes from blue overhead to blue-green as the sky moves toward the horizon. You often see pink or violet at the most distant point. When the horizon is visible, the earth vapors will seem warm in relation to the cool blue of the overhead sky. Remember: Every-thing is relative; most colors are grays in some degree. Their temperature is determined by what is around them.

I often use clouds in a dark or light mass to balance a painting. The dark-est cloud masses are nearest you. They change value as they recede, gaining a soft blue tone. If the sun is still high in the sky, the clouds will appear darker on the bottom and the most color you will see is a soft pink glow at the horizon. This is a generality, yet it seems to hold true most of the time. Light and shadow are as impor-tant in clouds as in any other part of your painting. Plan it well.

Clouds can show tints of every col-or you have on your palette. They come in hundreds of interesting shapes, including the following:

Cirrus clouds: These are the highest clouds, which look like vapors high in the sky.

Stratus clouds: These flat clouds ap-pear to be in layers. They are most of-ten seen toward the horizon.

Cumulus clouds: These fluffy white clouds are often seen after the rain. The bottom of cumulus clouds is flat-ter than the tops, which look like great mounds of cotton balls.

Nimbus clouds: These rain clouds, dark and heavy with moisture, usually cover the entire sky. When you ob-serve them closely, these clouds look like many soft gray layers, which be-

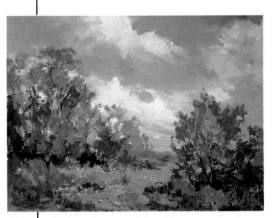

Clouds can often balance the other lights and darks in a composition. Notice how the sky color is most intense near the top and diminishes in value and color toward the horizon.

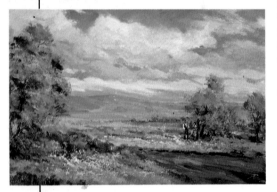

come darker the nearer you are to them.

Clouds are much like snowflakes. Their structure can be generalized, yet each is unique. There are several combinations of the basic cloud structures. *Cumulonimbus* is one of them. Often called thunderheads, these appear in the distance as billows of white. One of my favorites to paint are *altocumulus*, commonly called *mackerel sky* clouds, which look like puffs of cotton dotted across the sky.

Clouds do not merge one into the other as they recede to the horizon, but are in layers, each changing value as it comes closer to you. The darkest clouds usually appear higher in the sky. Study clouds before, during, and after a rain. Take photographs to refer to. Make sketches and take notes. Do not just paint what you think you see. Good information and lots of observation is still your best guide.

Don't forget that clouds often cast shadows. When overhead clouds are lit by the sun or the moon, you will see cloud patterns on the ground. If the clouds are at a distance, the shadows will only be in the area where the clouds are. If the clouds are only on the horizon, you will not see any shadow on the ground.

The sky is always changing. Clouds never sit still! When painting sky and clouds, you need to rely on both your knowledge and your short-term memory. Often you'll select sky colors and cloud formations from what you see and then rearrange them to create a good composition on your canvas. For example, once I was driving to teach a class after it had rained all night and I watched a sky full of cumulus clouds moving slowly toward the horizon. A few dark, moisture-filled rain clouds broke up the larger mass of white. When I arrived at the studio, everyone was standing outside looking up at the beautiful sky. The class voted

unanimously that the subject of the day would be to paint the sky after the rain. I took an easel to the parking area and had the class watch me paint *Abandoned*. I took the class through a preliminary explanation of what was taking place as the clouds moved slowly out of view. I chose a low horizon to place more importance on the sky. Before putting any sky color on the canvas, I planned the cloud pattern because I didn't want blue where the clouds would be placed, since this would be difficult to work over. After planning the clouds, I painted the sky, showing the variations of hues from blue down to green as the sky got closer to the horizon. I carefully blended each color variation. The cumulus clouds were a soft pink since the light was striking them from the top and making the underside gray. To clarify my process, I took the cloud formations from what I actually saw, but I worked out the pattern to make a good composition. I deliberately underplayed the landscape to stress the importance in the sky.

Personally experiencing different weather conditions is part of landscape painting. You will never be able to control weather conditions when working out of doors. To get what you want, you may have to put up with discomfort. When I paint in the cold, I work fast before my hands freeze. I wear gloves without fingers. They help but they don't get rid of the problem. For example, *Stormy Sky in New Mexico* was painted in fifteen minutes. I wanted to capture the rain falling from the huge cloud formations. Clouds can be composed in the studio and painted as they should look from our imagination, but there is nothing like painting the real thing. Being there to see, feel, and paint is far more inspirational, as well as informative. It's not the time it takes to paint, but getting good results that is important.

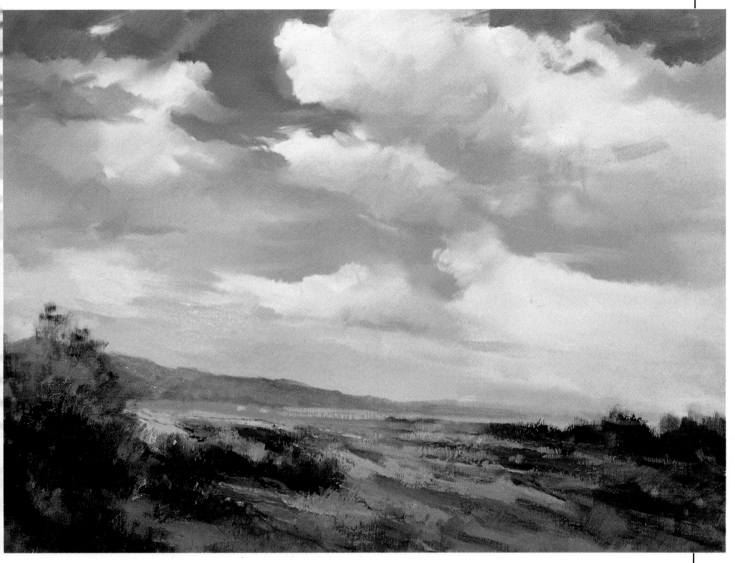

Abandoned
24″ × 38″

Before I put in any sky color, I planned my cloud pattern because I did not want blue where the clouds would be placed. After I planned their placement, I painted the sky, showing the variations of hues from blue to green as the sky grew closer to the horizon. The blue sky overhead was almost pure cobalt blue. I did use a touch of cadmium red light to soften its intensity a bit. No white was added at this time. The middle value blue is cerulean blue and white, with viridian green and white nearest the horizon. The cumulus clouds were a soft pink hue, with the flatter underside a gray mixture of alizarin crimson, viridian green, and white.

I used sap green and alizarin crimson to make the large shrubs. For the distant mountains, I used cobalt blue, cadmium red light, and white with a touch more red on the light-struck side.

The earthy tones needed for the ground and cloud shadows were sap green and cadmium red light, varied with a touch of cobalt violet and white. The various tints of color, such as the slightly pink-toned clouds, were cadmium red, cadmium yellow, and white. I continued these colors into the foreground to tie the painting together. Also, I used slightly grayed bits of soft cerulean blue to finish some of the sagebrush foliage.

Let's go to the sky for a last touch. The darker floating remnant rain clouds are alizarin crimson, viridian green, and white—the same mixture as I used for the shadow side of the clouds, only a bit darker.

THE DESERT AND ITS MOODS

The desert is one of the most fascinating places to paint. Perhaps to many people, the word "desert" conjures up an image of harsh, empty land, and it might seem an unlikely place to find really interesting subject matter. In fact, the desert offers an endless source of material. The desert is not unlike a person's face in its constantly changing moods and expressions. The desert is alive with color, often in various shades of gray, but still full of color. I find looking at the beauty of the desert an experience difficult to describe. I hope when I paint it, I capture some of the same solitude and subtle beauty that thrills the inner soul.

Once a year a group of California artists gets together to paint the desert near Palm Springs, California. We usually take two days for the paintout, although I sometimes take an extra day or two depending on the weather. On this particular trip I took along two of my friends as traveling companions. Sarah and Joan were also my students. We had a great time. Both Sarah and Joan were planning to paint, but decided to watch me instead on the first day.

We arrived early, about 6:00 A.M., as the sun was just coming up. Several of the group were already set up and ready to start when we arrived. If you plan to paint the desert, it's best to arrive early or late. The cast shadows are usually an important part of a desert painting, and they are at their best angles in the early morning or late afternoon.

It's great to have friends with you when you go out to paint. The companionship makes painting outings more fun, and besides, they can help carry your gear! We had to walk a ways to get the best view of the back mountains and buttes. The buttes are the volcanic formations that look a bit like huge lumps of coal. The distant mountains are various shades of gray, ranging from warmer grays for the nearer mountains to the blue-grays in the distant mountains. Most desert mountains have a barren beauty and more irregular shapes than mountains with vegetation. The sand and shrubs were great from any angle, although I did want to capture the rain-washed gully and its almost white sands.

After I walked around and explored every possibility for subject matter, I settled on what I wanted to paint. I usually use a large canvas on location so it's not surprising I chose a 24″ × 36″ (60 × 90 cm) canvas. I prefer to finish most of my paintings on location since I get a more natural finish and I seldom overwork. I work fast, and I'm sure it helps me be able to work large and still finish on the spot.

Joan and Sarah perched themselves on a rock and watched as I splashed color around on my canvas. When I paint the desert, I usually use a more intense hue for my undertoning. This helps bring out color when the gray is placed on top. I carry a spray bottle with my painting gear; any plastic spray bottle will do, but I like the kind that has an adjustable spray. First I spray the entire canvas with water; then I place a bit of paint directly on the canvas from the tube. Sometimes I use several colors, blending them or moving them around depending on the painting I plan to do.

For this painting, I used mostly a red-violet undertoning since I wanted some to bleed through. I planned to use violet as my dominant hue, and the red-violet showing through would make my gray tones more exciting. After covering the canvas with the vibrant red-violet hue, I gave it a few more squirts of water to make the undertoning run or drip a bit. This breaks the solid color I had previously placed on the canvas.

I let my canvas dry. All this took only a few minutes as it was now slightly after 7:00 A.M. and the sun was starting to climb a bit higher. The perfect time of day is in about an hour, when I will be starting to place my finished brushstrokes. While my canvas was drying, Joan, Sarah, and I had a cup of coffee.

With my canvas dry, I'm ready to get started. I mix various pots of gray, using several combinations of color and keeping some of the mixtures complementary to the red-violet undertoning. For example, I use yellow-green grayed with red-violet that produces a beautiful warm gray when white is added. I use all the colors on my palette to mix the grays, but the finished painting's dominant hue will remain violet. I wanted it to be more a blue-violet gray, with yellow-orange used in some areas for the desert foliage. I placed in a quick sketch using ultramarine blue—tinted turpentine—applying just enough pigment to let me see where I was going. Then I did a quick color wash to give me a key to the correct color and value changes throughout the canvas. Seldom do I use white when doing a wash, but this time I did. Because of the vibrant undertoning, it was necessary to control value as well as color. The addition of white in the first covering was absolutely necessary.

For the block-in I used large direct brushstrokes with a no. 12 bristle filbert brush. As I started to paint the distant mountains, I used a blue-gray, taking into consideration that there will be variations of subtle warm and cool grays when I finish the mountains. The middle range took on a bit of orange-toned gray, while the dark butte to the left of the canvas was almost pure pigment with only a bit of white in the gray mixture near the base of the mountains.

I worked over the rest of the canvas with a variation of gray mixtures, going slightly lighter and warmer near the center of the canvas to cover the undertoning. Later I corrected values and showed rocks, bushes, and foliage. I merely suggested the desert foliage at first and didn't add white to the gray-green mixture of ultramarine blue, sap green, and cadmium red light. Most of my block-in brushstrokes were directed vertically for the foliage.

I painted the cast shadows because they are important to the overall

Using the right gray is the key to painting the desert and its moods. For this painting, I used a red-violet underpainting that would peek through in places to make the grays on top more interesting. Before I painted over the undertoning, I mixed various grays. Most were variations of blue-violet, but I also mixed some very warm grays for the sunlit desert foliage.

Sunrise on the Desert
24″ × 36″

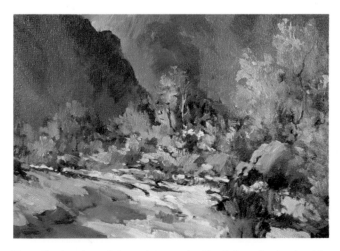

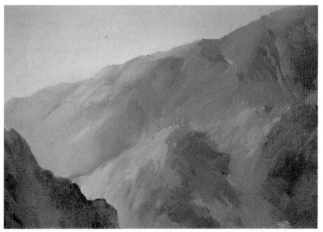

Here, the brushwork I used to render the foliage is clearly visible. The palo verde trees are a soft, grayed green. I reduced the contrast of values in the foliage so they wouldn't be too strong, yet strong enough to act as the focal point.

This detail shows the variety of grays I used, contrasting warm and cool to create the effects of atmospheric perspective on the distant butte and sunlight on the one in the center.

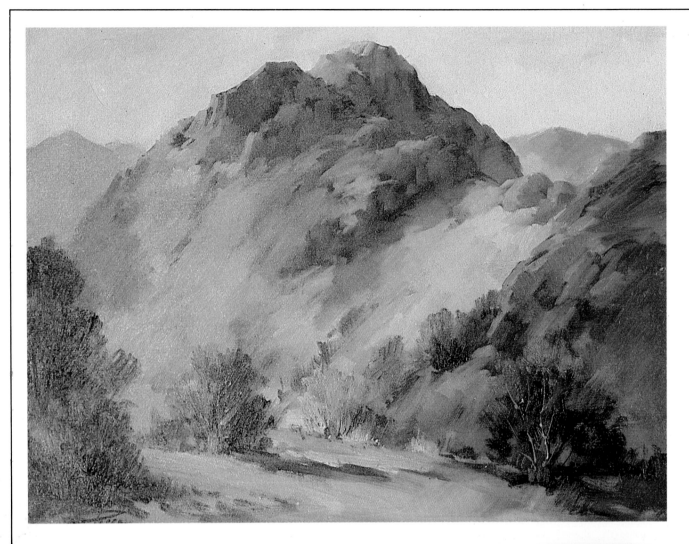

The butte was my first interest, since I could work in the bushes, rocks, and sand later when the light changed. The main thing was to capture the butte. I washed in the sky and back mountains with a soft light blue-gray, since it was necessary to have this area painted before I could do the main subject. Then I quickly selected darks from my palette or added to the mixtures when necessary. The sun washing out detail on the lower half of the butte and blending with the desert sands was the most exciting part of the scene I was painting. I quickly and carefully selected my warmer grays. The butte took about twenty minutes to a half hour to paint. Now I could take my time working the sand and foliage to be subordinate to the main interest.

La Quinta Butte
18″ × 24″

I used well-directed brushstrokes to show the irregularity of the rocky shapes at the top of the butte. Each mixture was carefully matched to reality and placed on with a definite direction in mind. If the brushstroke is varied, it can convey the angle change necessary to give a realistic look, yet retain a painterly quality. In other words, I used a free-style technique with a spontaneous, expert paint application.

statement, and I wanted to work out the values and colors before the light changed. The irregularity of the ground shows cast shadows across the gully. Shadows are also being cast from rocks and desert bushes. As I painted the cast shadows, I used a bit more blue-violet than what I actually saw since I knew I could tone it down later if needed. Without these interesting value changes on the desert floor, the painting would be monotonous.

I now have everything blocked in using correct color and value. This step took about one hour. The light is now perfect for me to start my finishing strokes. The distant mountains show soft ridges of various subtle grays. I directed each brushstroke to show the necessary value changes, going slightly cool on the shadow side and warm on the light side. Because the mountain range is in the distance, the value changes will be less obvious.

The mountain in the middle ground has a more obvious value change, and will show a bit more temperature change, so I added a touch more orange to the orange-gray on the light side. The dark butte has almost no white and little detail. It's a challenge to paint the mist that rises from the earth. It seems more obvious in the desert. All values become lighter at the point where the mountain meets the ground.

Now with a smaller no. 6 or 8 bristle brush, I started to finish the shrubbery. Most of my strokes are vertical and not heavy. I like a more sketchy look for desert foliage. I paint the rocks as simply as possible. Each brushstroke is directed to show light or shade. I also merge values slightly.

Now I use touches of such color as pure cadmium yellow light or thalo yellow green on the foliage to add sparkle to the all-over gray hue. I wanted the foliage to be the focal point, yet stay subtle. The finished work should read subtle, with nothing

standing out like a sore thumb.

I felt good about what I'd done and turned to see Joan and Sarah's reaction. Joan said, "I really like it. You kept it all so subtle."

Before Sarah could comment, I asked if either of them had any questions.

Sarah said, "Joyce, could you have achieved the same look if you had started on a white canvas?"

"No," I replied, "it takes the brilliant underpainting to work with the grays to get the look I want. Remember: I work fairly thin and this lets a bit of the undertone come through." Then I asked, "Well, Joan and Sarah, is it finished? Shall I quit?"

Joan exlaimed, "It looks great! I think we should eat. All this watching makes me hungry!"

After a midmorning sandwich break, I took a short walk around the area to see what the other artists were doing and visit for a few minutes. Joan and Sarah were getting out their gear to start their paintings. As I walked around, I spotted this beautiful butte just waiting to be painted. By this time it was about 10:00 A.M., and the sun had risen a bit too high to show strong contrast. There was something special about the way the butte was being hit with all that light, making the darks at the top stand out against an almost misty blending of values.

I still had my easel up and I hadn't cleaned my palette, so it was easy to pick up and move to the spot where I would paint the butte. The 18″ × 24″ (45 × 60 cm) canvas had already been toned with violet. In fact, I had painted on it previously and wiped it off because I didn't like what I had started. I often carry canvases like that with me on paintouts so I can practice different subjects.

I knew I had to hurry before the sun got any higher since it would soon wash out all my values. Since my palette was still full of gray mixtures from the first painting, it was easy to

select grays and get a quick start. I usually clean my palette several times as I work, so I don't advocate you follow what I did here. It can cause muddy tones. Yet, for this painting, I had no choice. I had to rely on what I had previously mixed, at least to start. I only worked until noon or a little after. Then while everybody suffered in the heat of the day, I went back to the van and took a nap. By then I'd already finished two paintings.

SEEING COLOR IN THE DESERT

The best time to paint the desert in California is in April or May. If you plan to go later in the summer, you may have to hide from the heat or run away from a lot of wind.

I took a class of twelve students on a traveling workshop to Palm Springs, California. I purposely did not want a large class. I arrived a day ahead of the students and drove around town to pick the best spots to take them. I selected two locations near town, yet you'd never know it to look at the paintings. It was the first day of May and the wild flowers were beautiful. It was exciting to see the desert verbena so prevalent.

One spot was an open field near town that had verbena-covered sand dunes and a few desert sage bushes. I liked the spot because it was simple. I wanted the students to learn to compose an interesting painting given simplicity of subject matter.

Our first day on location was beautiful. Since we were all staying at the same motel, we made a caravan to the spot. There was plenty of parking and room for each person to place his or her easel and not have to look over someone's head to see what they wanted to paint. I planned to do a demonstration to show the class how I would paint the scene. I also wanted to show the students how I directed my brush on the canvas to achieve certain effects.

I chose a simple composition, balancing a few sage bushes and desert shrubs with a simple left-to-right angle of one main sand dune. When your subject is subtle, without a lot of contrast, choose your pattern of light and dark well—usually the simpler the better. It really doesn't matter how subtle the subject is, it's the balance of objects that makes the difference. If you have any doubt about how you want to go, do a few thumbnail sketches showing different patterns of light and dark or a color composition or two. They'll help you make a decision.

I began by placing an oil wash of cadmium red light and sap green thinned with turpentine over my 18″ × 24″ canvas. I wanted a soft gray tone so I used little color. Then I selected the angle for the sand dune. I did not want it to be an obvious single mound, so I used only a part of the curved dune. My main thought in doing this was to stay away from any horizontal lines. The way the verbena trails down the sand dune is typical of its growth.

After I selected the angle I wanted for the sand dune, I blocked in all the foliage. The pattern of foliage is mainly to create a good composition, not necessarily to show bushes as such. I needed it to break up the light sand. The dark mass of foliage at the upper left corner helped me put more emphasis on the curve of the sand dune. Then I painted the sky, using the same cerulean blue, cobalt violet, and grayed blue for the cast shadows in the foreground. Then I blocked in the foreground tree so that when I painted the light sand I could make each stroke a final one. The fewer the brushstrokes, the cleaner the paint. The sand was a light, slightly warm gray. After the sand was in, I placed a few finishing touches on the foliage, varying the hue slightly to show where the light struck it.

Finally, I painted the verbena. I used floral pink, with a touch of cobalt violet for the verbena in the light. I chose alizarin crimson and white slightly grayed with a tiny touch of yellow green for the verbena in shadow. I placed in a slightly darker line under some of the verbena using alizarin crimson and sap green mixed with the floral pink.

This study took less than one hour from start to finish, yet every area was related. It just proves it's not the time spent, but what you do with the time that counts.

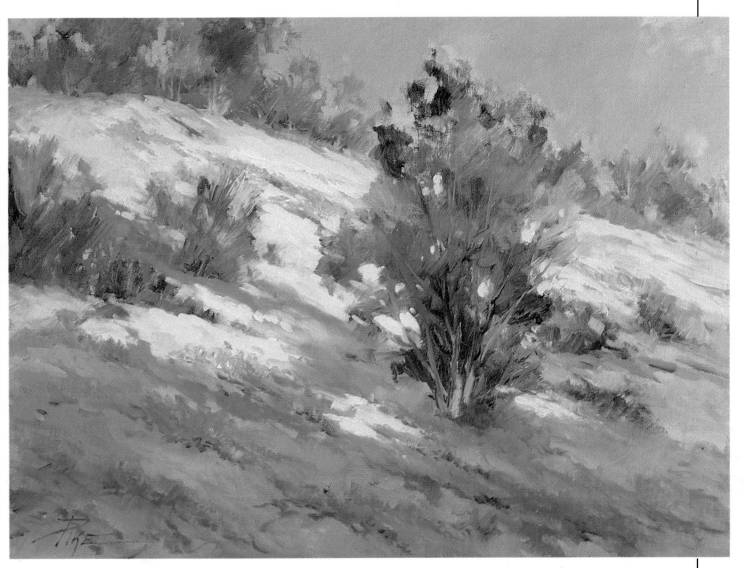

Desert Verbena
18″ × 24″

First I placed an oil wash of cadmium red light and sap green thinned with turpentine to give the canvas a soft gray tone. After selecting the angle of the dune, I used a combination of sap green and cobalt violet to block in all the foliage. Next came the sky. For this I used cerulean blue, cobalt violet, and a tiny touch of cadmium orange and white. I also used it for the cast shadows in the foreground, which I adjusted slightly with a touch more violet. I blocked in the light sand, using a mixture of cadmium red light, sap green, and white, after painting the tree in the foreground.

I painted the verbena in light with floral pink and a touch of cobalt violet lightened a bit with white. The verbena in shadow was alizarin crimson and white, slightly grayed with a tiny touch of thalo yellow green. A slightly darker line of alizarin crimson and sap green mixed with the floral pink made the verbena cling to the ground.

The spot I chose for our second day was close to the motel. It was beautiful: a flat desert area covered with patches of blue wild flowers and broken up with an occasional grouping of California poppies. The thing that interested me the most about the spot was the way the earth had eroded, showing a huge arroyo beneath the upper flower-covered plateau. Soft mountains could barely be seen at a great distance. A few more patches of blue flowers were far enough away to read only as touches of color.

Sometimes it looks as if you see the same color throughout the entire area you're painting. Most of the time, it's not the same color; it just looks that way. A good way to prove color or value change is to go to your local paint store and get a few color swatches—a range of ten or twelve colors will do. Be sure to get some cool blue-grays and some warm grays. As you observe the spot you plan to paint, hold up your samples until you can select one that is the nearest match to what you see in a distant sand area. Now compare that swatch to the foreground. Usually, the foreground will be darker or more intense in hue than the distance.

After we had selected our spots, I had the students group around me for the demonstration. I began by placing a soft turpentine and raw umber toning over my canvas. After the undertoning dried, I did a loose, quick block-in of the painting. I mixed three pots of paint: 1) cerulean blue, cobalt blue, cadmium red light, and white to produce a soft blue-gray; 2) cadmium red light, cadmium yellow light, and white to make a soft orange hue; 3) sap green, viridian green, cadmium orange, and cadmium red light for a

mossy green hue. I placed these three pots of paint far apart on my palette so I wouldn't confuse them. I next did a soft drawing using a bit of the dark green mixture thinned with turpentine.

After placing the horizon line on the upper two-thirds of the canvas, I started placing the sky with my blue mixture in the upper right-hand corner of the canvas. I applied the light orange mixture to place in the windswept clouds covering the remaining sky area. I used the same brush I had used for the sky without cleaning it, since I wanted to add a light tint of blue to my light mixture. I used the same blue sky mixture for the distant mountains as well as for all the blue wild flowers. I worked in the green mixture for the initial block-in of all the bushes, adding a touch of sky color to the distant foliage to show distance.

The shadow sand color is a combination in equal parts of the warm light and cool sky colors. I also used some of this soft gray for the foreground shadows. The sand is the lightest area, so I used the light orange mixture for the farthest distance, or the horizon. I added a tiny touch of the shadow sand mixture as I painted the sand from back to front, slightly darkening the sand in the foreground.

At this point, having covered my canvas, I selected value and color changes to complete my composition. I don't want to add detail or touches of color at this time. It took me about thirty-five minutes to complete this much of the painting.

The class worked about four hours, with me constantly reminding them about the changing light. I wanted them to get a pattern of light and

stick with it rather than to keep changing it as the light changed. We finished about 2:30 P.M. The desert heat had taken its toll on both student and teacher.

I left my easel up so I could finish the painting after class. It's amazing how fast the hot sun dries the paint. I really enjoy working over a dry base. I can get some interesting effects when the coverage is not so solid. I had finished the sky area on the block-in so I went directly to the flowers and foliage.

Now using more of my palette colors, I added thalo yellow to the light-struck side of the large clump of bushes nearest the center of the canvas. I did not change the shadow area. It was complete on the block-in.

The palo verde trees were showing touches of bright yellow blossoms. Although the distant trees were too far away to show much color change, I did use a bit more yellow where the light struck them. The shrubs in shadow stayed as I had done them in the original block-in. As I started to finish the flowers, I selected a smaller, no. 6 bristle filbert brush. With a few short vertical strokes, I placed in a few of the blue flowers with cerulean blue and a touch of white for the strongest light, going a bit darker for the flowers in the foreground shadow area.

I placed a few desert shrubs in the foreground with a combination of cadmium orange and the dark green mixture. I used a bit of the dark mixture to anchor the shrubs to terra firma.

As I finished the demonstration, I turned to find several very tired students watching me. Some had already headed back to the motel for a swim. We had two great days painting the desert.

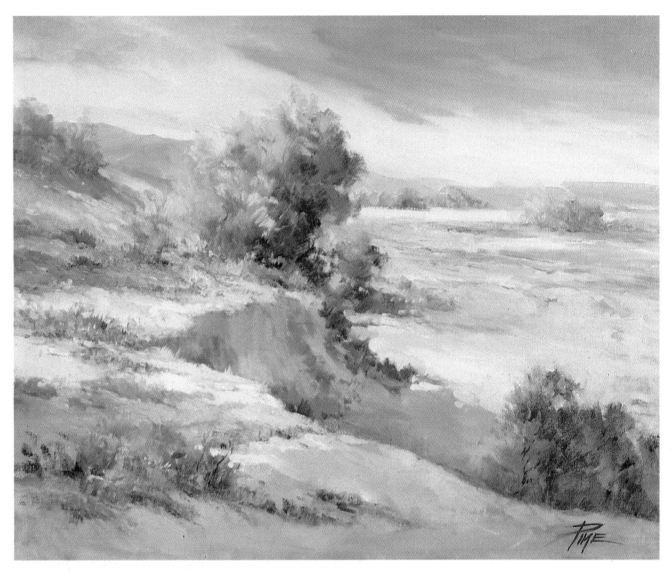

After I toned the canvas, I mixed three piles of color, a soft blue-gray, a soft orange, and a mossy green. I used these three to block in the painting. I used the blue mixture for the sky; the orange for the clouds; and the green for the foliage. I combined the green mixture and the blue mixture for the sand in shadow and the foreground. I used the soft orange for the sand at the horizon.

Desert Wildflowers
24″ × 30″

PAINTING THE PANORAMA

There is a very impressive mountain near the golf course in Morro Bay, California, where the panoramic view is breathtaking. Two different years and seasons I worked from a high perch near the top of the mountain to do a panoramic view of the bay. You can see how much taller the trees to the right have grown when you compare the two paintings. The earlier scene, *Panoramic View of Morro Bay*, is much warmer because it was painted on a beautiful blue summer day, while the other scene was painted on a cooler winter day. For that painting, entitled *Morro Bay in Winter*, I used my regular palette, with the addition of thalo green and thalo blue.

The compositions are slightly different; it was not my intention to make

them alike. In fact, the opposite was intended. Whenever you're successful in a painting, you may find it tempting to reproduce it several times. But be careful. Don't gloat about your success. If you find you're compelled to go back to a scene and work, make a few changes, like taking it from a slightly different angle.

After I started *Morro Bay in Winter*, I wanted to get my work done quickly and get home. It was cold out there! I put a soft oil toning of cadmium red light over the entire canvas using only turpentine. I knew if I used thalo colors, their intensity would be quieted down by the red-orange wet undertoning. I used cerulean blue and a touch of cadmium red light plus white for the sky and water. As I planned the

darks for the trees, I used one main mixture of thalo blue and cadmium red light plus white. I adjusted the value as needed, going slightly darker for the water. For a tint of pink over the distant mountains, I used cadmium red light and white.

I also adjusted color by changing blues where needed. For instance, I added a bit of ultramarine blue in some areas instead of the thalo blue I used throughout. This adjustment helped break up the all-over sameness of the trees and bushes. I painted the extra strong darks of some of the trees with thalo blue and cadmium red light plus a touch of thalo green. I carefully painted the trees over the blue water and sky undertones. I knew it would be all but impossible to move those

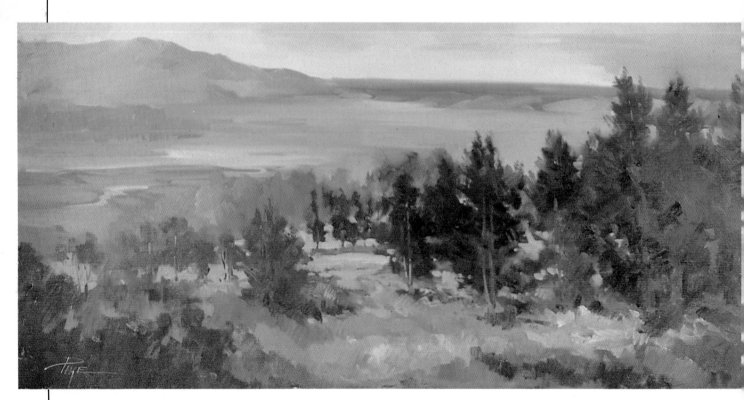

Morro Bay in Winter
24″ × 36″

I painted this painting quickly because it was cold! The winter season determined the cooler colors. The cooler colors, in turn, determined my use of a warm underpainting. I kept the colors a bit more closely related in value in this view. Remember that the key words are simplicity and unity.

darks around once they were put in, so I was careful about their initial placement. I made slight variations in the distant trees with a touch of white.

For the distant mountains, I used ultramarine blue, cadmium red light, and white. The mountains were a bit bluer than the slightly warmer tones of the muddy portion of the bay on the left. To warm this muddy area, I used a bit more cadmium red light and also added a touch of cobalt violet. I also used violet tones in the foreground bushes. The touch of soft green near the center of the canvas is the golf course fairway. For this, I used thalo yellow green and cerulean blue slightly grayed with cadmium orange and white. I used cerulean blue and cobalt violet for the foreground shrubs.

One important thing to remember when painting a cool picture is to keep all colors closely related. Do not jump around with too many colors. The key is simplicity. This entire painting took less than one hour. I was pleased with the results and did not touch it again.

The Panoramic View of Morro Bay shows the warmer day. The distant bay is almost violet in hue, with a bit of blue-green in the sky. A bank of pink-toned fog peeked around the distant mountain, giving a warm feeling to the sky.

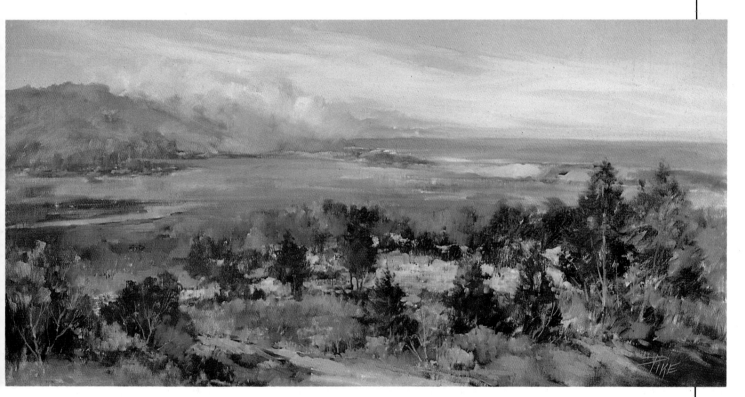

Panoramic View of Morro Bay
24″ × 18″

I did this painting on a warm, clear sunny day. The colors are warmer overall, with more contrast between the dark cool shadows and the bright area of sunlight. The focal area is the yellow green near the dark trees.

SEARCHING FOR SIMPLICITY

My subject is sand dunes in Monterey, California. I packed my traveling gear with only things I could carry comfortably, since I would be doing the painting out of reach of my car. I felt a bit like I was in the middle of the great Sahara desert, and it was just a matter of choosing one or two dunes to paint out of the hundreds there. It wasn't necessary to reproduce the exact scene I saw before me, but I wanted to convey a good composition out of the maze of dunes covered with beautiful ice plants.

After I set up my easel and had everything at easy reach, I began to search for the perfect spot. I have always enjoyed painting a simple subject; it's much like hearing a beautiful lullaby. The simplicity provides tranquility. The problem of painting sand dunes is how to handle a simple subject with sensitivity.

I have three separate paintings of the same area that show the different moods I was in when I selected my subject matter. All three show slightly different painting techniques. *Ice Plant-Covered Dunes* clearly shows more detail and a busier composition while *The Dunes of Monterey* and *Asilomar Dunes* are handled more like closeups. Yet all three work as separate paintings. Many times I will do a small painting with a simple composition and spend most of my time on a larger, more complicated painting only to find when I'm finished that I prefer the small, less labored study.

When I choose subject matter, I pay close attention to the shadows because they convey form. Form is most important in a simplified subject, since everything is as you see it. For instance, the patterns of darks as seen in foliage stand out like a sore thumb against the light sand, so they must be carefully planned.

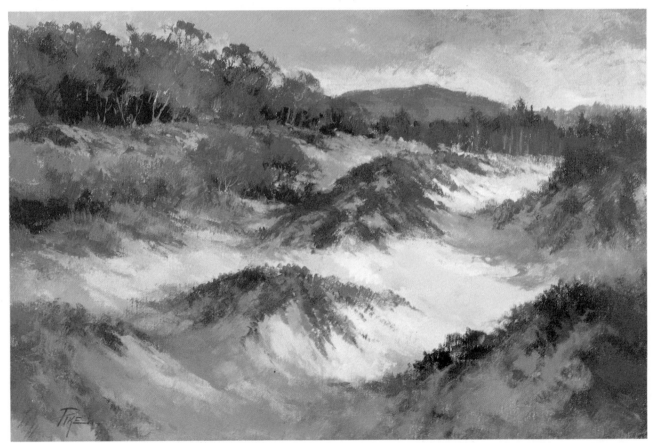

This painting of the white sands of Monterey draped with rust-colored ice plant was done exclusively with acrylic paints. I usually carry a limited acrylic palette with me at all times since I use acrylic so much to tone my canvas. My palette was the three primaries—Grumbacher red, cadmium yellow light, and cobalt blue—with sap green, Thio violet, and a large tube of titanium white. When I find it necessary to use an orange, I mix it from Grumbacher red and cadmium yellow light. When I need a strong green, I use cadmium yellow light and cobalt blue. When a strong dark is needed, I use Thio violet and sap green. This can be cooled with the addition of cobalt blue.

Ice Plant Covered Dunes
24" × 36"

This small 11″×14″ (28×36 cm) canvas was one I enjoyed doing the most. Here's a run-through of my color mixtures. First, the sky mixture is cerulean blue with a touch of orange and cadmium red light. I added white for the correct value. The lightest of all the mixed values is the white sand—a mixture of white, cadmium yellow light, cadmium red light, and only a touch of sap green to gray it slightly. The sand in shadow is a combination of light sand and sky colors. The ice plant is a mixture of Grumbacher red and sap green, varied from more red to more green. I used a small amount of alizarin crimson and cadmium red light for some of the more intense reds on the ice plant in light.

The Dunes of Monterey
14″×18″

Sand dunes are sand dunes, yet everywhere you see them there is something unique about the area that will make them appear different. These huge mounds of white sand near Asilomar, California, have ice plants that fall gracefully down the curves of the dunes. The lacy patterns are rhythmically beautiful.

I placed in mountains to show the distance in both size and color. I needed a shape to break up the curve of the large dune on the left so I placed in a smaller dune and grayed it so as not to take away from its beautiful white tone.

Asilomar Dunes
16″×20″

PAINTING BUILDINGS IN PERSPECTIVE

For city dwellers, which nowadays includes most of us, scenes with buildings are just as appealing and much more convenient than the natural landscape. I have always been fascinated with old Victorian houses, laden with gingerbread trim. The decorative complexity of these houses presents many irresistible views for the painter. On the other hand, I find old barns, sheds, and other rustic buildings just as interesting. My husband thinks it odd that I call an old wooden shack with weathered siding or the broken slats of an old fence beautiful, but to me, even though these structures are slowly giving way to time and are rapidly disappearing, they have much more character than the cold look of steel and concrete.

The most difficult aspect of painting buildings is creating correct perspective. Many painters have difficulty with this; needlessly so, I think. Perhaps because many books on perspective are too complicated and confusing, many painters are shy of tackling a subject that involves perspective. The trick, of course, is to keep it simple. For example, many of the old Victorian houses I like to paint have many eaves, gables, dormers, and bays that make it difficult to determine the angles and vanishing points. Here's a procedure for simplifying the problem that really works.

Almost every building has within it a simple rectangular form. I call this the "basic cubicle," to which all other shapes and additions are attached. Once you determine what this basic cubicle is, you can draw it on the canvas, usually with only two vanishing points. Then you can add on other architectural forms by simply comparing the angles by eye. Sometimes it's necessary to hold up a brush or pencil at arm's length, close one eye, and check the angle. Or you can always use a view finder.

Every time there is an angle change in a structure, there will be a new vanishing point. But if you keep comparing the angles to the ones in the basic cubicle, you should be able to locate the points without much trouble. Keep it simple, and take it one line or one shape at a time. Perspective needn't be difficult, but you must have patience.

Take a look at *Virginia City Castle*. Beneath all the architectural shapes and forms there is one long rectangular shape to which everything else is related. From the angle it was painted, most of the lines of the building converged at a point just off the left edge of the painting. Once I drew in the edges of the basic cubicle, I could eyeball the other shapes and angles.

Virginia City is a quaint old town in Nevada. The town was built on steep hills with narrow winding dirt streets during the Gold Rush. Most of the old buildings from that era have been preserved for future generations to enjoy.

I had just finished teaching a two-week workshop where each day I had twenty students painting on location in different parts of the town. One of my students decided to stay another day, and she and I went out to have some fun painting together. Painting with a companion is not only safer, but far more fun. Evelyn and I found time to enjoy each other's company as well as do our paintings. When you paint with a friend, you can share comments and advice. Someone else may see something that you might otherwise miss, such as a crooked window or door.

Since painting on location is almost a sure way to draw a crowd, Evelyn and I tried to find a back street, since neither of us felt like answering questions. I had certainly had enough of that during the workshop. As we drove the hilly back streets in search of a subject to paint, we could see the town far below. I spotted an old castle built by a wealthy gold mine owner. This beautiful old home overlooked the town like its regal name suggests. We set up our gear and went to work before the early morning light became overhead lighting by noon.

I chose a sketchy style of painting that I often use when I do buildings. First I applied an oil wash over my entire canvas. Since yellow was the dominant hue, I used Indian yellow, thinned with turpentine. I then used thinned ultramarine blue to do my sketch. It's best to draw with a color that will work with the chosen color scheme. Whenever the drawing is crucial, as it was in this painting, I use a bit more paint to produce a slightly stronger line drawing. I want to be able to see my drawing well before I start to paint. After carefully completing the drawing, I started to mix various colors without adding white, such as Indian yellow with a touch of cobalt violet to make a beautiful gray for the shadow side of the building. I can also darken this mixture by adding more cobalt violet. I used my favorite dark gray mixture of sap green, alizarin crimson, and ultramarine blue for strong dark accents.

I used several yellow-gray mixtures throughout the painting, all made with different combinations of pure cadmium yellow light, cadmium orange, and sap green with cobalt violet as the graying agent. Thalo yellow green, sap green, and viridian green were the only greens I used. For darker foliage, I added ultramarine blue and a touch of alizarin crimson to the greens to gray them. After I secured a color wash, I dragged my brush over the area to give it a loose, sketchy effect. Nothing in the painting took on a solid form. Everything had a more ethereal appearance.

After I was satisfied with the all-over effect, I added a few touches of almost pure white for a few needed accents, such as the trim around the doorway. I used subtle touches of soft blue as reflected lights. I added strong green accents to some of the foliage with a mixture of cadmium yellow light and viridian green. I laid in soft feathery strokes to finish the tree foliage. The finished effect is most important, and I felt satisfied with what I'd created.

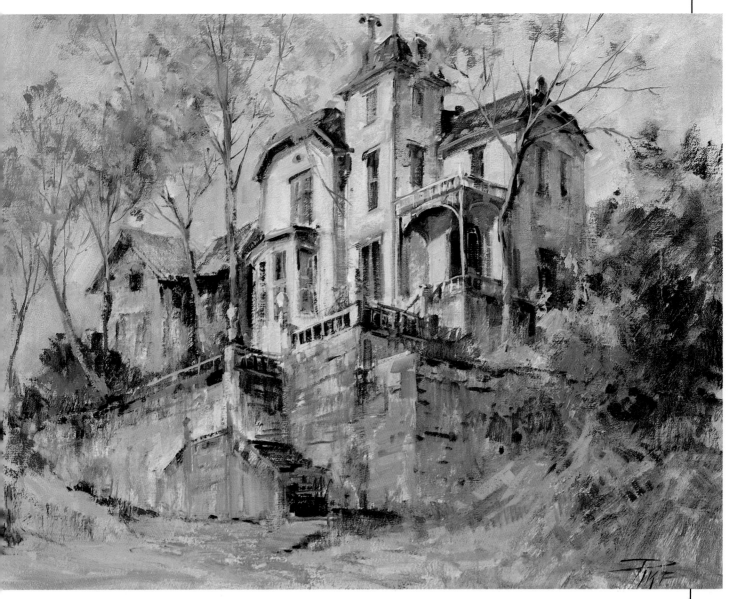

I chose a sketchy style of painting that I often use when doing buildings. First I used an oil wash over my entire canvas. Next I used thinned ultramarine blue to do my sketch. Since the drawing was important, I used a bit more paint to do a slightly stronger line drawing. I wanted to see my drawing clearly before I started to paint. After carefully working my drawing, I started to mix various color mixtures without adding white. I used several yellow-gray mixtures throughout the painting, from pure cadmium yellow light to grayed cadmium orange and sap green.

Virginia City Castle
24″ × 30″

MAKING A PATH FOR THE EYE

When you're painting it's often necessary to deviate from what you see for the sake of a better composition. You need to emphasize some things and deemphasize others so the viewer's eye will have an interesting path to follow through the picture. Keep in mind what it was about the subject matter that attracted you and inspired you to paint it in the first place. You might want to play up those qualities, while minimizing others, so the viewer can enjoy the special features of the scene as well.

Esther is a dear friend who has a beautiful old home in the heart of Los Angeles. All the homes in her neighborhood were built nearly eighty years ago, and all were large, picturesque estates at one time. Esther loves her garden and spends much of her time working among the pretty flowers. I was visiting her one afternoon, and while we were having tea in the backyard, I watched how the sun hit the edge of the latticework and was casting an interesting lacelike pattern on the ground. I commented on its beauty and mentioned that some day I'd love to paint it.

Esther said, "Why not now?" Well, I don't need much encouragement to whip out my gear and get right to work. I always keep a supply of painting gear with me at all times. It's an old habit formed after I found the need a few times and didn't have anything with me.

All I had with me to paint on was an old 24" × 30" (60 × 76 cm) canvas with a study I had done in a workshop a few days before. But that was fine. I enjoy painting on a used canvas. Often you'll find a bit of the underpainting can be useful.

Quickly I sketched the buildings, securing the perspective. Then I moved quickly to cover the canvas with a light application of paint: first, to cover the painting I was working over and second, to preserve the beautiful light pattern I was set on capturing.

Esther sat quietly watching me while her backyard came into view on my canvas. It was fun for her to see, I'm sure, but far more fun for me to do. The shadow patterns from the latticework on the ground gave reference to the warm day and also helped the eye travel through the canvas.

The beautiful old bougainvillea plant draped rhythmically over the latticework and roof. In actuality, it had many more blossoms, but if I were to paint too solid a mass, it would take away from the rhythm of the design. Converging or intersecting lines also help keep the rhythm or movement in the wood structure.

One recognizable object is the roof of the neighbor's house. Without this, it would be difficult to know that we are painting a backyard. I kept the sky a simple, soft warm gray, whereas in reality it was very blue. If I had used too much blue in the sky, it would have thrown off my entire color balance.

The dominant hue of the painting is a warm red-orange. I even warmed the concrete driveway and walkway, making them appear to be brick. There again, my purpose was to push the warm tones. In contrast, the cast shadows appear to be cooler against them.

Even though the focal area is lower and more in the lower third of the canvas, I could get by with it because the latticework commands so much attention. Also, notice how each segment of light has the correct value of dark or midtone behind it to allow the eye to travel properly through the canvas. Even the brilliant bougainvillea plant does not take away from the light-struck areas on the wooden structure. I used touches of soft blue trim to outline the roof on the house in the background. There again, introducing a touch more complement was needed to break up the warm overall tones.

When you work, do not let your attention drift for a moment. Think carefully before you place a brushstroke. You will produce less mud and far less frustration. When painting lines that are repetitious, such as the slats in the latticework, be careful not to overdo the obvious. It's not necessary to show every segment in strong light and dark. Be choosy where the light should strike, keeping the pattern working. In actuality, I saw much more light on the latticework, yet carefully selected the right amount to make my statement. The play of darks on the back fence set the stage for the light pattern on the wood structure.

Esther was amused and amazed at seeing her backyard come alive on canvas. She said, "You changed a few things. Yet I surely know it's my own backyard."

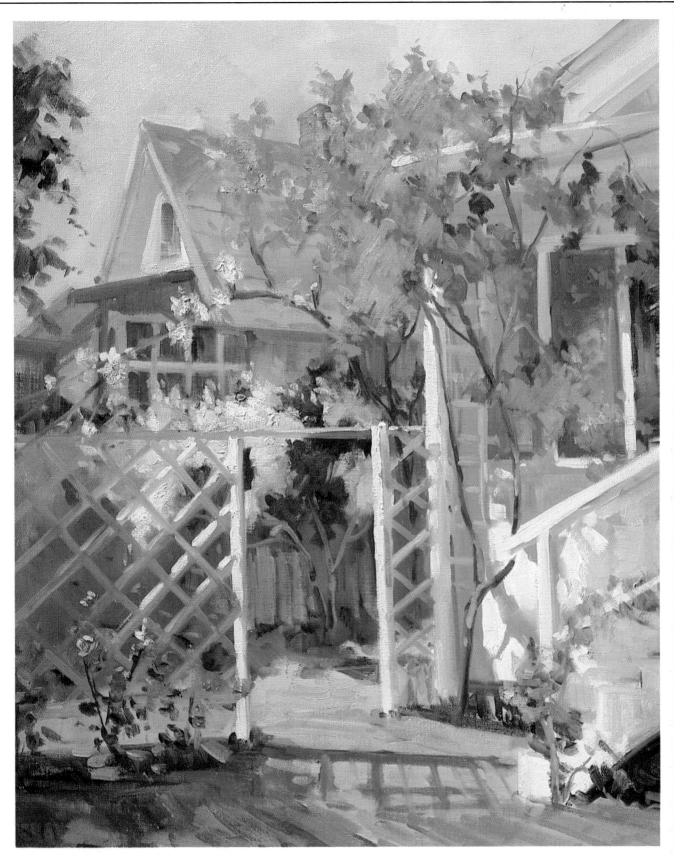

I was inspired by the way the light on the latticework in Esther's backyard cast an eye-catching pattern on the ground. I designed the picture to have an inviting composition. As you study the painting, notice how the intersecting lines come together for balance.

Esther's Backyard
30" × 24"

PAINTING THE SUNRISE

I got all my students out early one fall morning, and I do mean early—before sunrise. The lesson was to learn how to paint the first light of day. Sunrise is by far the most beautiful time of day. Seeing the day from its beginning creates a time when privacy and meditation seem to come together, setting the stage for the whole day. The class gave me a bit of flack about meeting on location before the sun was up, but discipline prevailed.

After we arrived, I set up my gear while it was still dark. The morning light was only a sliver over the distant hills. My demonstration took about one and one half hours, as I stopped to answer questions and gave a more complete finish to the work than I usually do. By this time, the sun was well up in the sky. The students had perched themselves around me as usual, only this time they had lap robes and hot coffee. I talked first about getting the gear ready and being sure to have everything out at your fingertips.

The light changes too rapidly to be messing around looking for something in your paint box.

It can get downright chilly before the sun warms up the day, so it helps to be prepared for the cold. Since I can't work sitting wrapped up in a blanket, I wear a blanket around my waist. This also keeps my legs warm when I stand to paint.

The sun had just started showing over the hills when I got things rolling. First I used a turpentine wash over my canvas, applying ultramarine blue and cerulean blue in the sky area. Then I added sap green and alizarin crimson to the blue mixture to make several variations of gray, which I planned to use on the remaining canvas. I added a touch of Indian yellow to vary the grays, going a bit more to the yellow where a variation was needed.

A slight suggestion of the composition was visible in the toning. Although I didn't plan to do a definite drawing, I felt I should suggest the placement of objects as soon as possible. I started to place in shapes, using the same colors I previously used for my toning. In addition, I placed cadmium red light on the light-struck side of the chicken coop. I was *not* ready to put in detail at this step. I needed to secure all values and color before losing the mood of the early morning sunrise.

Then I placed in a few loosely suggested brush shapes, just to break up the flat ground, and started to show the actual building. Using my loaded brush, I made a carefully directed brushstroke. This eliminates the drawing step. At this time, I established my focal point. I needed to know the focal area early, so all other values in the painting can work correctly.

I blocked in the distant trees when I placed on the wash. With a bit of ultramarine blue and sap green, slightly grayed with cadmium red light, I

I began with a turpentine wash, using ultramarine blue and cerulean blue for the sky, with sap green and alizarin crimson added to the blue for the rest of the canvas. I then suggested the shapes more strongly with the same colors because I wanted to indicate placement early.

gave a bit of recognizable detail to the tree area, but only a bit. As the sun continued to rise, a soft pink glow hit the cloud formations near the horizon. I turned to see if everyone was still with me and had not fallen asleep. Yep, they were still there! The sky was the lightest area we saw at first; then we saw fingers of light streaking across the ground, causing long shadows. That is the moment to capture— that breathtaking moment when all of life begins a new day. At sunrise the distant mountains read as a dark, gradually becoming lighter as the sun moved higher in the sky.

A big yellow rooster came out to crow. In fact, he entertained us with his loud voice during the entire visit. The hens wandered out slowly, showing far less interest in the strange intruders than the leader of the flock.

This was the moment I chose to record the scene. First I secured the sky colors, using cerulean blue with a tiny touch of cadmium red light plus white

to give the correct value for the lower portion of the sky, adding a touch of ultramarine blue as the sky became darker at the top of the canvas. Now I placed in the pink-toned clouds with white lightly tinted with cadmium red light. I used a fresh, clean brush to make a direct brushstroke, softening the pressure as I directed the clouds across the top of the distant mountains. For a few darker clouds higher in the sky, I used viridian green and cadmium red light mixed with white. At this point the sky was complete. Next I moved to the mountains to capture the value and hue before the sun became too high.

At the chicken coop I placed a mixture of cadmium red light, sap green, and ultramarine blue in various mixtures of gray to show the shadow areas. For the dark within the building I used sap green, alizarin crimson, and ultramarine blue. I also used a touch of the same mixture for the darks under the eaves.

I've mentioned before that things going on in the shadow areas of a painting can be more exciting than things in the light. When you have a dark area like the open door of the chicken coop and it is a large dark mass, don't paint it like that. It should be broken up, or it will read as a large dark spot on your canvas. The way I usually break up a dark area is to first place in a wash of midvalue; then I place in my darks, allowing a bit of the underpainting to come through. At this time, I placed a blue-violet reflected light on the shadow side of the coop with a mixture of cobalt violet, cerulean blue, and white.

After completing various darks, I put in the lights, such as the side of the building facing the direct light and the roof. I used cadmium red light and sap green, with a tiny touch of white to change one value slightly from another.

If I have a strong light on an object near the edge of the canvas, I do not

I eliminated the drawing phase and continued developing more shapes. I added the bushes in the middleground and defined the building with direct brushstrokes.

paint it as strong as it appears. You should direct your strongest contrast near or around the focal point. Remember: You must control your composition.

Instead of doing a line drawing, I directed my brushstrokes to show the various angle changes such as the roof. I made my stroke in the direction the roof slants. I used the same stroke for the board side of the coop. This not only works to show the old weathered wood, but keeps the painting from looking overworked. The large dark mass within the building still has touches of underpainting showing through. This is good. Do not paint things out until you are completely sure you don't want them.

Then I moved to the distant trees. In reality, there were several variations of greens and grays. I wanted to only suggest this area. I massed in a darker green to the left of the canvas with sap green and a touch of alizarin crimson, giving the appearance of a few taller pine trees. I then topped the remaining mass with a few brushstrokes of a slightly warmer hue using viridian green and cadmium red light.

The rapidly moving light now flooded the landscape, making the shadows appear blue-violet and quite strong. This is a bit too much contrast to show at first light, so I toned values down a bit from what I actually saw. For the cast shadows, I used a mixture of cadmium red light and ultramarine blue to make a soft violet-gray. For the foreground foliage, I used cadmium orange and viridian green over the underpainting for soft warm grays.

The area behind the coop showed the most light striking the ground. For this, I used cadmium orange, cadmium red light, and a tiny touch of cobalt violet. I used a small amount of thalo yellow green for variation in this area, and it also helped show the strong light. You will notice I never used a completely solid brushstroke. I kept the animated feeling throughout the entire painting by stroking the canvas lightly. I put in some chickens and added a few fence posts as broken objects to give a touch of realism.

I planned my focal area from the beginning. I needed my darks to support the lights I would use for the finish. At this point, I concentrated on touches of light around the door. I used short, direct brushstrokes, slightly separated, almost like pointillism. I painted the fence posts with a mixture of cadmium red light and sap green.

I added a strong light pattern to break up the dark doorway with the same light mixture I used on the roof. This light also secures the focal point. Then I was ready to get down to the fun part of painting the chickens. Using the same mixture of cadmium red light and sap green, I blocked in the chickens, going a bit redder for the hens. Where the light struck the hens, I used cadmium orange, adding a bit of cadmium yellow light for the rooster parading in the light.

Next, I painted in the horizon and foreground foliage. You can see how the painting progressed from very loose and underdetailed to more controlled and specific. I broke up the dark of the doorway to keep it from being a dead spot. I secured my sky colors using cerulean blue and ultramarine blue. The clouds were white, toned to a rosy pink with cadmium red light.

The painting continued to solidify as I worked. I added some light strokes to the foreground, which helped establish the focal point. I didn't use solid brushstrokes; instead I allowed the color beneath to show through.

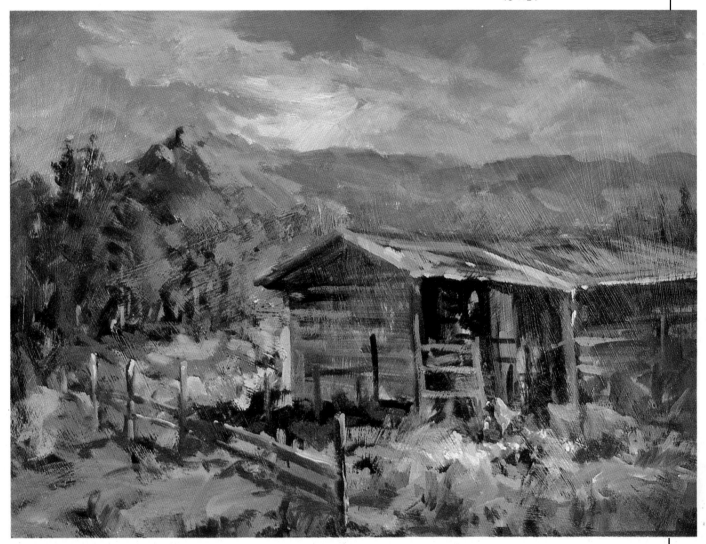

As the painting reached final resolution, I was very careful to adjust the colors to preserve the quality of light created by the sunrise. Those areas struck by sunlight were kept warm to contrast with the cool shadows. I placed touches of blue sky in the foreground and the red for the chickens on the trees to tie the painting together.

CHAPTER SEVEN

SEASCAPES

The sea never ceases to fascinate with its changing moods—tranquil and soothing or frightening in its power. The beauty of the sea has also enchanted artists for centuries. Perhaps because it is never still, but constantly in motion, artists have attempted to catch its glory on canvas.

Somehow the romance of the sea touches people's every relationship with it. Boats and ships, docks and harbors, and all their trappings are almost as fascinating as the sea itself. Even the most ordinary of structures offers some quaint color or texture for the artist. Old boat sheds, abandoned piers, castoff equipment all make interesting subjects.

Because the sea is so changeable, painting it can be a challenge. When doing marine subjects, it's even more important to plan before painting. The more you know about the sea, the better you'll be able to capture its character on canvas. Studying great seascapes by the masters, taking many reference slides and photographs, and sketching the sea as often as possible will help you become familiar with the colors and textures of the sea.

In this chapter, we'll examine the important aspects of painting marine subjects. We'll study the finer points of depicting boats and harbors, then surf and rocks along the coast, and finally panoramic views of the ocean.

I've always loved the sea, and I've planned to live near it most of my life. When painting the ocean, there are many things to consider: time of day and lighting; mood, color, and composition; and detail. This cove on the central coast of California is one of the most beautiful in the world. I painted it at sunrise when the ocean was almost turquoise blue, with exciting touches of cobalt blue and violet tones dancing through the oncoming waves and distant water.

PAINTING BOATS

A selection of reference photos.

One of my favorite spots is Morro Bay, a sleepy little fishing village located on the central coast of California. There, every year for the past sixteen years, I've taught an outdoor painting class to students from all over the United States. They enjoy the beautiful cool summers while painting the area. Our subjects range from painting old buildings, the ocean, the rocks and surf, and of course, the fishing boats in the harbor. These boats are as full of character as are the skippers.

Besides the fishing industry there's always a lot of activity around the harbor. Interesting repair shops are constantly working over the boats, since salt water eats away at whatever it touches. This harbor is guarded by a huge dome-shaped rock appropriately called Morro Rock. The narrow entrance to the bay allows only one boat at a time to enter. I often enjoy sitting on another huge rock formation at the mouth of the harbor and watching the precision with which each boat makes its way to its mooring. Many of the boats have been out fishing all night, and the fish are cleaned as they return, calling hundreds of sea gulls to enjoy the remnants of the catch. As I watch each boat gliding slowly by, I often make several sketches of the different designs or take reference photographs to study the different designs thoroughly before I start to paint. Each boat has something unique about it. A complete understanding of the basic shape of a fishing boat is important. It may take research, for example, going to the public library and studying art books on the subject, such as *Painting and Drawing Boats* by Moira Huntly.

Finding a good photograph of a boat is great, but it's more important that you understand the basic structure of a boat before you proceed to work from a photograph. I know that anyone who has ever been successful at painting harbor scenes works mainly from the real thing. Being familiar with your subject is the first step to a successful painting. (For more information about photographing your subjects, see page 133.)

I'd like to take you through a typical day of painting boats in a harbor. My first job is to select a subject and then check with either the skipper or someone in the area to make sure it doesn't leave. Coping with this devastating problem has taught me to make sure the model remains long enough for a successful day of painting.

As I start to put together my composition, I sometimes use a view finder to select the elements, although some rearrangement is almost always necessary. After I select which boat or boats will go where, I carefully draw in each boat on the lightly toned canvas. For this toning I usually use cadmium red light or cobalt violet, or both, thinned to a tint with turpentine. This red, or red-violet, undertone works great with the blue or blue-green overlay I usually use for harbor paintings, although there are times when I change colors. This must be taken into consideration if I choose another dominant hue. It's always better to use the complement for the first toning. I decided to use an oil toning for this demonstration. The difference between an oil and an acrylic toning is that oil cannot be wiped off without taking everything off down to the white canvas, while acrylic allows you to wipe off the drawing and leave the original toning intact.

After the drawing is secured, I established all my darks, midtones, and lights. Always an important factor, color is placed in over the undertoning to get rid of the brightly colored tone. While some colors may have to be subdued, others may be brought to a more intense hue. All should be planned to work harmoniously with both the value and color scheme before placing them on the canvas. Remember to apply the paint after you have established the color and composition. Finish work can take all day, if needed, but it isn't really necessary to complete a painting. Often little or no detail is required for completion.

When painting boats, I like to use

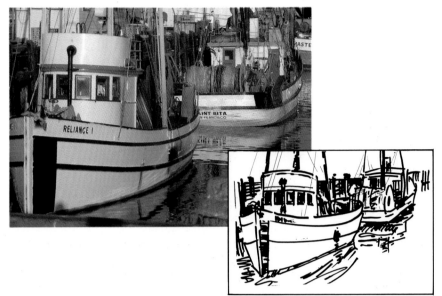

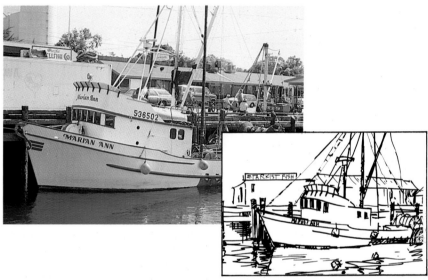

Here are some reference photos and the corresponding sketches I did. The sketches help me record important details of the ship's rigging and gear and the perspective. As usual, an artist often needs to deviate from reality to create a better picture. Sketching helps you simplify or adjust your subject matter so your actual painting process is easier.

the greatest contrast for the focal point. That may mean I must paint other values darker than what I actually see. I like to select the correct values by making a comparison, much the way I compare shapes when I do a line drawing. For example, if I decided to use three boats in my painting and the lightest boat was actually located near the edge of the canvas, I'd find it necessary to use the stronger value change on another boat nearer the center of the canvas to make a good compositional balance.

I continued placing colors until my entire canvas was covered with both color and light and dark patterns. The next step was to place on such individual characteristics of each boat as rigging or equipment. Since there's a certain amount of general equipment aboard a fishing boat, it's a good idea to familiarize yourself with each object as much as possible before you attempt to draw or paint it. It's embarrassing to find out you've placed some essential piece of equipment in the wrong place or connected a line where it shouldn't be connected. I have a few simple rules when doing things like masts or rigging. For example, if you find it difficult to make a straight line for a mast, use a straight edge or ruler. Place the narrow edge directly on the wet painting; then with a loaded no. 4 bristle brush, make one swipe down the ruler. If the ruler should make a mark on the canvas, you can repair it easily by going over the area a second time without the ruler. The rope lines, or rigging, can also be placed in from start to finish with the edge of a painting knife, or you can use the rigger brush, which is a long, thin brush specially designed to make thin lines. Areas like windows can be placed in with bold brushstrokes and then shaped later with a finish stroke. You may even find it's not necessary to work over the original stroke.

While I've covered a few essentials of painting boats, I have yet to explain what happens to the areas around the boats, such as water, buildings, docks, and pilings. These ele-

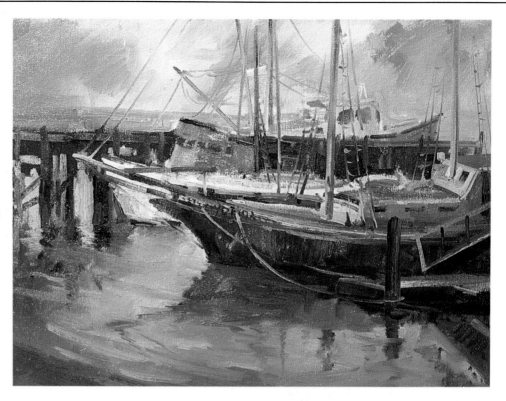

One never knows when inspiration will strike. When I saw this schooner, I forgot my weariness and grabbed my gear to paint it. I worked quickly and loosely. I used a minimum of detail to keep the focus on the red hull of the boat.

The Red Schooner
24″ × 30″

ments are important, yet they should be played down to support the main subject—the boats. Let's consider water first. It may seem obvious to note that water is not a solid mass. It should show variation in value, becoming darker with green or blue-green in the foreground and becoming lighter with more blue or blue-violet at the horizon. Water should also show movement, with various hues showing the reflection of objects. For example, if a boat is reflected in the water, its reflection is a less-intensified reverse image of the real thing. To show the movement of the water over the reflection helps differentiate between the mirror image and the actual boat. This can usually be done with only a few well-chosen strokes. To overdo this step can be disastrous. Pilings or docks usually read as a dark pattern, but they can also be reflected in the water. It isn't always necessary to show as much contrast as you actually see. Many times, this contrast is too strong for the spot where it really appears, and you must subdue it for the sake of the overall composition.

Down through the ages people have been fascinated with boats. They have individual personalities, and if boats could talk, they would hold you spellbound with their stories. Whenever I drive to the waterfront, I'm amazed at

the changes. I seldom see the same scene as boats come and go to their moorings.

The day I painted *Call of the Gulls* this group of boats was clear and blue, giving everything in shadow a blue-violet hue that contrasted with strong touches of sunlight. I try never to have a preconceived painting in mind when I go out to paint. I learned a long time ago that does not work.

I wanted to get away from a typical view and give more attention to the slow moving water in the bay. It was necessary to suggest subtle value changes in the negative space, keeping the eye contained in the upper half of the painting. By using the small boats as supporting objects, I wanted to keep attention on the main boat. I made the darks strong, with little detail. I barely suggested the rigging. I needed it, though, to prove the existence of the reflections, which created the real mood.

It was necessary to do a complete sketch of the boats before starting the painting since I wanted to relate the size and shape of all the objects. The background area of soft tree shapes was actually there. It worked perfectly to silhouette the main boat, creating a strong pattern of light and dark. Notice how the darker area of water in the foreground moves the eye to the

focal point. The placement of gulls in flight helps provide a feeling of life.

I was on my way home from a workshop when I painted *The Red Schooner.* I decided to stop at a waterfront and have a sandwich. While I was settling my weary body in a chair, I glanced out the window and saw this beautiful twin-masted schooner. I forgot about being tired, gulped down my sandwich, and rushed to the car for my gear. The only canvas I had with me was one on which I'd done a seascape demonstration a couple of days before. I took turpentine and washed off any wet areas, leaving the few spots that had dried. Talk about a busman's holiday! I carefully scrubbed a soft violet oil wash without any white over the entire slightly damp canvas. That produced a soft film of violet, since the canvas was almost down to the original white ground. Now as I sketched in the boats and docks, I used ultramarine blue thinned to a wash with turpentine.

With my drawing secured, I quickly took pure alizarin crimson and cobalt violet and scrubbed a base on the hull of the red boat. As I started to mix my grays for the boat, I used only color and complement—alizarin crimson with a touch of sap green for the darker grays, with cadmium red light for the lights. I actually used very little

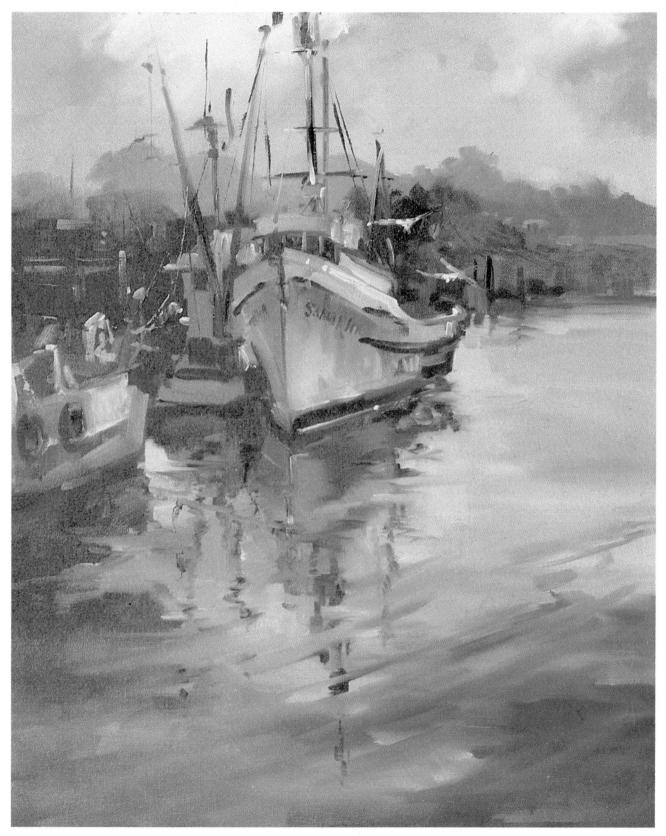

The day I painted this group of boats was clear and blue, giving everything in shadow a blue-violet hue in contrast with the strong highlights. I wanted to get away from the typical view and give more attention to the slow moving water in the bay. By using the small boats as supporting objects, I kept the main boat from becoming static. The background area of soft tree shapes was actually there and worked well to silhouette the main boat.

Call of the Gulls
24″ × 18″

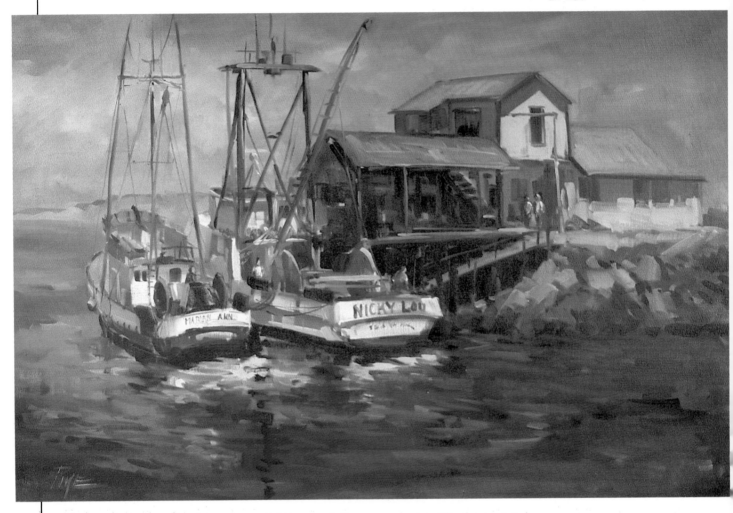

I enjoy working in an alla prima manner, finishing a painting in one session. The day I painted *The Old Repair Shop* was windy and cold, not ideal conditions for painting. However, the cold was an incentive to think carefully before and while I painted so I didn't waste a single stroke.

There are two things to notice in this detail. See how the violet underpainting peeks through in places. By contrast, it makes the yellow sunlit areas of the building look even warmer, while making the shadow areas appear cooler. The hints of the underpainting also help knit the picture together.

When I'm painting, particularly in the final stages, I seldom leave anything out, but I do use loose brushstrokes. Notice the gear aboard *Nicky Lou*. Everything is accurately placed, scaled, and the right color, but sometimes I used only one or two brushstrokes to indicate an object. The overall effect is what's important.

white. For the sky and part of the water I used viridian green and alizarin crimson plus white, but I kept the hue more toward the violet. The sky and water had to work as subordinate areas to the bright red hull of the schooner. Looking closely, you'll barely see a boat behind the wharf, which I almost lost in the foggy sky. Adding a few distant objects often helps create a feeling of realism. I did a bit more softening in the water, as the day had almost no breeze, but that allowed me to put more emphasis on the red hull. I finished the painting quickly. I may be overworked, but not my painting!

The boats *Nicky Lou* and *Marion Ann* were in the shop to be spruced up—a necessary procedure for the fishing industry. The day was windy and cold. I was bundled so that I could hardly move. Most people would call me crazy to try to paint under such conditions. It was a challenge to capture the wind movement in the water.

The sky was gray, though there was enough sun peeking through at times to give great contrast to the light on the building and the boats. I took advantage of the light, since it kept the painting from being too dark and formless. I barely suggested several figures, yet they give movement and life to the painting. The men were watching me from their work, and finally one came over to see what I was doing.

I did the detail carefully, giving thought and consideration so each brushstroke meant something. I seldom leave anything out, yet I try to keep my strokes loose and deliberately placed. The areas of dark under the old shed roof show many variations of values and color. The entire painting reads blue to blue, violet to blue-green with dark as my dominant value. Red-orange was the complement

Even with the weather conditions, I carefully worked out all necessary

value and color characteristics before attacking the canvas. I used touches of pure color complement on the floats as well as on the red bottom of the *Nicky Lou*. This created the punch the painting needed.

Notice the slight curve of the bay in the background where the horizon is only a whisper. Many times it's best to play down any strong points in the distance that take the eye away from the focal point.

Painting the rigging can be a discouraging experience, but it gets easier with a little practice. I used a long-handled brush, or maulstick, and placed it at the top of my canvas, almost letting it touch as I drew only one careful stroke with the correct size brush. The amount of paint needed for this procedure is personal, but I suggest not to go too dark. The lighter sky area, previously painted with white in the sky mixture, helps subdue the dark rigging.

PAINTING FOG

There is fog in Morro Bay. To me, it's an artist's dream. Painting soft shapes emerging from nature's own delicate curtain can be even more beautiful than the dazzle of bright sunlight. Just as I finished setting up my gear, the fog parted, letting a bit of sky peek through.

The water was lavender-gray, with subtle blue touches moving through, which contrasted with the color of the fog in the reflections. Fog often has a pink-lavender hue depending on the time of day. This particular day, it seemed a bit more violet than usual.

The morning light striking the side of the boat was very soft in the fog. As it parted, showing a bit of blue sky, the light on the boat took on a blinding glare. The bow of the boat lost in the fog gave the illusion of a lost edge, which helped cut down the glaring light striking the boat.

The pilings should not look like ten little Indians; they should only be suggested. Usually they provide the strongest contrast in your painting and may or may not be the needed area for the focal point. If not, play them down, merely suggesting them with a single subtle stroke of the brush. Avoid detail and emphasize their irregularity slightly.

When I paint details such as windows, trim, or rigging, I think first where I want each stroke. Then I carefully place it in with as little effort as possible. When painting windows, I choose a brush the size the window should be and apply it with only one stroke. The rigging should be sized the same way. Pick a brush the same size as the line you wish to make. Using a brush on its side often gives the perfect width line. The lines extending from the mast to the bow are best

placed in with a brush called a rigger. The size is up to you. I like a small no. 1 rigger, and I'm always careful not to get the value too dark for the rigging. In doing the entire painting, I plan each brushstroke or area, striving for a clean, underworked finish.

I planned this day of painting with fog as my subject. As I arrived, the fog started to part, making beautiful patterns in the sky, but it changed my preconceived plan of attack for the day. The parting fog patterns made it easy to place both the main subject, the boat, and the supporting elements, the buildings, in a pleasing composition. As the fog separated, the light struck both the stern and cabin of the boat. In reality, the buildings showed a stronger contrast than what I painted, but to keep the viewer's eye on the boat, I played down the strong light hitting the buildings. The dark

A Foggy Day in Morro Bay
22″ × 28″

Fog is fascinating to paint. Painting the soft shapes emerging from the mist is an exciting challenge. Often the fog and water obscure the horizon, giving a floating quality to the boats. Fog often has a pink-lavender hue, depending on the time of day. When I did this painting, the fog was a bit more violet than usual. The water was a lavender-gray, with subtle blue touches in the reflection.

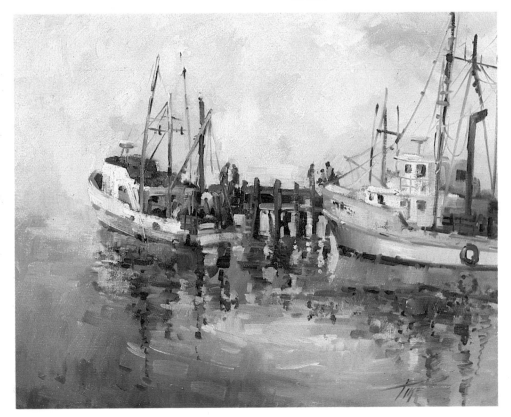

blue water contrasting with the light stern gave a perfect balance of values for the focal point.

The painting is mainly blue-violet, with yellow-orange used to gray it. You can see a touch of complement where the float is hanging down over the side of the boat and reflecting in the water. I also used bits of the complement in the darkened area inside the shed.

Remember: Color has little or nothing to do with value. Objects can be dark or light without color, or color can be used in any value change. The dark yellow-orange gray I used for most of the strongest darks on the buildings looks like raw umber, yet I actually mixed this dark warm hue from sap green, ultramarine blue, and cadmium red light.

I wanted the blue foreground water to read as a dark to help secure the fo-cal point and to give a more realistic look to the water. First I placed in a blue-gray—a mixture of ultramarine blue, sap green, and a touch of cadmium orange—to gray down the predominant blue hue. I added a bit of cerulean blue and white over the gray with unblended brushstrokes. I broke up the large mass of dark water by bringing a bit of sky color into it to unify the entire painting.

Violet tones in both the background water and the fog obscure the horizon line. Soft violet-grays are in the rocks on the right of the canvas. The rocks show almost no detail so as not to take away from the light striking the boat and buildings.

The colors worked from the beginning of the painting and nothing had to be adjusted. This is a good example of how color and complement can work if you plan them before painting.

In for Repair
24″ × 30″

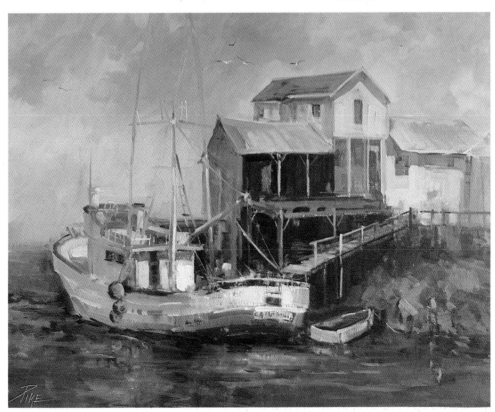

Strong contrasts give this painting its power. As the morning fog broke, light struck the cabin and stern of the boat and the repair shed, creating a stark pattern of lights and darks. I played down the value contrast on the building to keep the viewer's eye on the boat. I kept the shadows dark, but enlivened them with hints of color. The foreground was also a dark, broken with touches of sky color.

SEEING BEAUTY IN THE COMMONPLACE

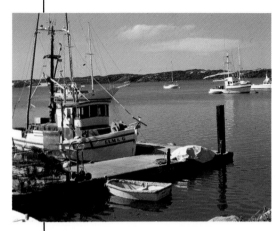

This is a photograph of the scene.

Working on an acrylic-toned canvas, I carefully planned the placement of each object I wanted in my painting, and I also made sure every object balanced for a good working composition. Using ultramarine blue thinned with turpentine, I drew everything in relation to a point of measure. I measured the boat's height in comparison with its length. I also made sure the cabin was the correct distance from bow to stern. If everything is measured relatively, the drawing will be correct.

One day I held a workshop at the waterfront and we painted some of the moored boats. I wanted the students to have a good selection and purposely went where the boats were moored in individual slips.

The day was one of those Chamber of Commerce days with the water a beautiful shade of blue. The light hitting the side of the boats was as strong as it would ever be, and the whites seemed whiter than ever. The boat I selected for my demonstration was moored at the end of a row of boats. I chose it because there was blue water in the background instead of another boat.

The spot was a natural, and I wouldn't have to change much of what I actually saw. Everything seemed to work well together, including the two small rowboats in front of the small wharf area. I did eliminate some boats anchored out in the bay since they detracted from the main boat. When the class arrived on location, we were able to park our cars facing the row of boats, which made it easy to rest when needed and difficult for onlookers to bother us.

I had set up my easel and toned my canvas after I'd selected the location so I would be ready to start the demonstration as soon as the students arrived. With everyone standing or sitting around me, I started my drawing. First I selected the placement of each object to make sure I would have room for all the things I planned to put on my canvas. I decided to raise the sand dunes in the background to show more of the water and also because I didn't want all the anchored boats in the background. In the photograph you can see a distant boat that looks as if it is sitting, like a hat, on the boat I'm painting. That had to go.

Before I actually started to draw, I checked my perspective. By holding my brush horizontally at eye level, I can estimate how far down the boat is located below eye level. This measure-

ment helps me know how much of the inside of the boat to show so I can work the perspective correctly. With all these things in mind, I now started to relate objects with correct measurement. For example, I asked myself how the height compares with the length or width and also what is the correct angle. Once I made the major measurements, I could place in smaller objects with little or no problem. For the drawing I used ultramarine blue thinned with turpentine. When painting boats, don't skip lightly over the drawing. Be sure of each placement before you proceed.

I had previously toned my canvas with a multi-colored acrylic toning slightly darker than usual because I wanted to be sure the light areas would read strong. The light areas were the first I painted since they set the value key throughout the painting. Once they're placed in, I selected the water values to work with the lights. I used cadmium orange and white for the strongest lights, graying this mixture slightly with cerulean blue for the areas where the lights diminish. I wanted as strong a contrast as possible, and by first putting in the lights, I could plan my shadow values better. As I proceeded, I placed in the midtones throughout the foreground area. I painted each to show less contrast than on the light-struck side of the boat.

I watched the small rowboat rock with the movement of the water. Things that move can be a problem. Often you paint them the way you see them at the moment. Instead, you should draw an object in, using the best composition you can, and then wait until it moves around to where you have drawn it. Then quickly check the location of light and shadow and place it in. The rest should be easy even if the boat does move.

I mixed three variations of blue for the background water, one slightly more blue-violet with cerulean blue and a touch of cobalt violet. I added a

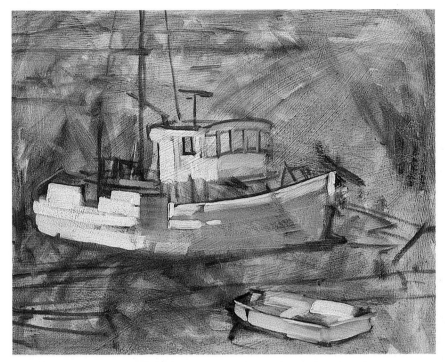

Then I placed in all light areas, starting with the strongest light on the side of the hull and cabin of the main boat. For this, I used white lightly tinted with cadmium orange. I added ultramarine blue to the original mixture to slightly gray the small boat in the foreground. I used the same mixture for the shadow side of the boat, with a bit less white.

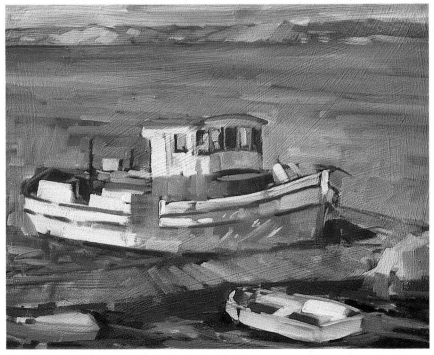

My next step was to cover the underpainting with correct values. Starting with the water, I used direct, unblended brushstrokes to apply three-color mixtures from blue-violet at the base of the sand dunes to blue lightly tinted with viridian green at the foreground area, with cerulean blue and white for the middle area. The wharf was a gray mixture of ultramarine blue and orange. I used the same mixture for the sand dunes in the background, only the dunes are more blue to show distance. I used a bit of the same gray in other foreground areas, such as the pilings and the water. I used a strong dark made from sap green and ultramarine blue under the wharf or wherever I saw strong darks.

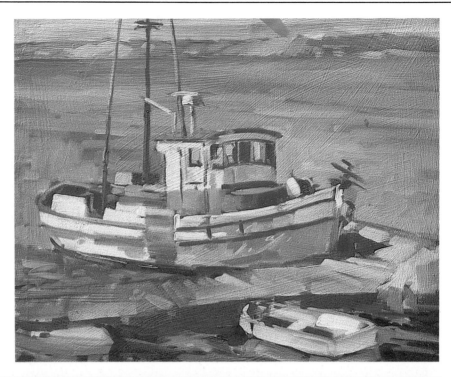

I started to pull the painting together by placing in important details such as masts or other rigging. At this stage, I checked my composition. If any color or value needed to change a bit, I did it.

The ELMA G
18″ × 24″

With everything working, I added final touches and bits of detail. Although I feel the painting was finished at the previous step, this is just the icing on the cake.

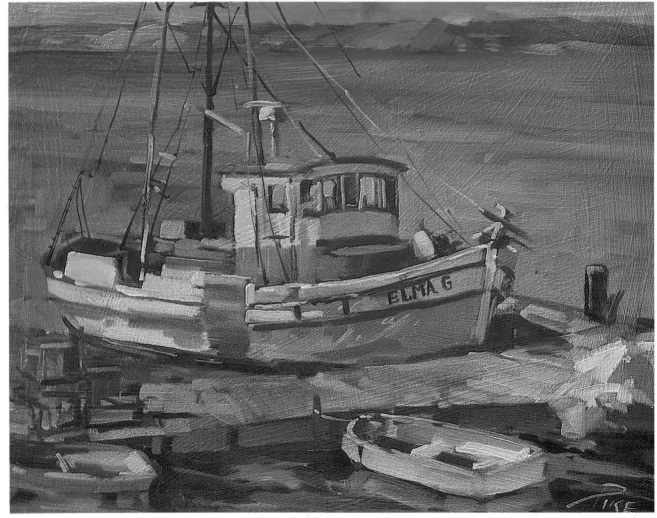

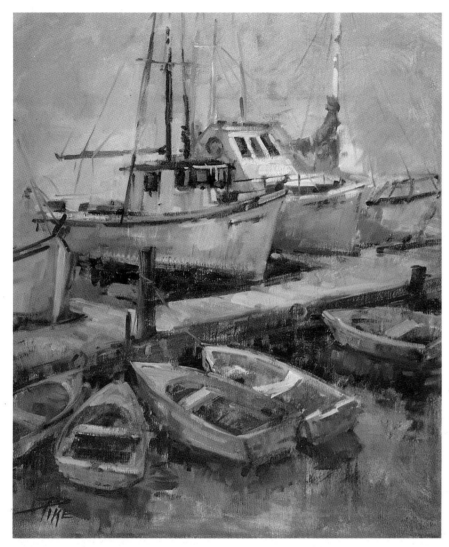

I was fascinated by the small dinghies lined up in front of the larger boats, and as the tide changed, the small boats changed direction with the outgoing tide. Fascinated by the small boats, I went back after I had finished teaching and quickly painted them. I purposely left out any sign of life, such as birds or people, that might take interest away from the small boats.

Never Too Small to Be Important
24″ × 20″

bit of white to make the correct value. Another mixture is almost pure cerulean blue and white. The third is cerulean blue with a touch of viridian green and enough white to paint the proper contrast between the shadow side of the boat cabin and the water. As I painted the water, I used direct, bold brushstrokes with little or no blending. I wanted to show lighter streaks through the water caused by different depths of the bay. It isn't always necessary to blend. Often the values are better if not blended. Blending can cause you to lose what is so beautifully done spontaneously.

I grayed the sand dunes in the distance with ultramarine blue, cadmium orange, and enough white to give the correct value for shadow. I added more white and orange to show the light side.

I decided to play the sky down by using cerulean blue, cadmium orange,

a touch of cobalt violet, and white. I painted the sky darker than what I saw because I want the eye to go to the light on the boat. If I had used too much light in the sky, it would have taken the eye away from the intended spot.

The foreground water was dark. I used cerulean blue, viridian green, and a touch of cadmium orange, going a bit darker near the wharf with sap green and ultramarine blue. Again, I went slightly stronger in contrast with what I saw to make the small boat stand out. The light striking the wharf was slightly warm in contrast with the strong blue throughout the painting. For this warm gray, I started out with ultramarine blue and orange; then as I added a bit of white, I warmed the mixture slightly with a touch of cadmium red light.

At this point, I checked to see if all the values as well as colors were

correct. After this, I was ready to place in the rigging. First I secured the main mast, which is usually located near the back side of the cabin. The long poles to either side are for albacore. The radar equipment is located at the top of the cabin. With these three major items placed in correctly, I used a rigger brush or side blade of my painting knife to suggest lines. I always try to do fewer lines than what I see and also to use a few darker and lighter ones to vary the contrast.

PAINTING THE OCEAN

There are several steps to learning how to paint the ocean. First, you must understand the importance of design, or the balance of lights and darks. No matter what the lighting conditions or what the water is doing, you must first have a good balance of lights and darks. I plan every seascape I paint by first doing several small thumbnail sketches using a felt-tip pen. I change the pattern of darks around to best fit the subject I plan to do. This step also keeps you from doing something you will have to correct later, like putting the horizon directly in the center of the canvas or making the darks too heavy on one side. If you are comfortable with your thumbnail sketch, there is a good chance you will be happy with the finished painting.

The next step is to plan wave action. My advice is to study the ocean. Make several wave action sketches, or best of all, take several photographs of wave action in different stages to use

as references. As you plan your seascape, know how each wave or swell relates to another area. Don't paint things that can't happen. The next step is to understand how to make water appear to be moving. This is done by the way you place the loaded brush on the canvas and, of course, by how well you're able to lose and find edges. To achieve certain effects, such as a wave crashing against a huge rock, causing an explosion of spray in the air, the brush must barely touch the canvas, or the spray will look like it's made of concrete.

Shadow patterns are also part of the illusion of reality. Water moving within shadow is just as important as water moving in the light. After you have all the elements working, you must be extremely careful not to overwork. It's easy to keep messing around until you lose the fresh, clean look you had before adding finishing touches.

To me the ocean is one of God's most beautiful creations. I love to sit

and watch the ever-changing beauty of color and form before me. I seldom take my easel out of the van when I make trips to the ocean. I prefer taking photographs or slides of the many changing shapes. I often make several sketches, most of which are small black-and-white thumbnails that I do with a felt-tip pen. The purpose of these sketches is to find a balanced pattern of light and dark. If I feel comfortable with my first thumbnail sketch, I have a good chance of liking the finished painting. Often, the hardest person to please is yourself.

I have a slide file in my studio with hundreds of slides of the ocean in every weather condition and time of day. I also have a slide viewer that won't damage the slide even if one is left in all day. The image is about 10″ × 10″ (25 × 25 cm). You can purchase such viewers at your local photography store.

Years ago when I was just a pup, I decided to drive to the ocean to paint,

Use slides as references to learn about action of the waves. It's much easier to study a wave frozen in a photograph until you are familiar with the painting procedure.

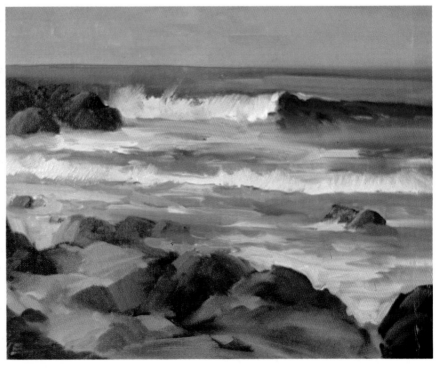

never having done a seascape on location before. My ignorance was bliss. I arrived with a flimsy easel, a 24″ × 48″ canvas board, and a snack tray to hold my palette. I proceeded to paint every rock and grain of sand in place. Children grouped around me so I could barely move, and their questions were more intellectual than any first attempt at painting the sea on location deserved.

As you've already guessed, it is difficult to do a painting of the ocean on location. Learning to work from sketches or photographs is far easier since the waves stand still. I chose two studies of the beautiful Monterey Coast of California to show how I work with photographic sources. The day was sunny and blue, with vivid colors dancing through the constantly moving water. Both photographs were taken with composition in mind. I used the view finder on the camera for the best arrangement of rocks and water. Then I waited for good wave ac-

tion and snapped the shots. These two photographs were taken at the same time. The color is the same, yet the two compositions are totally different. One photograph (opposite page) shows the horizon line, while the other photograph (below) has no horizon and shows a sandy beach. They both show rock formations in different arrangements.

I suggest you do many of these small practice subjects. Each time, you gain more information to help you work on a larger canvas. Planning is not only important, but *crucial*. Take a word of advice from the original mistake-maker: Start small and go big, not the other way around.

I placed the slide with the horizon visible in my viewer and studied it to see what should be changed. The composition looked good. I won't have to change much. On a slightly toned canvas I started to work out my dark pattern first, placing in the dark of the main wave. That selection

should be made first because it is the focal point and its placement is crucial to the rest of the composition. For the dark of the wave, I used viridian green and a touch of cadmium red light to slightly gray the green. I then placed in all the rock shapes with viridian green, cadmium red light, and ultramarine blue. With that, I finished putting in my strongest darks.

Then I added orange to the mixture for the lighter rocks near the main wave. I used some of the same lighter tone to vary the value on the foreground rocks and sand. For my final value on foreground rocks, I went slightly lighter, adding white and a touch of cerulean blue to the same mixture. This bluish tint helped tie the water and rocky area together as well as lighten and gray the rocks, in contrast with how they appear in the slide.

The distant water is a combination of ultramarine blue and a tiny touch of Grumbacher red and white to

The slide is just a starting point. Don't copy it exactly. Change what is necessary to create a good composition. The direction of your brushstrokes should follow the motion of the water.

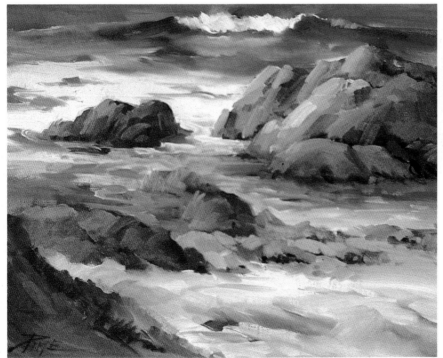

produce a soft violet-blue at the horizon. The foreground water is cerulean blue, with a touch of thalo blue and cadmium red light to gray it. I added white to make the desired value. I used thalo blue, thalo green, and white to show the darker water in front of the main wave. This area is more intense in color than any other spot in the painting because of the light foam pattern that parts to show clear water beneath. The shadow grays of the wave and foam pattern were viridian green and alizarin crimson, with a touch of ultramarine blue, which makes a beautiful blue-violet gray. I always put in the shadow of the breaking wave first with a thin application of paint. Then with a loaded brush, I painted the lights with as few brushstrokes as possible, following the direction the water is falling. Next I went to the white foam of the flattened wave. As I worked this area, I started at the outer edge of the spent wave, working my brush back over the intense color beneath to produce a lacy pattern of white over the dark water. I used a bit of the same light mixture for the foreground water, only now I added some of the blues on my palette to show variations in color.

These small studies should be done quickly and left almost unfinished rather than overworked. Remember: Capture the movement of the water from the slide, but improve the composition, if necessary, from your own knowledge and imagination.

I chose the other slide for this study for several reasons: You can see the reflection of the breaking wave in the water beneath it, a point sometimes left out when seascapes are composed. There is no visible horizon line. The angle focuses on the wave action without showing great distance. The composition isn't just water and rocks.

The ice plants on the dune add interest to the foreground.

Before I began, I studied the entire slide for areas to change. I purposely left out the strong light of the main wave as it extends to the left. By softening this area, I could take away the straight look to the wave and still keep the wave action believable. I just improved the composition a bit. Also I didn't want to show the white sand as it appeared in the slide. It seemed to pull the eye too rapidly to the foreground. I also played down the ice plants on the dunes in the left corner and used a dark in this area for balance. In the slide the water in the background seemed very bright. I felt it best to gray it down a bit to keep the intensity of the middle-area water the focal point.

I used a combination of thalo green and cerulean blue for the lighter, more intense water tones, with a touch of cobalt violet for the violets in the foreground water on the left of the canvas. The distant water behind the main wave was a combination of ultramarine blue and cadmium red light, with just enough white to lighten it slightly. The white water was the same mixture I used in the previous demonstration.

The soft gray of the rocks was a mixture of sap green and cadmium red light for the base color, with cerulean blue and a touch of cobalt violet and white for the light overtones. I de-emphasized all the rocks, with the exception of the larger, central formation near the focal point. Here the light foam and breaking wave contrast with the brilliant emerald green water. The floating foam trails up the cresting wave in full sun as the light strikes the wave at an angle. No shadow is cast from the cresting wave onto the floating foam. If the light were more

to the side or behind the wave, the floating foam would be in shadow, changing its value from a strong light to a shadow tone. The direction of brushstrokes is a very important part of seascape painting. I'm going to take you through a few ways to direct your brushwork.

When you are placing in any shadow where a lighter value is used, such as a shadow of a breaking wave, use as light an application as possible to ensure a clean overlay of the lights. As you apply lights, direct a loaded brush in the direction that the water is moving with a slightly backward push to show where the spray is moving upward from the thrust of the breaking wave.

As a wave is spent and its spray bounces on the shore, use a vertical scrubbing motion to actually show the wave movement. Floating foam should be painted horizontally. The loaded brush should float over the intense undercolor without picking up the wet underpainting. You can do this by gliding a loaded brush or knife over the surface.

Sandy areas should first be scrubbed in slightly darker than what you intend to go later. The next layer should show the irregular terrain, as you direct your brush over the ground movement. Loading your brush when you are sure of a value helps make your statement believable.

When painting rocks, you should show the form both in light and shadow. You should mass rocks in first with a thin application of dark. Then with the brush or knife, add finish strokes over the wet underpainting, directing the brush or knife to show the curve or segment of the rock. The brush or knife works equally well, whatever your preference. You can even use both, if you desire.

PHOTOGRAPHING SUBJECTS TO PAINT

When you photograph any subject you intend to paint later, be sure to look for interesting angles and incorporate other objects in your photographs to help balance the composition. Take vertical as well as horizontal pictures or slides of a variety of subject matter.

When you photograph any subject that shows the horizon line, keep it either above or below center. If you plan on changing the location of the horizon line in your painting, be aware that you will also have to change the perspective. Take these things into consideration before you snap the shutter. If you have a photograph you really like and plan to work from, and it has the horizon line in the center, just show more sky or more water in working out your composition. Working with no visible horizon line such as in photograph can be interesting as well.

Lighting is of utmost importance. If you prefer strong contrast, wait for a clear day with bright sunlight; the camera cannot see values that are not there. Set your camera according to the directions that come with the film and use a tripod whenever possible.

Purchase a slide sorter if you plan to take slides. You will find it valuable when you compare slides for a painting. I have a box viewer that projects any slide 8″ × 8″ (20 × 20 cm), making it a perfect enlargement to work from as I stand at my easel. I can see the slide clearly without bending or having to look through a hand viewer.

If you prefer working from a print, you can mount it at eye level on your canvas by using a clamp that extends far enough from the stretcher bar so that you can tape or fasten your print to it. I purchased one at a local art store, but if you can't find one, be inventive with things you find at your local hardware store.

Look for the unusual shot. Try to find things that are different, such as the maze of interesting objects found aboard any fishing craft or what you see when standing on the wharf and looking directly down into a moored boat with the crew at work. Take photographs during different times of the day and under all weather conditions. Not only should you have a variety of angles, but you should have different lighting conditions as well. Be sure you read the camera settings suggested for all weather conditions. There are times your camera can be your best tool. Use it.

Don't think you are cheating when you work from a photograph. Just remember "working from" is the secret. Don't copy it entirely. Just use it as a tool to help you compose.

Here are some reference photographs to give you some ideas. Because the sea is in constant motion, the camera can be a valuable tool for studying its moods and movements.

PAINTING THE OCEAN ON LOCATION

The Monterey Peninsula of California is one of the most beautiful spots where surf meets sand. Maybe you've heard about Pebble Beach Golf Course. It's located about one mile from the Asilomar Conference Center where I teach a class every year. On a sunny day, the water is a brilliant turquoise blue—almost too blue to be believable.

We arrived on the spot I had chosen for the day's class, ready to get in a full day's work. Although it was only a few hundred feet away from where we were staying, we took our cars so everything would be handy.

First, I asked the class to look at the maze of rocks, sand, and water. How should you select what you want to paint from what you see? You can vary the size of objects to make a good pattern of light and dark. That's the easy part. When you have a pretty

good idea of your composition, you have to be sure your wave action can truly happen. When you are composing your painting on the spot, it sometimes helps to use a Polaroid camera to stop the wave action. It's good to know what waves are doing before you plan your composition. If you know how a wave breaks, you can use this knowledge and not be confused by the constantly moving water.

As usual, I toned my 18″ × 24″ (46 × 61 cm) canvas with an acrylic wash using ultramarine blue, viridian green, sap green, and Thio violet. I placed the more intense green in the center of the canvas, going blue to blue-violet around the outer edges. I used all four colors to make a gray for the rocks. Notice that I haven't shown the wave action in the undertoning.

With the composition well in

mind, I can work the lights over the dry acrylic undertone. I was inspired by the large rock formation that showed a peep of the ocean as the two rocks leaned against each other. Since I didn't want the hole to dominate, I planned to use the rock formation closer to the left side of the canvas. This placement of the rocks made it better for me to use wave action nearer the center of the canvas for better balance. Since I don't want the rocks to overpower the wave action, I went more to the blue-gray in the rocks to stay closer to the dominant hue. The darker rocks to the right were mainly for balance, although they provided a perfect opportunity to show water washing over them. You should always show water in movement whenever possible. The sky was really blue, making the entire scene seem too blue. I used soft clouds and a

First I did a toning with acrylic using most of the colors I plan to use for the finished painting. I also suggested the large rock formations to balance composition.

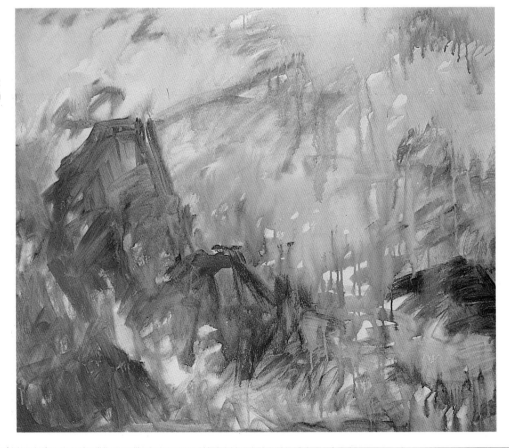

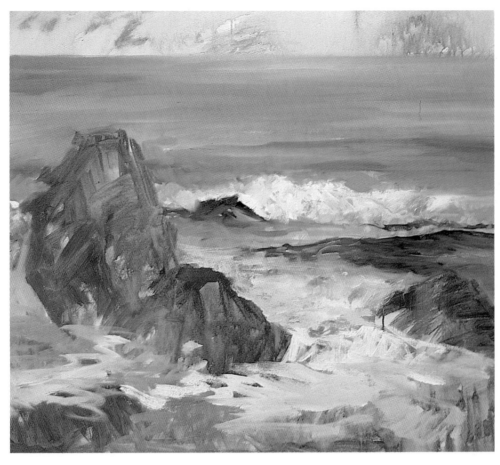

I finished the composition lay-in with oil, placing in the breaking wave as well as the moving water in the foreground.

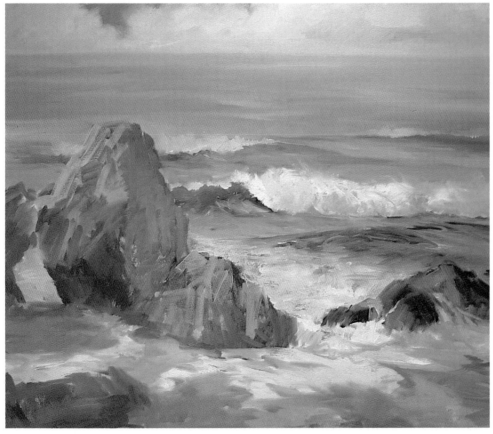

I finished covering the canvas with an oil overlay from sky to foreground rocks.

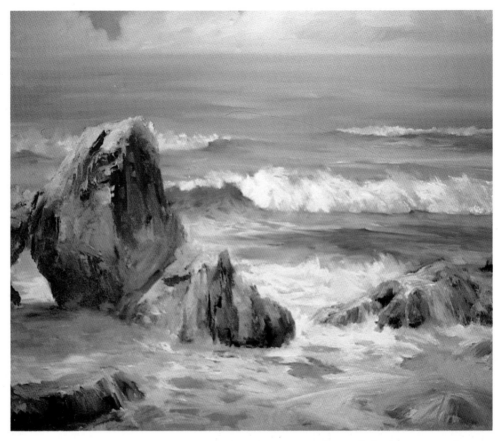

I placed in detail as I worked each area to completion, being careful not to overwork.

more blended hazy horizon to quiet down all the blue.

With the toning dry, I started to move quickly to mix and apply paint. First I placed in a mixture of viridian green and a touch of Grumbacher red for the darks in the main wave and swell in front of the wave. With a mixture of viridian green and alizarin crimson and white, I next placed in the shadows of the breaking wave and the moving water all the way to the front of the canvas. I put in the shadow cast by the large rock on the white foam with the same mixture, adding a touch of ultramarine blue. With all the shadow tones of the white water in, I placed in the lights of the white moving water. I used my brush loaded with a mixture of white lightly tinted with cadmium orange to show strong sunlight. I directed my brush to show the breaking wave. I didn't entirely cover all the shadows. If I had, the wave would look like it was in suspended animation. I also placed in all the white moving water in front of the large dark swell with the same mixture. The direction of my brush was very important. I glided a loaded brush over the tinted surface, allowing some of the undertoning to show

through. I was careful not to cover all the soft gray undertones.

The easiest way to paint floating foam is to work as simply as possible. Don't try to do too many curls. Place in the needed darks and bring the lights back gently into a triangular shape as the light goes into dark.

For the distant water, I used ultramarine blue slightly grayed with cadmium red light and white (be careful not to use too much red). I varied the values to show some movement, although at that distance, little movement is visible. The soft clouds at the horizon were a mixture of Grumbacher red, viridian green, and white for shadow, with orange and more white added for the lights. I used a touch of cerulean blue to break up the clouds.

Now that I had most of the canvas covered, I turned to the rocks. First I placed in a base coat of sap green, Grumbacher red, and a touch of cerulean blue. I added a bit of cadmium orange to vary the mixture. I placed in the light side of the rocks with a loaded painting knife, directing it to show the irregular surface of the huge boulder. For this I used a mixture of orange, ultramarine blue, white, and a speck of Grumbacher red. There

again, I varied the mixture to show several values and different colors, but I concentrated the strongest light at the top of the rock where the gulls leave their droppings. I first placed in the foreground rocks in dark with a mixture of sap green, ultramarine blue, and cadmium red light, going more to the blue. Then I placed a bit of light on the rocks, using the same light mixture as for the large rocks. I painted the lights with a painting knife, leaving the darks in to show the shadow side of the rocks.

There's only one way to paint gulls. You must know their shapes even if you're only doing a few flying off in the distance. You must know what they look like when they are flying. I keep a sketch pad exclusively for gulls. I spend as much time as possible at the waterfront sketching gulls in every conceivable position. When you are sure of their characteristics, you can paint them from memory. If not, it's good to have something to refer to. The value of the gulls against an object or area is important. White against white means nothing. You may need to adjust the value so the gulls show up in contrast with the background.

I placed in final details such as sea gulls and highlights to complete the painting.

Gull Rock
18″ × 24″

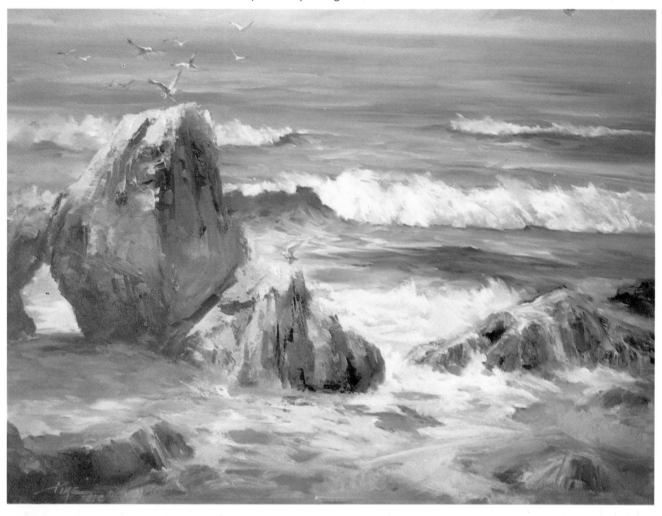

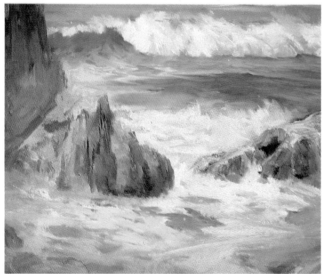

Here you can see how the brushwork suggests the action of the waves.

SECTION FOUR

GALLERY

This gallery section contains a selection of my paintings with comments on what I was thinking about as I painted them. The subject matter and style differ, but all are the result of painting in a direct manner. Before I put paint on canvas, I thought about my composition, color scheme, and so on. Since I often use an acrylic underpainting, I can work on a layer of color without fear of muddying my final colors. I apply the paint with deliberate strokes and do not do much blending, particularly in the final phase of adding the finishing touches.

I always try to remember why I paint as I paint. What is it about the subject matter that appeals to me and how can I express it best in my paintings? Thinking about these things makes painting more than just an exercise in copying a small piece of reality. I want my pictures to communicate to viewers, so they can discover something about me as well as about themselves.

Painting is still a pleasure for me, and I hope my paintings give a little pleasure to those who see them. I hope this book will give you more fun and add satisfaction to your painting, and I hope your paintings brighten up the people who see them as well.

HOLLISTER PEAK AT SUNSET

36" × 60"

On one of my trips to New Mexico, I fell in love with a Frank Tenny Johnston painting I saw a a local gallery. This painting was alive with subtle shadow color. I couldn't get it out of my mind. One evening as I watched the sun go down behind Hollister Peak near Morro Bay, I realized I could use the same lighting I had so much admired in Johnston's painting. I seldom use a large canvas when I go out on location to paint; 24" × 36" (61 × 91 cm) is usually my limit. This painting of Hollister Peak is 36" × 60" (91 × 152 cm)—definitely not a good size to do on location. But if I had done it smaller, I would have lost the delicate handling of the shadows. I really wanted it large, and I didn't want to work from photographs or another smaller painting. Anyone who saw me must have thought I looked ridiculous with this large painting on my outdoor sketch box easel.

I used a lot of color in my toning to help me get the beautiful shadow grays as I laid gray over the brilliant acrylic undertones. The clouds weren't really there, but they added a great deal to the composition. I often use clouds to break up dull areas in the sky. There are a lot of subtleties in this painting. Almost all the granite formation at the top of the peak is in shadow. On close examination the violet-grays are full of color. All the pink-violet tones make the yellow-green light striking the grassy area of the hill stand out to become a strong focal point, as well as complement all the violet-grays and pink-toned clouds. The grazing cattle are small in scale to show the enormous size of this beautiful peak.

MONTANA DE ORO BLUFFS

36″ × 40″

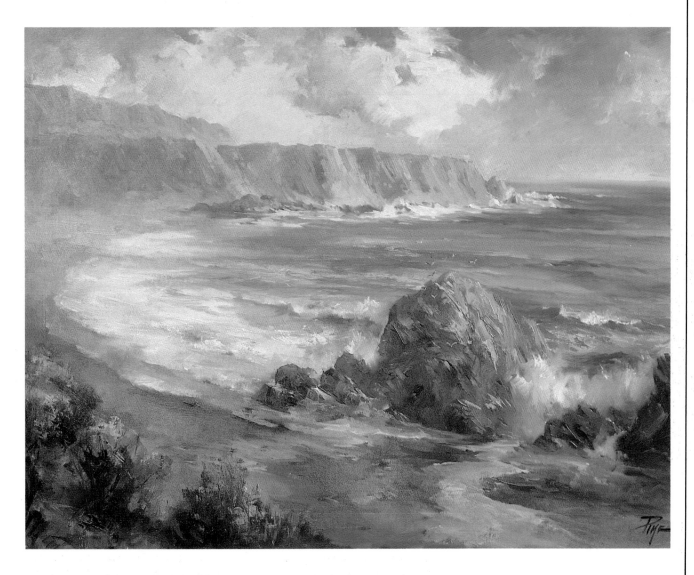

What looks like a huge rock to the right in my painting is really a mountain. Its name, Montana de Oro, means "mountain of gold." The color at sunset is always a beautiful golden hue because of the mineral content of the soil, which truly accounts for the name given to it when Spanish galleons first anchored nearby.

One afternoon, I decided to do some sketching at the ocean and chose this beautiful cove. Rain had fallen all night and part of the morning, giving everything a just washed look. The rain had stopped, but there were still a few remnants of clouds.

Each time I return to a spot to sketch or paint, I find different things to take my interest. On this day, it was the beautiful bluffs off in the distance. Their soft violet-gray color seemed to dominate the entire scene. I made a few sketches, but my first thoughts were the ones I went with. Whenever I'm inspired from the beginning, I usually stay with my first feelings.

The rough sketches were enough for me to work from back at my studio. I toned my canvas with an all-over gray. I didn't use a variation of color this time. For several minutes I

sat and stared at the large canvas. I made mental notes about where I wanted to place things. I decided to place the bluffs higher on the canvas. As I started to lay on color, I used a large no. 20 bristle brush to cover the canvas quickly with various mixtures of blue, blue-violet, and blue-green. I had to use enough violet in the foreground to balance the color, so the bluffs wouldn't be the only violet, or my colors would not have held together. If I worked the color more to blue-violet, I could use the pink-orange lights on the bluffs as part of my complement.

PHOEBE AND FRIENDS

24″ × 18″

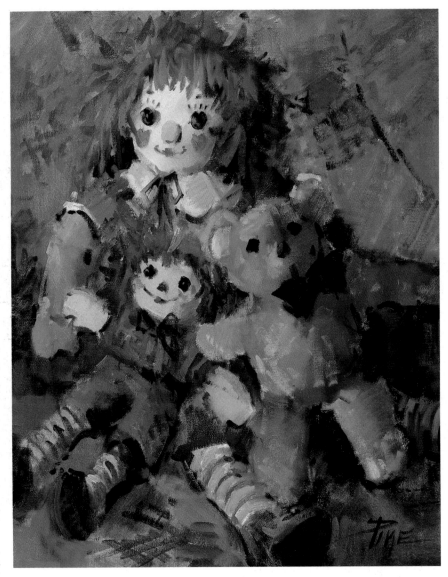

We all have things we do just for fun. I love dolls. Maybe I really never grew up, but whatever the reason, I certainly am not alone. Many dear folks share my love for dolls. Phoebe is a large rag doll with lots of personality. The smaller rag doll is Andy from a set of Raggedy Ann and Andy; the teddy bear is one of my childhood toys. This painting was done as a demonstration for a class.

The entire painting took only forty minutes to complete, yet I was satisfied with the results. There was something about the loose style that seemed to make the toys come alive. I leaned them together to keep them from looking too posed. For the background I threw an old pink quilt over the back of a chair to support the toys since they couldn't support themselves. Phoebe's red hair blended into the background, making her face stand out.

I worked all the values around the toys so the dolls' faces would be the lightest part of the painting as well as the most detailed. I carefully planned to have arms or legs touch the canvas edge for a stronger composition. To show everything in the center of the canvas, with nothing going out, creates a dead space around the picture. If you want to make things appear to be moving, don't outline. Use a series of short, straight strokes with small spaces between the lines. I used the dot-dash method of making a line in several places in this painting, such as around Phoebe's arm and under Andy's leg. Smiles weren't done as a continuous line either, but were broken up.

I try to get what I want with little or no blending. I've found through the years that I tend to do less blending with each passing year. Although, who knows, next year I might take up ultrarealism.

AFTER THE BALL

30″ × 40″

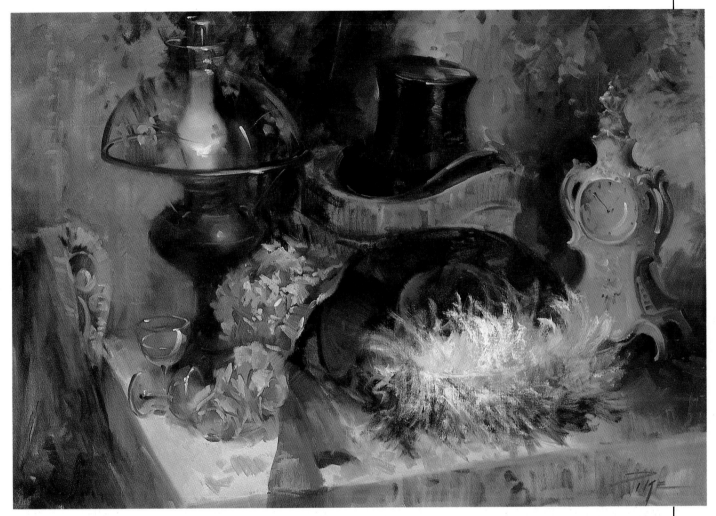

I have an aunt who collects old hats, and I borrowed a few from her collection to do this setup. I also used my old porcelain clock in the painting as it fit well with the period of the old hats, and I added a kerosene lamp with a hand-cut crystal shade. There was even an old leather hat box for the beaver fur hat. As I selected each item, I was careful to pick things that would show contrasting textures such as clear crystal, porcelain, satin, vel-

vet, fur, and feathers. It was fun to paint each object's realistic form. The overall color was red, with many red-grays to support the brilliant red-violet of the flower-bedecked hat. When objects such as hats are used, it's fun to tell a story. That's why I called this *After the Ball*.

WHITE DAISIES AND GLADIOLI

30″ × 24″

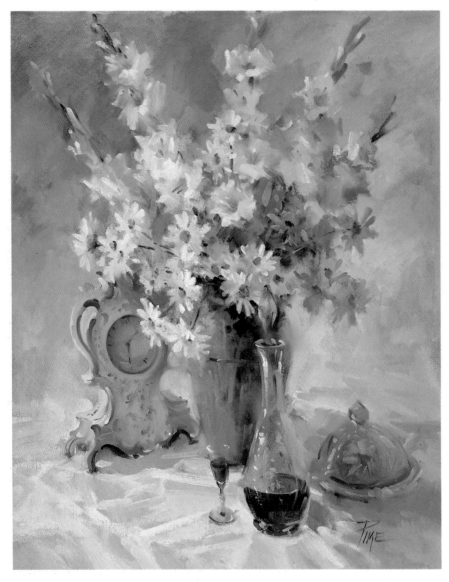

To take a vase filled with *white* flowers and set them on a *white* tablecloth with a *white* background can be a challenge. After I've arranged the set-up with as many white objects as possible, I needed to choose a dominant color to mix with the white. Once I picked the color, I could concentrate on the values, which were the main element of the painting.

For this painting, I chose blue-green as the dominant tint, with red-orange as the complement. The red-orange is in the clock and in the wine in the glass and decanter. Remember that value has very little to do with color. The wine is dark, but still red-orange. The clock is light, but still grayed-orange with touches of pink. There are many variations of gray in this painting. Some are a neutral gray with more complement added, while others go toward the dominant hue.

To make the flowers seem three-dimensional, I used cool grays, showing some daisies in shadow against the lights and warmer background, with the whitest white in the daisies in light against the darker background. The strong blue-green of the vase showed the strongest use of the dominant color. I chose this spot of strong color to create a strong focal point where the white daisies contrasted with the top of the blue-green vase. The strong blue-green color on the wine decanter and butter dish not only showed realism, but added dominant color throughout the painting. The folds of the tablecloth were left unblended to break up the expanse of the cloth. This interest in the foreground also helped bring the viewer's eye to the foreground, since the same grays are used in the background. It's better when painting close values to keep the background in the distance.

Once I recorded all values, I carefully worked in detail with as little effort as possible. The secret that makes a white-on-white painting work is value. To overwork detail could take away the subtle beauty of the close relation of values.

BELL OF PORTUGAL ROSES

22″ × 28″

I don't know if you are familiar with the Bell of Portugal rose. When it opens up, it isn't a tight, perfectly formed rose. It has a more floppy appearance. A friend of mine brought me a huge armload to paint. At first, I couldn't make up my mind if I wanted to use a dark background to make the roses stand out or a high-key composition with a light background. I decided to use strong darks, with more emphasis on the light flowers. I also chose to use red and violet as my dominant colors, so the red centers of the roses became part of the overall color balance. The whole painting is alive with dark violet-reds and light pink colors.

Sometimes it's interesting to do only flowers without a vase. The losing and finding of edges and the merging of values as flowers are lost in the background are important when there isn't a supporting object such as a vase. To make the entire mass work, the flowers should be painted from every angle, and each flower should be turning in a different direction. The leaves are almost undetectable, with only a few touches brought to recognizable form.

The most important thing to think about when doing only flowers is light and dark. But excitement can be lost if the proper values aren't established. When painting the flowers, I was careful to use well-directed brush-strokes with almost no blending. Each value and color were carefully mixed and placed directly on the canvas with a loaded brush.

This is what I call a mood painting. It hangs in my bedroom, and I like the feeling it gives the room. It's like having a rose bush growing indoors.

YELLOW CHRYSANTHEMUMS AND FRUIT

24″ × 30″

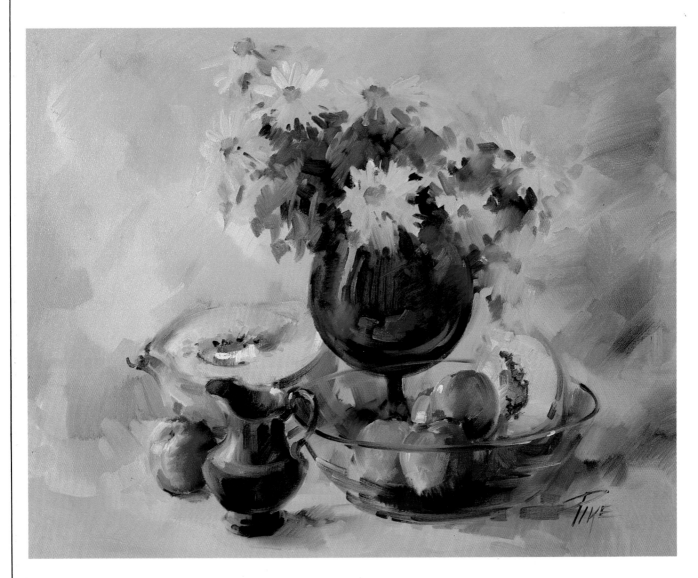

It was the peak of the summer fruit season, and I had a yen to paint fruit. I chose a large, clear glass bowl to show all the glorious color of the fresh fruit. Now I had to decide what to use with it. I tried a dark background, but it wasn't the right complement to the fruit. Then I tried a light background, but it wasn't right either. When I placed the large dark-green brandy snifter next to the clear glass bowl, the color of the fruit popped out. The color seemed brighter because of the dark complement next to it. That's what I wanted.

Then I placed the yellow chrysan-themums, which I planned to under-state by blending into the background with little detail, all of which helped keep the emphasis on the bright red-orange nectarines and honeydew mel-on. I used the small pewter pitcher to show another strong dark, along with the darks in the fruit bowl. Had I used only the large green brandy snifter, it would have read as a big green spot in the center of the canvas. The mass of green leaves also helped break up the round look of the snifter.

Give yourself a challenge such as I did and make it work. Not only is it fun, but it's rewarding.

PALE YELLOW ROSES

24″ × 30″

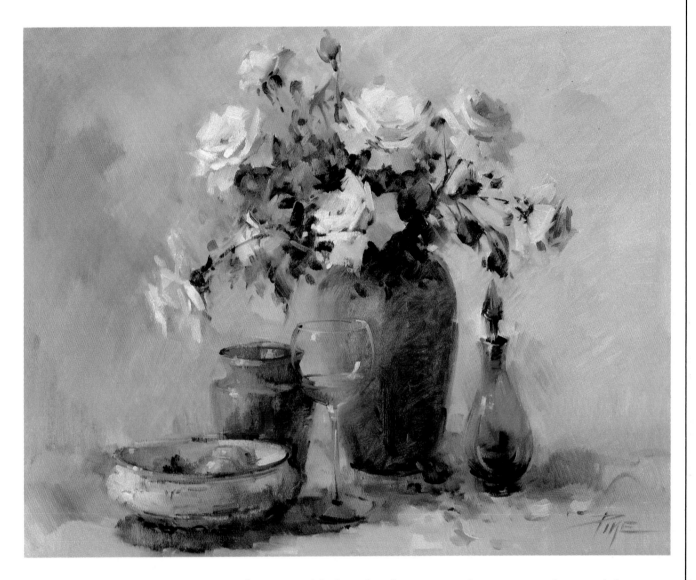

It was two o'clock in the afternoon, and I had just finished teaching a morning class. The freeways are a mess at this time of day, so I decided to stay a few hours to give them a chance to clear out. While I waited, I painted. What else? I can't stand to just sit. The class had done these beautiful roses that morning, and I certainly couldn't let them go to their grave without preserving them for posterity.

I felt like doing a traditional arrangement. I chose a few objects off the shelf and moved them around until it felt right. I chose three darks—the two copper objects and the green glass decanter. The white porcelain dish worked well as a light against the dark. The wine glass is like a puff of smoke. It didn't change the value, but it did break up the two dark objects so close in value and color.

As I worked, I concentrated on making each element as realistic as I could. The roses show their individual personalities, yet the focal point was not neglected. I still showed strong darks against the light yellow roses. I had fun working a more detailed painting, and there was less traffic going home.

CAMBRIA BY THE SEA

24″ × 36″

I was standing on a grassy ledge over-looking massive rock formations with swirling patterns of foam moving rhythmically around them, sometimes pounding, sometimes caressing. As I stood looking down, the water was very dark, at times showing deep purple over a viridian hue. The moving foam formations were light green, showing the dark water below as the foam separated into lacy patterns. Watching moving water can mesmerize one into complete tranquility. I was inspired to paint the motion of the water without the typical wave action so familiar in most seascape paintings. The massive main wave is in its first stage of breaking. I deliberately planned it so that it wouldn't take away from the interesting pattern of loosely painted foam. The slight suggestions of cresting waves in the distance diminish in size to show perspective. Though loosely painted, the rocks take center stage in either shadow or sun.

I did the entire painting in acrylic. After it dried, I felt the need to enhance some of the colors with an oil overlay. I used soft washes of pure color mainly in the deep water tones. Then with touches of lightly tinted white, I went over the soft green acrylic foam with sparkling touches of warm highlights. The combination of the two mediums works fine if not painted too thick. Just don't try to put acrylic over oil. It won't work. I wanted the viewer to feel that he or she was standing where I stood and enjoying what I saw that beautiful day in Cambria by the sea.

TREES IN ATASCADERO

24″ × 36″

When summer is over, the leaves start turning warm tones, drying and falling, covering the ground with a blanket of color. Depending on the area, the fall colors can vary from earthy gray-greens to brilliant red-oranges. It is a great experience for an artist to paint the glowing fall colors from nature.

My friend Alice and I went over to Atascadero, a small town just over a low range of mountains from the California coast where I live. I drove slowly, watching the colors become more intense as we moved farther away from the coast. Then I spotted an area where a dry creek passed under the road. Alice and I had a terrible time finding a spot where we could park the car. As often happens, we spent more time getting set up than it actually takes to do a painting. Don't get discouraged when this happens; usually persistence will win out.

Often adding wildlife or people to a painting will be the perfect, final touch. It's always better to plan such an addition from the beginning; if everything still works, go for it. Here, I only suggested the deer, which you don't even notice at first glance. That's the way I intended them. Their location is not as important as playing them down. I kept them small and used the same mixtures as the surrounding foliage, camouflaging them.

BIBLIOGRAPHY

Bridgman, George. *Constructive Anatomy.* New York: Dover, 1973.

Hogarth, Burne. *Drawing the Human Head.* New York: Watson-Guptill, 1965

Huntly, Moira. *Painting and Drawing Boats.* Cincinnati: North Light Books, 1985.

Mayer, Ralph. *The Artist's Handbook of Materials and Techniques.* New York: Viking, 1981, fourth edition.

Sanden, John Howard. *Painting the Head in Oil.* New York: Watson-Guptill, 1976.

INDEX